MICK MOON

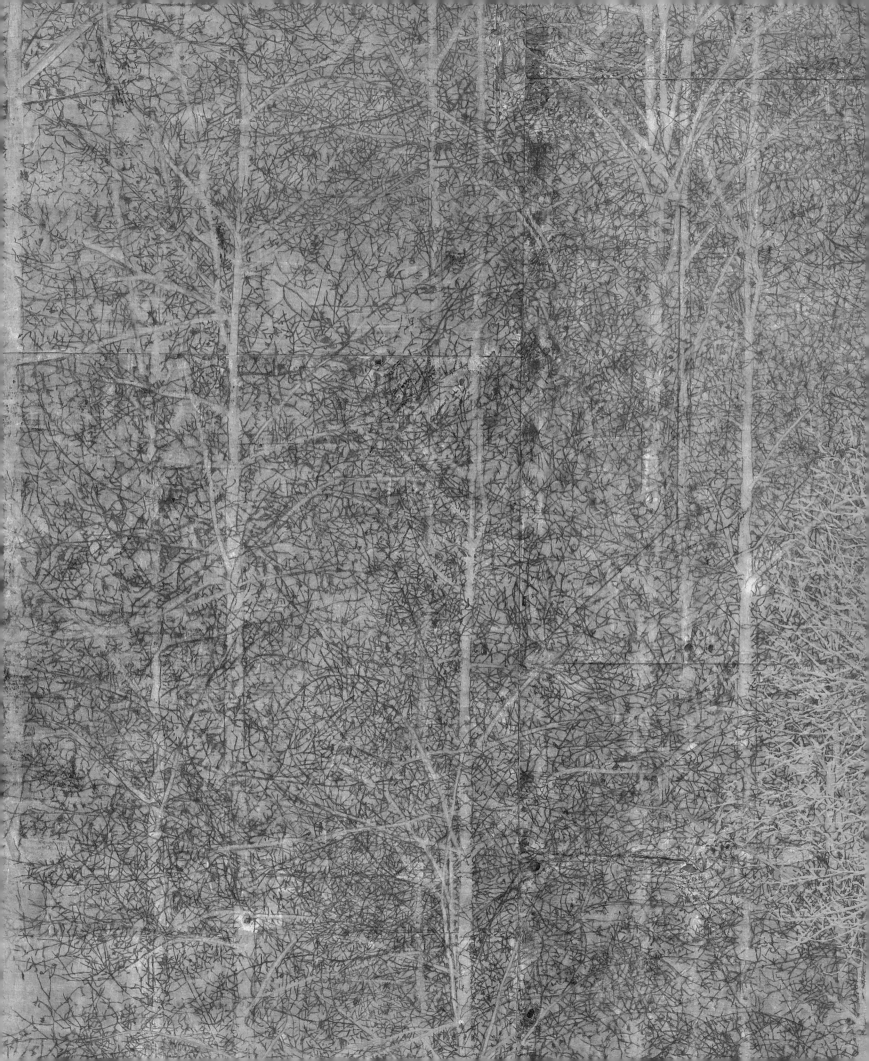

MICK MOON

MEL GOODING

Royal Academy of Arts

Contents

Foreword

In 1968 Mick Moon moved into the top-floor studio of a large house in Addison Gardens, West London. The house belonged to Howard Hodgkin, who had used the studio himself before moving to the country. Working in the studio downstairs was Mick's friend Patrick Caulfield. That year Mick arranged a studio exhibition of his recent paintings and another friend, John Hoyland, brought along his dealer, Leslie Waddington. This visit led to a contract with the fledgling Waddington Gallery, which already represented Hodgkin, Hoyland and Caulfield. Three exhibitions of Mick Moon's paintings followed in quick succession, one of them bought in its entirety by Alistair McAlpine, then the most prolific collector of contemporary art in Britain. This in turn led to an exhibition at the Tate Gallery in 1976.

I joined Waddington Galleries in late 1972 with the responsibility of looking after their nascent print publishing programme. At that point I was less familiar with Mick's work than with that of the other three artists, but I quickly developed an affinity for it. My arrival coincided with the period in which Mick had turned towards the actual contents of his studio as a means of creative expression. Process and content were fusing as he literally took impressions of the studio furniture – floorboards, doors etc. – as the bedrock of his paintings. I was intrigued by the way this elemental printmaking, not so different from brass rubbing or monotyping, not only underpinned the paintings but also became transmuted into its subject-matter. In the exhibition that accompanies this book there is a strikingly simple example of this lifelong transmogrification, with the floorboards of his studio in Peckham reappearing in the form of the Indian Ocean – from the mundane to the infinite.

His father had been in the army in India. Mick's wife was Indian. He travelled to India for the first time to visit her relatives and it was there that he discovered, both from life on the street and through Indian miniatures, the vivid and intense colour that came to infuse his work. He was drawn to the East End of London, where ships would arrive from the subcontinent, bearing not only goods from India but also Indian migrants who then settled there. He became fascinated by displacement, both people and artefacts finding a home a long way from their roots. Throughout the 1980s and '90s the materials from his studio served to conjure up a stream of paintings and painted monoprints that bore testament to this sense of displaced existence and, because printing was such a basic ingredient of his working methods, it was natural that he and I should be drawn closer and closer together in our working lives. I dealt in the paintings and distributed editions of prints, which regularly featured at both the gallery and at art fairs abroad, where they invariably proved highly successful commercially. Indeed, the vast majority were sold abroad, which is why they have remained relatively unknown in Britain. Besides, Mick has always chosen to live out his life away from the public eye, maintaining a healthy lack of interest in the glitz, glamour and hyperbole of the contemporary art world, preferring the company of fellow artists to that of dealers or collectors.

For an artist of such stature, this monograph is long overdue and, after a personal association that has lasted over 40 years, it seems fitting that it should be published to coincide with an exhibition of his latest paintings at my gallery.

Alan Cristea, 2019

Opposite: 1 *East*, 1996
Print, 120 × 91 cm

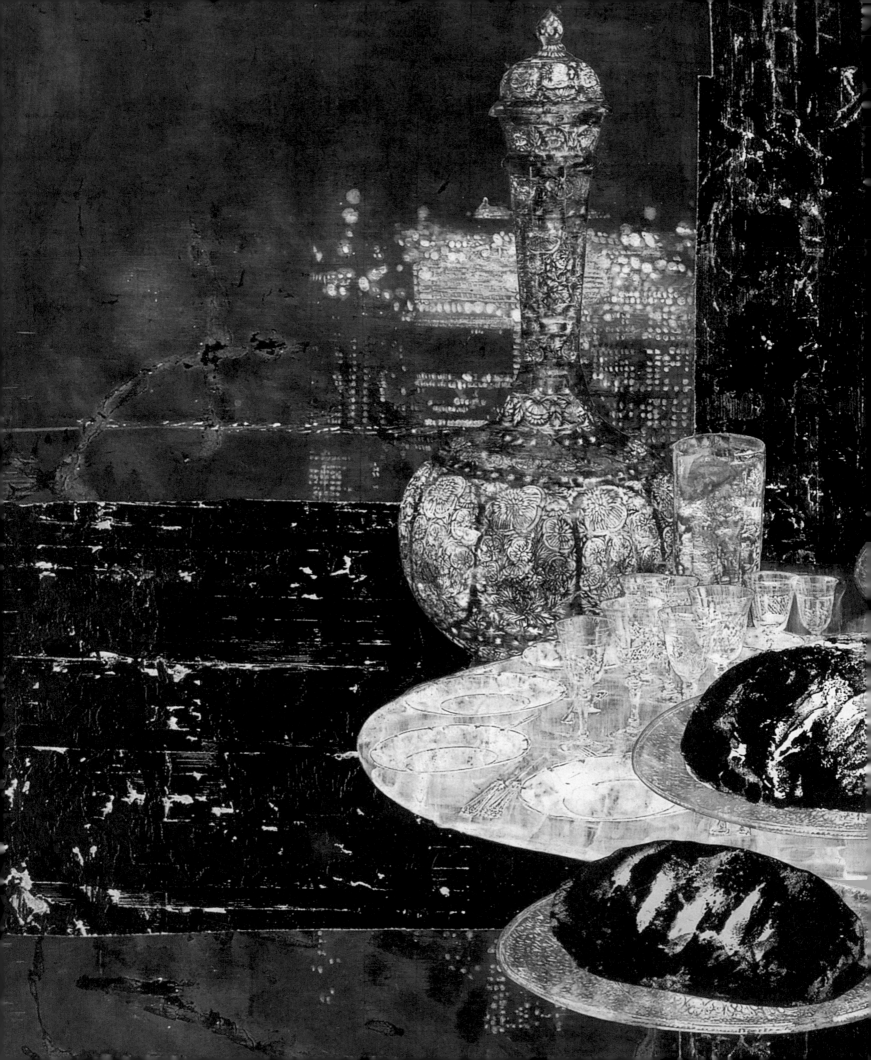

Starting with What You See

'The poet is looking for both inwardness and images. He wishes *to express the interiority of a being of the external world*. He does it with a strange purity of abstraction, withdrawing from immediate images, conscious that one does not arouse dreams by describing. He confronts us with the simplest motives of reverie; with him, we enter the chamber of a dream.'

Gaston Bachelard[1]

For more than fifty years Mick Moon has pursued a singular career in art as a teacher, painter, printmaker, collagist, painter-printmaker. Of his generation of visual artists Moon is the master poet of reverie, of the dreamlike movement of the free and undirected conscious mind over the miscellaneous, banal and exotic, objects of everyday life, and their presence, immediately visible or else disguised, imagined and recollected, in the spaces and places we inhabit, the chambers in which we live, work, think, muse and dream. A deep thinker but not a theorist, an artist of the ever-present living imagination, Moon has written almost nothing, his most concentrated ruminations on the mysteries of perception finding, instead, appropriately enigmatic expression in the wordless practice of image-making and signifying.

His paintings and prints, in all their diversity, function in each case as the focus for quiet and reflexive contemplation. In complex ways they embody remembrance, observation, spontaneous gesture, memories of topographies, places and atmospheres, abstract painterly opacities, glimmers, shimmers and translucencies, radiances and intimations of inky shadow, inchoate matrices of mineral matter, calligraphic ideograms and arbitrary diagrammatic structures. Any one work may combine this accumulation of contradictory signifiers, contrasting marks and images, as if its demonstrably slow and deliberate aggregation had found a momentary resolution in a complicated simultaneity – an intricate poise – of image and evocation, sensation, thought and feeling.

Moon's paintings and prints (which to all intents and purposes are as rich and complex in their making and in their effects as the paintings and collages) offer pleasures compounded of the immediately sensory (the rich surfaces and visual contrasts of the work itself), the dynamics of mental response (recognition, surprise and reminder) and the joys of reflective reverie. Their resonant evocations may be at once precise and vague, beginning often with a direct recollection

of a known and remembered object or a place (a studio wall, a seafront, tea-chest stencils, a bidriware vase), or a familiar experience (looking on a daily basis at the fanciful stained-glass lights of a front door, coming upon a table set with glassware, a memory of post-war greengrocers' shop posters), or an aspect of a work of art (the painterly densities of Abstract Expressionism, the cool exactitudes of a Patrick Caulfield still-life, the spatial complications of a late Braque studio painting).

But the complexity of Moon's pictorial chemistry, the slow deliberation and gradual accretion of his compositional processes, have behind them, quite evidently, a desideratum like that of Magritte's: 'The only painting worth looking at has the same raison d'être as the raison d'être of the world – mystery.'[2] This mystery of the world begins with life itself, and provokes the deepest thoughts, and the most inconclusive. Its invocation is not necessarily immediately accessible to the young artist; to be capable of it he must work to arrive at it without premeditation but through assiduous preparation, a kind of initiation.

Not every artist, however gifted, is capable of what the poet John Keats described as 'Negative Capability': 'that is when a man is capable of being in uncertainties, Mysteries, doubts, without any irritable reaching after fact & reason'. Even the great Coleridge, he remarked, 'would let go by a fine isolated verisimilitude caught from the Penetralium of mystery, from being incapable of remaining content with half knowledge.'[3] Moon's greatest strength as a mature artist would seem indeed to lie in his extraordinary 'negative capability' to work with impressions and intimations – 'uncertainties, Mysteries, doubts' – to create images whose power lies in their indefiniteness, without regard to a critical programme or a dominating idea. In a period of literal presentations, discursive polemics and prescriptive aesthetics, it is a rare achievement.

After an impressive early career, a period of some years, in which it may be said that the artist was consciously experimenting, and in differently fruitful ways seeking a way into the discovery of his essential subject. This central theme was to be the mysterious dialectic of concrete external

2 *Melting Pot*, 1990-91
Screenprint and woodblock, 127.5 × 109 cm

actuality – the world of the five senses – and the immaterial structures of thought and reverie, the generative inner world of mind and emotion that we call the imagination. It is concerned with the inevitable limitations of what Stephen Dedalus, in *Ulysses*, famously thinks of as the 'ineluctable modality of the visible': the inescapable beginning of thought, and the search for meaning, in the visible objects of the world. '... at least that if no more, thought through my eyes. Signatures of all things I am here to read...'[4] As in Stephen's stream of consciousness, the paintings of Moon have no definitive focal point, no immediately clear thematic intention, they present no single indicator of a precise external subject or field of interest; figure and ground are never clearly differentiated, they merge and separate, are veiled and suddenly clarify.

Inescapably, we see to start with. Then comes the evidence of other senses, as thought follows, the stream of thought, involuntarily associative, without order, but seeking order in

3 *Still*, 1994
Monotype with collage, 54 × 40 cm
Image courtesy of Rosebery's, London

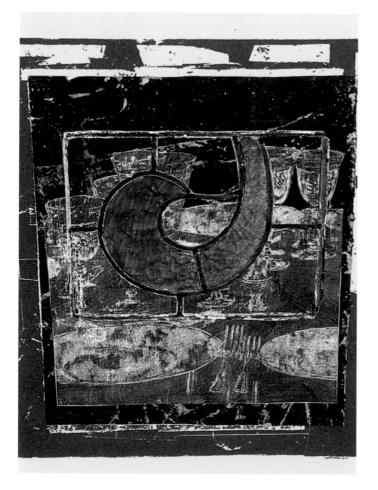

the things seen. Moon's paintings would be difficult indeed to assign to any familiar modus or genre: they are in part abstract, in part representational, they may have elements of still-life and landscape, they may combine painting, printmaking, collage and transferred typography. They are crammed with evocation and reference, moody shadows, complex markings, lettering, glimpses of precisely specific objects. The more we contemplate them, the more we recognise them as essentially metaphorical: they are representations of a mind and imagination at the complex moment of perception, of the astonishing richness and excitement of looking at ordinary things caught – apprehended as we say – in the otherwise indescribable welter of the visible. In its magical transformation into a conceptual complex, the purely visible (if such a thing exists) is transcended into vision. 'Sensation, revelation' said Braque, Moon's most admired great predecessor.[5] Braque also said (and Moon would readily agree): 'If there is no mystery, then there is no poetry, the quality I value above all else in art.'[6]

The beauty of giving precedence to the visual is thus that of both precision and vagueness. It also allows for a certain arbitrariness. A bidriware casket serves as well as a slice of white bread, a lettuce or a glass chalice; any of these objects might elicit a similar pleasure of surprise that it is here, visible and present, before our very eyes. Fancifully *realised*. This and not something else! The objects presented in Moon's paintings give this pleasure, the stylised exactitude (a technical matter of which more later) of their representation, their seemingly arbitrary selection out of the whole infinite world of things, their gnomic presence in a picture. Why *this* and not something else?

And what to make of it? It is never isolated and presented as a 'subject' in itself: the enigma of its arrival in our field of attention is not like that of the deadpan conjuring of *trompe l'oeil* exactitude in a late Patrick Caulfield painting – *voilà!* – a vase of flowers, a wine glass, a lamp! It is in fact always most carefully premeditated and prepared, as by the laborious working of a direct relief print of worn floorboards, or an intricate woodcut, or a digitally processed treated photograph: it is incorporated as an element in an overall image that appears to have no programmatic logic. As often as not, its effect is hallucinatory, or its placement in the field of vision is like that of an object in a dream where nearness and distance are confused, where a stencilled or a scribbled place-name, or a sign for a stylised leaf or a silhouette of flowers, disrupts pictorial space. In the latest paintings, the floorboard rubbings are just such a sign, or rather, perhaps, a *trace* of actuality, coextensive, so to speak, with a reverie of a birch wood or the offshore sea.

These mysterious motifs may be laid on the planar space alongside a bituminous matrix, the abstract (or concrete) actuality of spread and smeared paint or viscous ink, a summoning up of darkness-itself with no pictorial intention, as in *Melting Pot* (fig. 2). It may be repeated, along a line or in

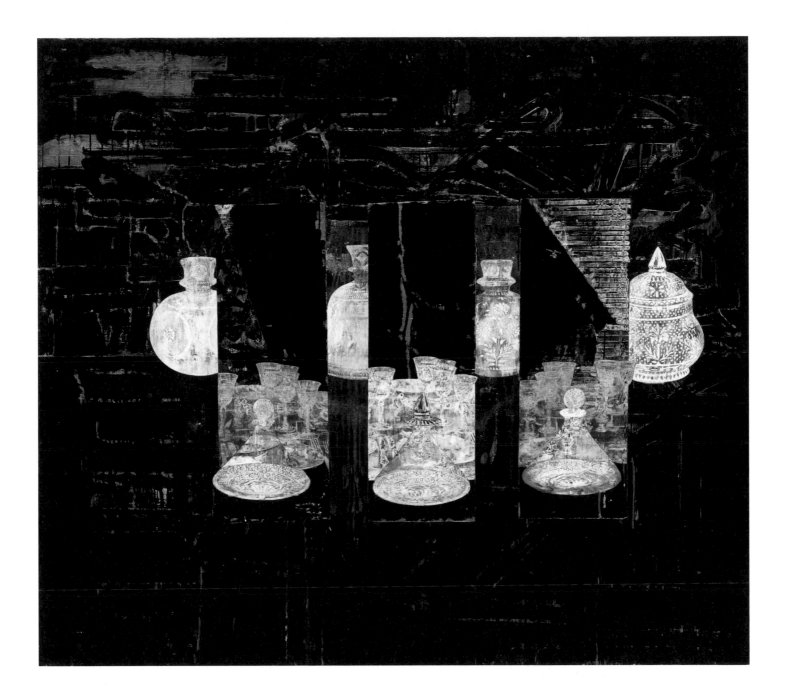

a cluster, as in *Decanters* or *Ethnic Touches* (figs 4, 45). It may
be contained in a grid of such ghostly images, as in *Red Cross*
(fig. 116), a grid that can only be ironic, since its order has no
programmatic thematic purpose (sliced white bread is naturally
serial; drinking glasses in a set are as a matter of fact identical).
It may find itself obscured in part by a kind of painterly doodle,
or within a weave of pattern, or a chaos of indeterminate colour-
shapes. There is no composing rule. There is only the imperative
of the creative moment, the thought-felt determination of the
picture as a whole. This accounts for the ghost-like appearance

4 *Decanters*, 1993
Acrylic on calico mounted on canvas, 162.5 × 187 cm
Private collection

of objects and figures in Moon's paintings, their apparitional
presence signifying their status as an image, *an item of thought*.
We had best (again) take Braque's word: 'Once an object has
been incorporated in a picture it accepts a new destiny.'[7] Yes. It
has entered the dominion of the sign, a world that is ineluctably
coexistent with the visible.

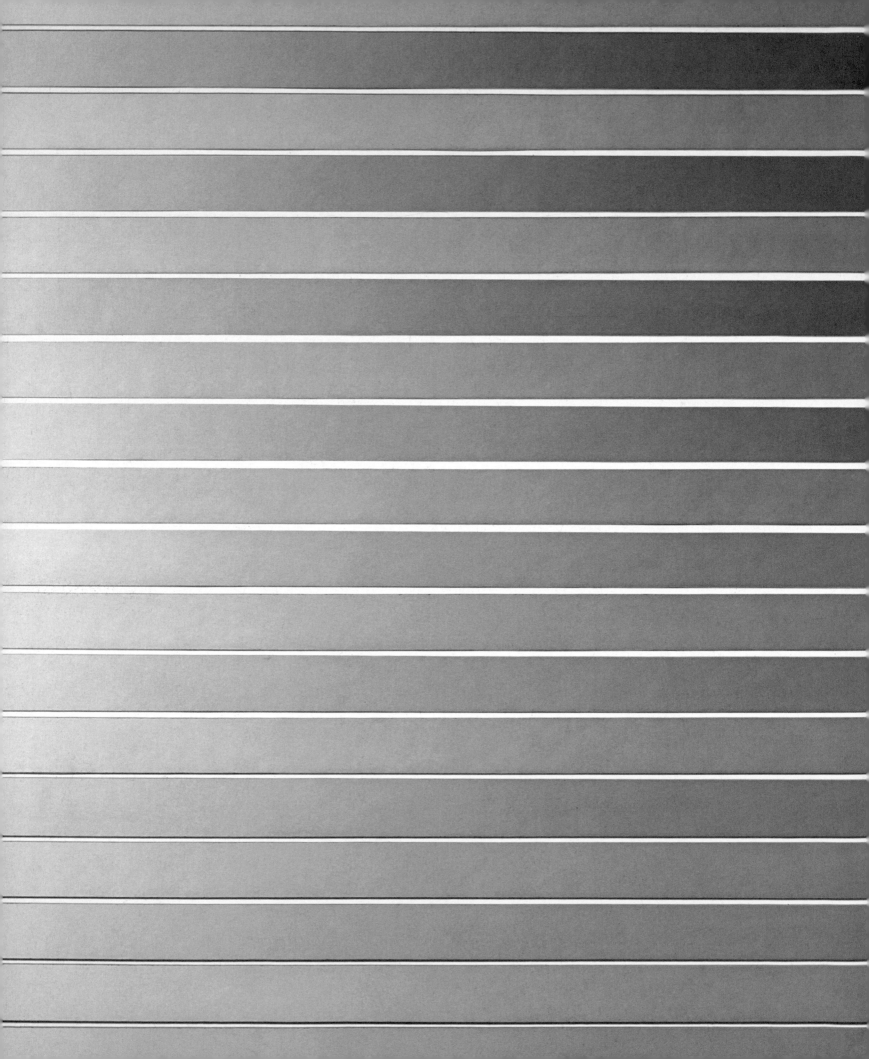

Ideas and Investigations: The Early Work

'Abstract? To be an abstract painter does not mean to abstract from naturally occurring opportunities for comparison, but to distil pure pictorial relations.'

Paul Klee[1]

'The only valid thing in art is that which cannot be explained.'

Georges Braque[2]

The Thinking Eye

Mick Moon has always been a philosophical painter. This might be taken to imply a certain cerebral quality to his approach both in technical matters (often complicated and carefully premeditated) and in his thematic preoccupations (constant for long periods, and through changes of manner), but in fact his paintings have always made an immediately direct, even visceral impact. They surprise and sometimes perplex the viewer, but they always bring a visual pleasure compounded of fact (the physical fact of their presence) and mystery: they are at once intensely material, powerful physical presences, and indeterminate in their imagery, which hovers at the bound of intelligibility and ambiguity. They are obscure objects of desire.

From the mid-1970s, after the cessation of what he called the 'strip paintings', through to about 2010, the initiation of the 'wood-grain as water' paintings, his work has been obdurately objective and tangible, even confrontational. I mean by this that Moon's paintings from this long period of creative diversity do not behave in the way that paintings tend to do in your presence; they beguile the eye, but do not easily or immediately disclose their secrets. They demand attention, a constant movement of the eye and mind from surface to image, from layer to layer of matter, from recognisable, if enigmatic, object to indeterminate space or painterly opacity. Diversely printed and collaged, or directly imprinted, with stencilled lettering or signs on the surface, painted (from expressionist scribble to *trompe l'oeil*) and meticulously drawn, they are works that challenge the spectator to speculatively read their meanings or invent interpretations. Just as the mind grasps a coherence, they slide into ambiguity, as the eye seeks (and finds) a new configuration of forms, patterns, images, colours and textures. They are certainly things, with a distinctive and complex 'thinginess'.

After National Service, Moon studied at Chelsea School of Art, a college associated always and most particularly with painting, and having passed through the Royal College graduate school for one year without touching the sides, in the autumn of 1963 he was invited back to teach at Chelsea by the Principal, Lawrence Gowing, a somewhat conventional artist, but a teacher, art historian and art school administrator of great

intellectual distinction. He had clearly seen that Moon would bring to teaching a perceptive and intelligent eye and an acute and experimental approach to the problematics of painting. Gowing was gathering around him at that time a brilliant cohort of young artists to work alongside the established artists (Ceri Richards, Prunella Clough, Leon Kossoff, Jack Smith, Tony Whishaw among them) who had maintained Chelsea's reputation as one of the great London colleges. These younger artists included Jeremy Moon (no relation), John Hoyland, Antony Donaldson, Allen Jones and Patrick Caulfield.

For the young Moon it was a time of great excitement, and it was at Chelsea that he made, with Hoyland and Caulfield, the two closest and longest lasting artistic friendships of his life. Both played a part in Moon's formation and development as a painter, though in each case their influence was mediated by way of working proximity, good company and conversation; it was deeply assimilated and not in any immediate way stylistic. The ironic literalist Caulfield was coolly systematic, a slow and painstaking worker who aimed for absolute clarity of image, a perfect almost industrial simplicity of surface, and more or less banal subject-matter (things known to the eye: formulaic images from comics and school books, cliché still-life objects, studio and other interiors, modern designer furniture and windows); Hoyland the passionate abstractionist immersed himself in energetic serial adventures in expansive planes of acrylic colour and dramatic atmospheres of light, space and matter.

In different and unexpected ways, consciously and unconsciously, while entirely absorbed by his own quite specific and inner-directed preoccupations and determinations, Moon was to use aspects of the art of both friends in his own work. As he moved from the carefully judged hard-edge impeccable planes of shifting colour-tone of his early strip paintings to the intractable and messy imprinted surfaces of the mid-70s 'painting-objects' and 'object-paintings', and the paintings thereafter, to the apparition imagery of later collage-paintings, to the imprinted wood-grain-as-water paintings of the last few years, it was in Moon's artistic nature – open and assimilative, concentrated and closely focused – to conduct this conversation, and to utilise in a profoundly personal way his awareness, without any need to suggest (let alone theorise) affinities, or to adopt or adapt stylistic devices or mannerisms. Their artistic relations were a matter of mind and of attitude rather than of manner and artifice, of consonances deeper than style. They brought a creative conviction to his uniquely personal, periodically changing, project, to a body of work always driven by a reflective originality.

It was a project that began in earnest in 1967, with the making of the first of the so-called strip paintings. It was a late start: Moon was already thirty years old. What work he had done before this cannot have been entirely unimpressive, if his career at Chelsea and the Royal College, and his appointment

to the stellar staff at Chelsea were any indication. But it has been Moon's decision from early on in his career to present the making of the strip paintings as its real beginning. It is the first body of work that he deems worthy of retrospective critical consideration. Its programme (and in this case, that term is wholly appropriate) was laid down with the first painting, in what became a series of perhaps fifteen works executed over a period of about five years, from late 1967 to 1972, when he brought it to an abrupt stop.

First Strip (1967; fig. 5) was an experiment undertaken after Moon had looked again at the pedagogic notebooks of Paul Klee, an artist he had admired for many years, gathered together in his great book of practical theory, *The Thinking Eye*. It is clear that Moon was looking for a creative focus, for some clue as to what he might do that was not merely arbitrary. 'Begin with an empty canvas and see what happens' was still a starting point for many artists at this time: the history of post-war abstraction, and the instinctively automatic procedures of both *tachisme* and 'action painting' had left the field open to such freedom from purposeful forethought. It was not an option for Moon, even in the modified forms of Greenberg's much vaunted 'post-painterly abstraction', whose primary qualities of 'clarity and openness' were those that at that moment Moon might have been inclined to favour. (Certainly there were significant contemporary colleagues – Hoyland and Jeremy Moon among them – whose work was within that ambit.) Moon was himself temperamentally inclined to the adoption of premeditated constraint. In this respect his prolonged engagement with the strip paintings – and his working of this mode to exhaustion – was indicative of his *modus operandi* thereafter.

Horizon light: horizon colour

Klee's thinking was of a depth and richness that deeply affected Moon. In particular, he responded to Klee's concept of art as essentially philosophical: as an experimental quest for, and demonstration of, correspondences between systematic graphic and painterly devices and ontological and metaphysical realities; and those between a material expression of relationships (as between colour, tone, interval, number, etc.) and the spatial and energetic realities of being and moving in the world (fig. 8). Especially, Klee was fascinated (one might say obsessed) with the ways in which gradations might chart and formally symbolise movements between one extreme of existence and its opposite: black to white; dark to light; bottom to top; deep earth to infinite air; density to clarity; chaos to order; origination to finality; etc. That we see these relations in terms of movement implies that they may be understood therefore as representations of the ineluctable modality of the temporal: that the graphic or painterly 'pictorial form', however abstract, may thus encompass the implication, or even the presentation of the tragic.

5 *First Strip*, 1967
Acrylic on hardboard, 15.2 × 304.8 cm
Private collection

6 *Untitled No. 5*, 1968
Acrylic on plastic, 104.1 × 304.8 cm
Arts Council Collection, Southbank Centre, London

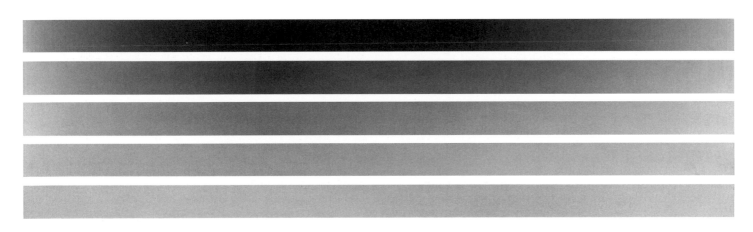

7 *Untitled No. 6*, 1968
Acrylic on plastic, 104.1 × 304.8 cm
Artist's collection

'We are artists, practical craftsmen' wrote Klee, 'and it is only natural that in this discussion we should give priority to matters of form. But we should not forget that before the formal beginning, or to put it more simply, before the first line is drawn, there lies a whole prehistory: not only man's longing, his desire to express himself, his outward need, but also a general state of mind (whose direction we call philosophy), which drives him from inside to manifest his spirit in one place or another.... I emphasise this point to avoid the misconception that a work consists only of form.... The most exact scientific knowledge of nature, of plants, animals, the earth and its history, or of the stars, is of no use to us unless we have acquired the necessary equipment for representing it; ... is useless to us unless we are equipped with the appropriate forms; that the profoundest mind, the most beautiful soul, are of no use to us unless we have the corresponding forms to hand'.[3]

First Strip may be seen in some sense as a primitive manifesto: it stated in the simplest starkest terms the principle of gradation as the formal basis of the series of paintings made between 1967 and 1972, a project that the artist has described as 'an exploration of colour and its internal relationships.' He had found a purpose. He quickly moved on to find a form 'appropriate' to his 'philosophical' inclination. In *First Strip* he simply traced the gradation from white to black along the length of a hardboard plank-like support. It was an exercise implicit in Klee's many pedagogic sketches and notes concerning the opposition of black to white, and the graduated progressions, going through grey, between them. Like Klee, Moon needed to deepen the game, and the obvious move (inspired directly by Klee's own elaboration towards the end of

Volume I of his *Notebooks: The Thinking Eye*) was to complicate the device by introducing colour and colour-tone gradations. By further adding parallel strips he introduced vertical and diagonal dynamics across what was in effect an expanded field.

After a failed experiment using abutting vertical columns of gradated colour on a single support, which created an optical disturbance quite at odds with his objective intentions, Moon made a decisive breakthrough: he changed support and format, adopting standard industrial 10-foot x 6-inch white formica strips aligned vertically in parallel banks, first of five, then of six, finally of eighteen. Laid on a base, he found that a minimal one-inch gap between them eliminated the optical distortions that distracted attention from the almost imperceptible mathematically determined adjustments of colour gradation along each strip, and of the colour-tone variegations across the aggregate surface from side to side, top to bottom and diagonally in four directions. (In the later strip paintings he adopted less rigorous constraints, working more intuitively and experimentally not simply with gradations, but with aesthetically determined colour variations.) A surface of discrete and structurally identical units assumed the appearance of a unitary plane, across which light (attracted and augmented by the faintly lustrous hard white under-surface), shadow, tone and colour played in ceaseless kinesis, as they might over a field of barley or a sheet of lake water, as the sun or moonlight changes on a visual field from dawn to sunset, and dusk to dawn (figs 9–11).

These natural similes are perfectly appropriate to the effects (at once purely optical and allusively visual) of the strip paintings. They are spectacular (in the true sense) objects,

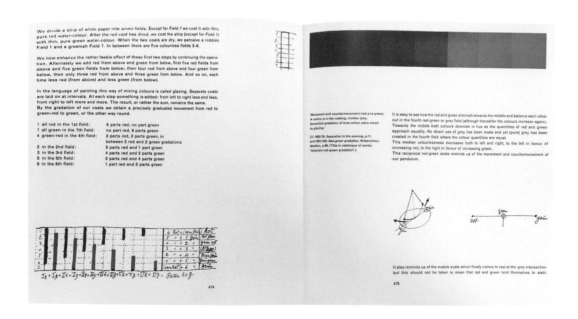

8 Paul Klee, *The Thinking Eye*, London, 1961, pages 474–75. Spread illustrating 'Movement and Countermovement (red and green)'

Opposite: 9 *Untitled*, 1970 Acrylic paint on plastic, 243.8 × 304.8 cm Tate

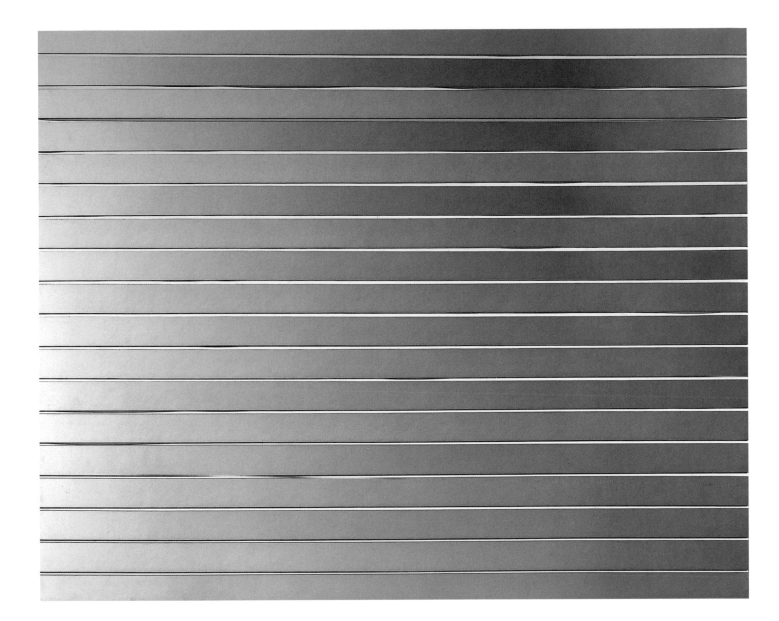

born, in the first place, out of a carefully devised programme with two quite distinct aspects. The first is the outcome of a deeply intuitive practical interest in the phenomena of colour and tone, with their relations to mathematical and musical interval as the basis of both visual and audible harmony and discordance, and their essential habitation in time. These effects are congruent with those in the natural world of light, movement and colour: they are *correspondances* of a kind that Baudelaire would have recognised:

Like prolonged echoes that far away merge
In a shadowy and profound unity

Expansive as night, vast as light
Perfumes, colours and sounds answer to each other.[4]

The second is a more visceral and less easily expressible aesthetic, whose expression is in the visible manifestations – the unpredictable visual effects – of the dynamic colour fields created by the programme, and their relation to phenomenological experience of the world. We cannot help but read formal horizontals – even a single drawn line – as analogous to the natural horizons that bound our visual field, whether those of land or sea; multiplying horizontal bands in parallel as in the strip paintings creates a further

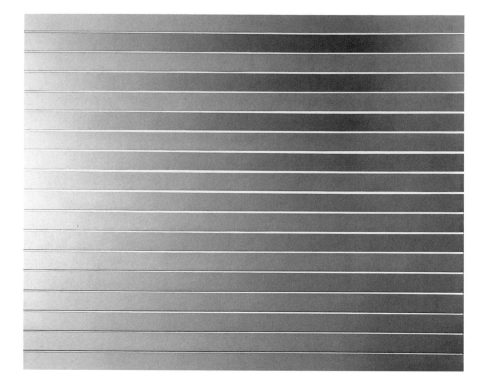

10 *Untitled No. 1*, 1970
Acrylic on plastic, 243.8 × 304.8 cm

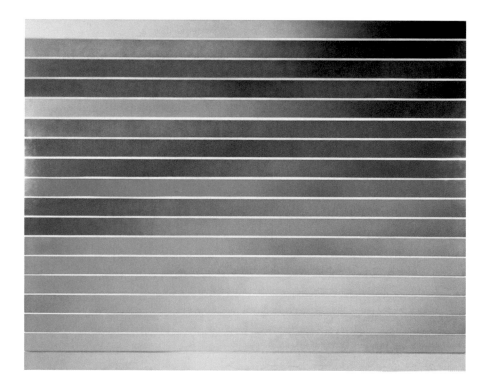

11 *Untitled No. 5*, 1971
Acrylic on plastic, 243.8 × 304.8 cm
Private collection

12 *Untitled No. 2*, 1971
Acrylic on plastic, 243.8 × 304.8 cm
Alistair McAlpine. Courtesy
Waddington Custot, London

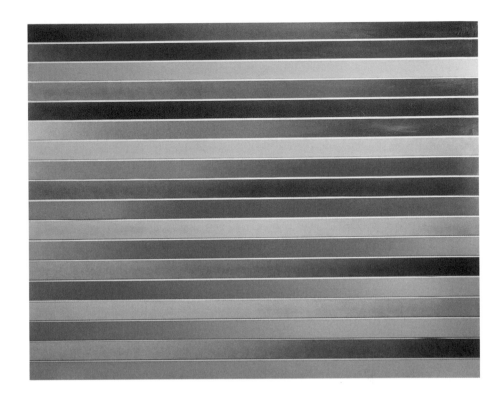

13 *Untitled No. 12*, 1973
Acrylic on plastic, 231.1 × 304.8 cm
Courtesy Waddington Custot, London

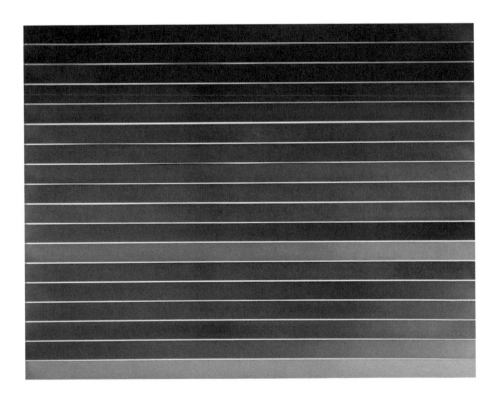

effect of a planar field (as of a terrestrial plain or marine or lacustrine surface) stretching away: visually, the vertical become inescapably horizontal. But the paintings remain minimal paintings not pictures: brilliant objects, ineluctably visible and tangible in the space we occupy. And as such they do more than present resemblances: they are novel *inventions*, contrivances that propose possibilities of light and colour, and correspondences of form and space hitherto unseen.

In Klee's *Notebooks* Moon will have found much that touched on these two aspects. Sometimes gnomic, sometimes poetic, sometimes didactic, Klee gave mind and voice to an artistic vision that inspired and validated Moon's first major project. '[The artist] is a philosopher', wrote Klee, 'without exactly wanting to be one'. The world may not be the best of possible worlds, he continues, but it is not so bad that it may not be taken as a model; it is not, however, the only world possible. 'It dawns on him that the process of world creation cannot, at this moment, be complete. He extends it from past to future, gives genesis duration.... Standing on earth, he says to himself: this world has looked different and in time to come it will look different again.'[5]

The world from where I stand: studio floorboards, walls, windows

Visiting his studio sometime in the early 1970s, the influential dealer John Kasmin remarked to Moon that the strip paintings had a 'West Coast look'. He had in mind no doubt the minimal cool, systemic and repetitive paintings and objects of such California-based artists as David Simpson, Robert Irwin and John McCracken, artists who lived and worked in Los Angeles, between the desert's horizons and the ocean's edge, and whose driving preoccupation at the time was with colour, space and light. Their predilections for perfect finish derived from the impersonal hi-tech streamline of automobile engineering, surfboards and shop-front *moderne*. (McCracken had made his first monochrome 'planks', designed to lean against the gallery wall, and surfaced to a high finish in polished resin, in 1966.)

Although Moon's paintings had behind them an altogether different origin – their 'genesis' in Klee's exalted terms – Kasmin was in certain respects close to the mark. Certainly there was something in Moon's conception of his project that was in close accord with McCracken's view of his own 'planks', which he saw as 'existing between two worlds, the floor representing the physical world of standing objects, trees, cars, buildings, human bodies, and everything, and the wall representing the world of the imagination, illusionistic painting space, human mental space, and all that'.

In an age in which the establishment of a recognisable signature abstract device could be the making of an artistic reputation (as indeed in the case of the very good West Coast artists mentioned), it is indicative of Moon's singular

determination to use painting as an investigative process that at a certain point in 1973 he simply ceased to make paintings of this kind. They had outstripped their purpose. They had become, he thought, merely beautiful. The 'merely' was unjust, but he clearly felt, more significantly, that they had 'no potential for evolution', that he could not extend them, in Klee's terms 'from past to future.' Some time after, Moon had second thoughts about this, but by then he was committed to new directions. At first, however, he felt he had simply come to a dead end at a blank wall.

Seeking a way out of the impasse, Moon did what artists in such a situation often tend to do. He looked around him, and began with what was immediately to hand, or to foot, as one might say. There was a hiatus in viable productivity, but not in creative projection. He realised that the studio itself constituted a subject rich with implications: the artist in the studio is the primary 'standing object', he is part of McCracken's 'physical' circumstantial world; he is Klee's artist, standing on the horizontal earth. In this primary world he is the representative human being, whose purpose is to engage playfully, experimentally, with that world and present his discoveries in the creative transformations of Art. Placed vertically on the wall, a painting has revelatory force, it has entered what W. H. Auden called a 'secondary world': that of McCracken's 'imagination, illusionistic painting space, human mental space and all that'.[6]

After several experiments Moon developed and elaborated what was a radically rudimentary technique: to take direct imprints onto calico from the floorboards, the walls, the windows and the furniture of his top-floor studio. (The house in Addison Gardens in Kensington belonged to Howard Hodgkin, and Patrick Caulfield had a studio on the ground floor.) The imprints (or casts, as the artist usually describes them) were made of strips and mostly rectangular shapes of wet paint-impregnated canvas or calico, laid face-down onto wet painted surfaces, themselves marked and modified by the studio dust and detritus on the floor. When dry, the fabric was forcibly stripped from the painted surface. It naturally registered imperfections, scars and indentations, as well as the ordered parallels of the boards: every random line and accidental imperfection was caught in the textured paint. These painterly fragments were incorporated and stuck down in layers, sometimes in billows and folds, to create the large finished paintings, which were designed to hang loose against the wall rather than to be rigidly stretched. The sense of the paintings as objects rather than as pictures, or simple impressions of studio features, is intensified by the attachment of casts or direct prints of other objects, or even the objects themselves, as evocative physical embellishments.

It was not surprising, perhaps, that Moon should have seen in the studio itself a thematic focus for his investigation.

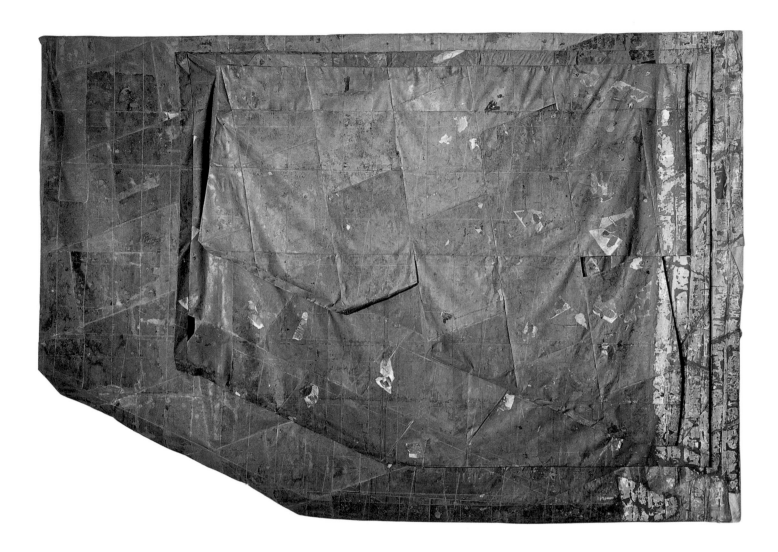

14 *North Light*, 1975
Acrylic on mixed materials, 246.4 × 355.6 cm
Courtesy Waddington Custot, London

His final written thesis at Chelsea had been on the subject of Georges Braque's late studio paintings, works which have never ceased to preoccupy his imagination, and whose philosophical potentialities are closely aligned with those that have animated his own painting to this day. Over time, and through many phases of work, Moon has progressively shifted his immediate creative gaze away from the rich confines of the artist's studio, into other rooms haunted by other voices than those of Braque and Klee, to landscapes and urban places, and finally to the mysterious marine vistas of his latest work. But his essential philosophical focus has been utterly consistent: how can painting be truthful to experience, and transform the subjective immediacy of the incomplete and transitory moment, the here and now of the primary world, into a revelatory object that somehow both encapsulates and escapes time?

North Light (1975; fig. 14) was the first successful work to emerge from the new approach. Nearly twelve feet by eight feet, it is a magnificent object that intends to memorialise the light that enters the studio window – the 'north light' of the title, the diffuse indirect sunlight favoured by artists – whose angle of fall might be suggested by the diagonal edge at lower left. Nothing could be further in presence or appearance from the immaculate formalities of the finely calibrated strip paintings. And yet a persistence of interest in the phenomenal world, its variegation and light, is indicated by the title. *Of course*: Moon had no intention of relinquishing his central artistic interest in the ineluctable actualities of seeing and being as the essential subject of his artistic transformations. The diagonal light through the enlarged studio window is the light of the world beyond.

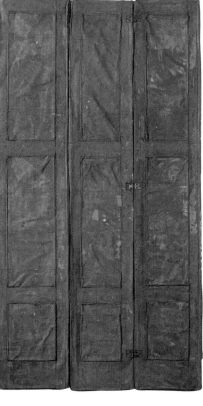

Left: **15** *Double Glaze*, 1996
Acrylic on canvas, 226 × 243.8 cm
Courtesy Waddington Custot, London

Below: **16** *Top Light*, 1976 (detail)
Acrylic on canvas with polythene, 139.7 × 127 cm
Courtesy Waddington Custot, London

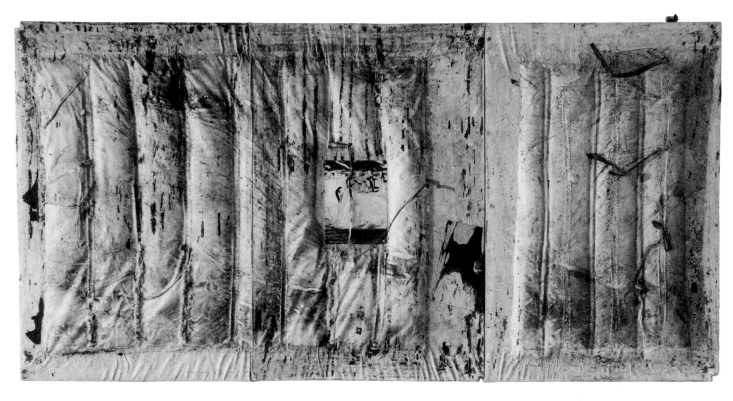

But where the 'strips' were purely and perfectly allusive and without circumstantial content (except in their industrial origin, whose virtue was their standardised perfection) the roughly imprinted, painted and stained coloured hangings maintained a direct contact with the given world; they registered (literally) its grit and abrasions, they had no abstract purity of form or finish. They were toughly actual, rebarbative even, being marked, scarred, creased, un-stretched, falling as the dynamics of the actual determined. They bore the very imprint of the floor the artist had stood on, the uneven imperfect surface of the horizontal world. Lifted into the vertical as hangings, they became intensely tactile painted *images*.

But they were not quite paintings in the usual sense: as objects they were in fact more like tapestries, or theatrical backdrops. In either case, invoking those precedents is *apropos*: the word 'tapestry' derives from the ancient Greek or from Old French for carpet, or any heavy fabric covering a floor or table top (beautiful carpets have always been used as table coverings or used as hangings); a painted backdrop is intended in the theatre to evoke a setting, to play the part, so to speak, of *place* in a fictional action, to put the spectator in mind of somewhere else than the stage itself, to enable the 'willing suspension of disbelief'. Tapestries played precisely such a role in the galleries and saloons of the rich, as backdrops that brought indoors the illusion of other, outdoor, places, other times, the secondary worlds of legendary or biblical landscapes, or the ideal country scenes of the rural residences of their wealthy owners.

Moon's 'paintings' in their tangible physicality now related directly to the phenomenological world: they were both of it, and in it. They were indisputably *facts*, presently at hand, in the here and now, as, of course, are any paintings, but they were different in these respects: paintings may seek to represent the world (imitate nature or symbolise its dynamics), whereas the hanging paintings of Moon *duplicate* it, carry its imprinted traces; they are subject to its circumstantial contingencies as part and parcel of their expression. Their *fictional* content (the 'somewhere else' that landscape paintings or interiors or still-lifes have in common with theatrical backdrops or tapestries) is the artist's studio in which they have their origination: its light, its floor, its walls and windows, etc. They intend to transport us there, to that other place, to the studio as both an actual and a symbolic surrogate for the world at large, the place of the artist's 'world creation' where (in Klee's terms) he acts in the knowledge that 'this world has looked different and in time to come it will look different again.'

Opposite, below: **17** *Insulation Jacket*, 1978
Acrylic on calico, 114.3 × 231.1 cm
Courtesy Waddington Custot, London

18 *Drawing*, 1976
Acrylic paint, wood veneer, graphite, ink, paper tape and metal,
127 × 170 × 8 cm
Tate

It did not take long for Moon to take in the implications of what he had done: he had quickly moved beyond the literal transcriptions of the objects he had made in the period of research following the cessation of the strip paintings, in which he had first presented simple facsimiles – windows, frames, folding chairs, drawing boards tables, stepladders – created by direct printing, then folded and fragmented, sometimes, even, placed in polythene bags to be hung or pinned on the wall like demonstration specimens (he called these works 'object paintings'). In her introduction to Moon's exhibition of the strip paintings and work in progress at the Tate Gallery in 1976, Judy Marle noted of the works of this transitional period that it was 'precisely because the "symbolic function" of the objects Moon selected was itself rooted in the business of making art that the visual, the physical, the formal and the metaphysical are fused together in each successfully completed work.' Works of this transitional period – *Double Glaze* (fig. 15), *Drawing* (fig. 18), *Insulation Jacket* (fig. 17; all 1976), interesting as they are, were essentially experiments. *North Light* and the similar *Loft* (1980; fig. 22) gave a clearer indication of his direction of travel, and they were followed by a series of works that established Moon as an artist of exceptional critical interest.

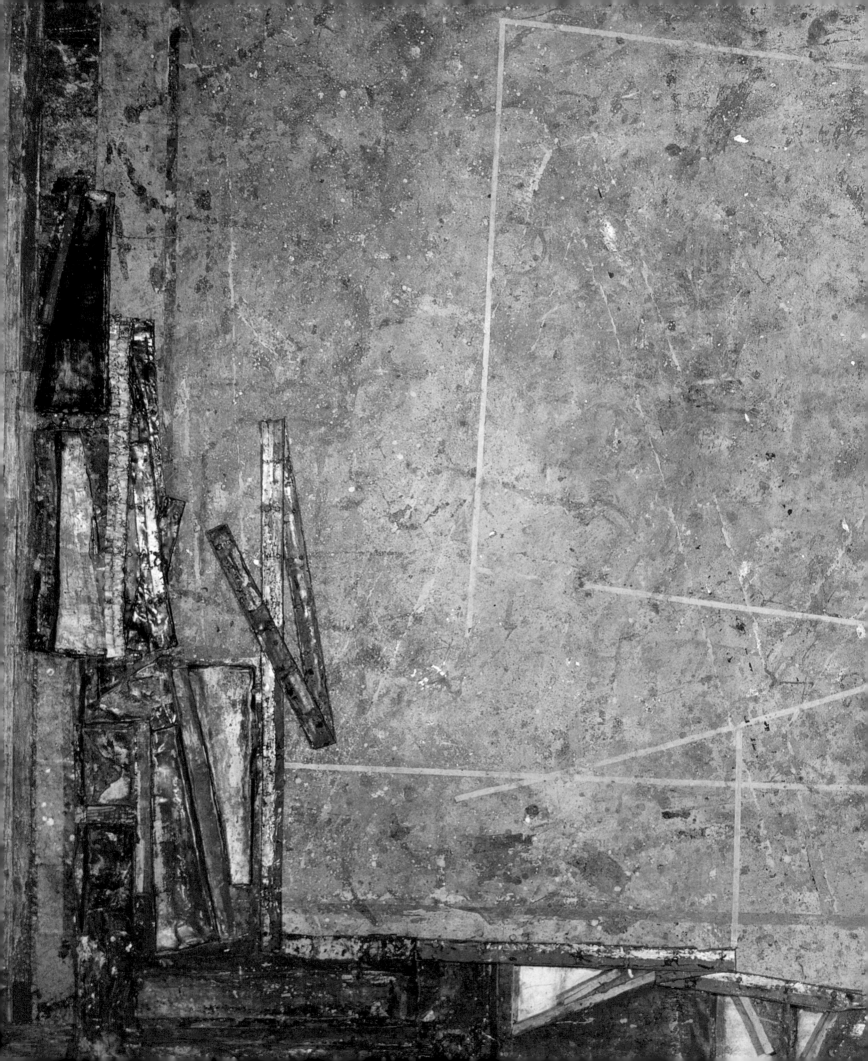

The Hanging Paintings

'Life then becomes a perpetual revelation.'

Georges Braque[1]

An exemplary table

There appears to have been no ordered progression in the making of the work in the transitional period between 1973 and 1978, when Moon finally settled on a mode of making that gave him the freedom to develop a coherent series of works original and recognisable in method and manner, rich in possibilities of reference and allusion, and powerful and extensive as paintings in the grand (abstract) manner. Characteristically, Moon tried one thing after another, sometimes doubling back between making the 'object paintings' (casts of studio objects folded and fragmented in polythene bags) and the more straightforward 'paintings', cast impressions folded and hung from the wall, recognisable as the objects from which they had been cast (windows, drawing boards, floorboards, table surfaces, padded insulation jackets).

Drawing (1976; fig. 18) consists of four panels, cast, two from each of two imperial-size drawing boards, the basic portable flat surface for life drawing or sketching. These impressions were made from wet-painted canvas wrapped around the prepared wet-painted boards and stuck down for many hours. Removed by force, the imprinted canvas was folded and glued so as to create an all-round cast of the board. The configuration of simple forms suggests a kind of demonstration of both method and result: a model of the procedure by means of which Moon worked on the more ambitious paintings. There is a deadpan banality about the work that draws attention to the surfaces as interesting in themselves – they were 'half-way to being paintings' Moon remarked; and in this they anticipate without irony in themselves the way in which the larger hanging paintings would incorporate evocative graphic markings and object imprints into painterly surfaces.

Table (1978; fig. 19), made using essentially the same direct-printing techniques as in *Drawing*, is an altogether more ambitious work, and is less ambiguous in its reference to the sources of its themes, its acknowledgement of specific art-historical precedence. It comprises four layered canvas casts of a studio worktable (two of these were taken from the underside, which adds its own twist to the basic device of tilting a horizontal surface into the vertical). As I have suggested, this has implications for the spectator aware of the procedure, who addresses the image with its 90-degree shift held in mind, an aspect of his psychological apprehension of it that demands a subtle mental poise, in which two points of view, so to speak, are held simultaneously.

'[It] is not the actual physical placement of the image that counts,' wrote Leo Steinberg in his seminal essay 'The Flatbed Picture Plane'.[2] 'There is no law against hanging a rug on a wall, or reproducing a narrative picture as a mosaic floor. What I have in mind is the psychic address of the image, its special mode of imaginative confrontation, and I tend to regard the tilt of the picture plane from vertical to horizontal as expressive of the most radical shift in the subject-matter of art, the shift from nature to culture.' 'The flatbed picture plane makes its symbolic allusion to hard surfaces such as table-tops, studio floors, charts, bulletin boards—any receptor surface on which objects are scattered, on which data is entered, on which information may be received, printed, impressed—whether coherently or in confusion.'

Such pictures, insists Steinberg, 'insist on a radically new orientation, in which the painted surface is no longer the

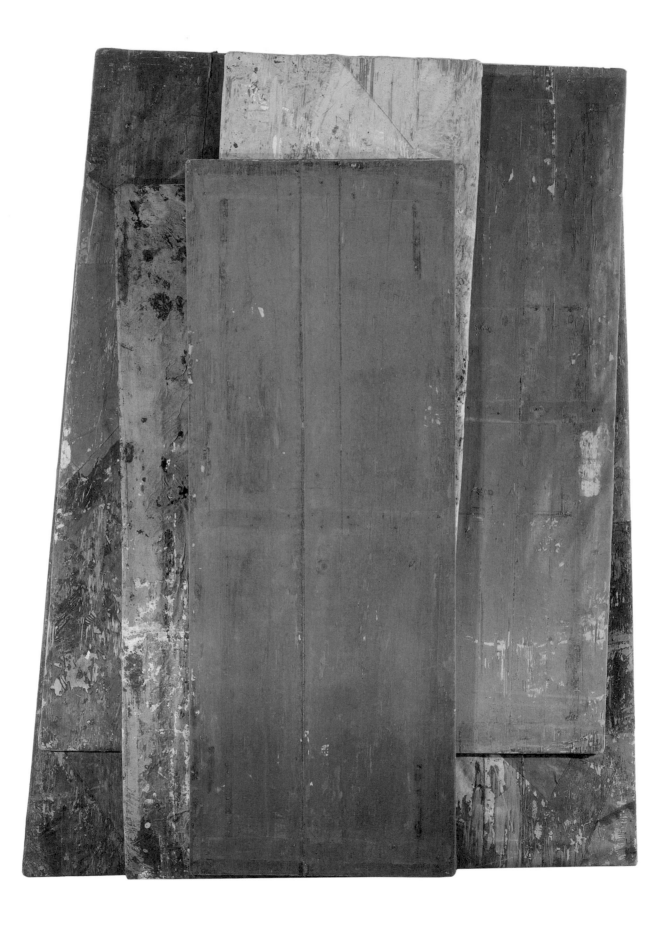

analogue of a visual experience of nature but of operational processes.' These processes might be standing, taking casts, handling objects, painting, looking at the world and all that that entails. Steinberg makes verbal play with the conceptual vertical/horizontal shift, but of course he knows well that Rauschenberg and Dubuffet – the two artists he cites as having effected the shift to the flatbed picture plane – hung their paintings, combines, constructions and collages vertically (mostly) on the wall (as does Moon). The term 'flatbed picture plane' is perfectly apposite to our case: it refers to the flat bed of the etching press, that is, to the technology of taking an impression from a necessarily horizontal surface as a means to create a reproductive image. (Steinberg quotes from Webster's Dictionary: 'a horizontal bed on which a horizontal printing surface rests'.)

This radical re-orientation, horizontal to vertical, has a modernist pre-history in representational and Cubist paintings, of which Moon was acutely aware, a history that is clearly referenced in *Table*, in its colours, forms and textures. It is first to be seen in the still-life table tops of Cézanne, lifted visually at an angle to the horizontal as if in a fruiterer's display, or more extremely as if the objects – apples, pears, jugs, etc, – were performers on a steeply tilted table-top stage. Picasso and Bonnard used it, respectively to visual analytic purposes and to dizzying optical effect. In the late Braque paintings featuring studio tables, palettes, billiard tables, works that were central to the development of Moon's visual thinking, the verticality of table tops is insistent: they are brought up directly parallel to the picture plane. (In one of the greatest of the late studio paintings, *Atelier VIII* of 1954-55, fig. 20, the back of a vertical standing canvas in the studio alludes wittily to this transposition, being itself aligned with the – pictorially vertical – table top and a horizontal canvas. The great white schematic bird that flies freely through this magical space reminds us that the reality of the painting is poetic.)

The ochre, orange, white, brown and green of the cast and layered panels in *Table* unambiguously recall both the characteristic palette and formal structures of Picasso and Braque's Cubism (both 'analytic' and 'synthetic'), and the cast of the virtually unblemished grain of the table underside at the forefront of the ensemble is a conscious reference, in its shape and placement, to Braque's own deeply witty use of decorator's wood-grain in the first Cubist *papiers collés*. (Moon's painting reminds us that wallpaper is prepared – pasted! – for hanging on just such a trestle work table as he has printed; as Braque, the son of a painter-decorator, would have known.) The incline of the right edge of the work is intended (we know from Moon

19 *Table*, 1978
Acrylic paint on canvas, 212.1 × 160 × 9.5 cm
Tate

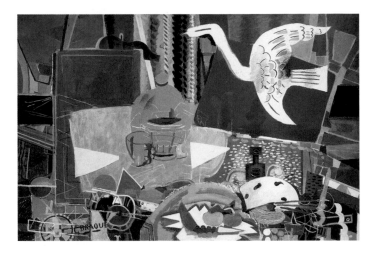

20 Georges Braque, *Atelier VIII*, 1952-55. Oil on canvas, 132.1 × 196.9 cm. Private collection

himself) to remind us of the use of the diagonal in pictorial perspective, the device by means of which recessive horizontal space is represented optically on a vertical surface: the very opposite, in fact, of the spatial devices of Cézanne and the classic Cubists.

Table is a painting rich in allusion, powerfully confrontational, and grandly beautiful. If *First Strip*, as I have suggested, was a demonstrative manifesto for the strip paintings, *Table* might equally be seen as a keynote work, a knowing anticipation of the series of paintings that was to follow, a richly suggestive clue as to the ways in which they might be read, and a droll indication of their historical antecedence. (Moon was well aware, of course, that *tableau* is French for picture or painting, or board; and that 'board' is another word for table, or for plank.) It is clear that whatever else is happening in Moon's art at this moment, the history of modern painting – and all that that might entail – is a living presence, a crucial and enthralling thematic subtext to his creative project. (It is also the case that 'the table' as an exemplary commonplace and banal object of contemplation, recurs constantly from Edmund Husserl onwards through phenomenological literature.)

Three other paintings from the same year, 1978, indicate that Moon, once embarked, was quickly and confidently getting under way. *Low Light* (fig. 134) is coolly explicit: there is no disguise in the blunt verticality of its image of parallel horizontal boards; and little embellishment, beyond the remnant of the casting calico, top left and left margin, of its origin, which suggests an elegant frame, or a conventional stretcher ('this *is* a painting', as Magritte, an artistic hero of Moon, might say); the passage of black may fancifully suggest (as does the title) the approach of night in the studio. In *Varengeville* (fig. 21) the

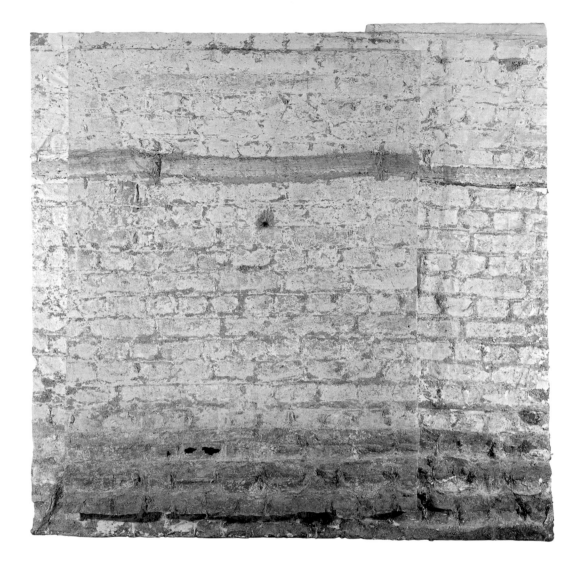

21 *Varengeville*, 1978
Acrylic and mixed media
on two canvases, 192 × 183 cm
Birmingham Museums Trust

Opposite: 22 *Loft*, 1980
Acrylic and media on canvas,
210 × 254 cm
Courtesy Waddington Custot,
London

bare brick wall of the studio is represented by layered calico casts, whose disposition paradoxically suggests sagging, but whose visual shimmer of tones and tinges, of grey-white, pink and green, create of the most banal subject a sensation of subtle beauty, as of light playing across the wall. In *Argenteuil* a portrait-format rectangle appears to lean against a brick wall at right, a section of floorboards on the right (a perceptual conundrum of cubist complexity). This 'painting within a painting' is a complicated, richly hued pattern of diagonals, created by colouring rectangles of the surface cast, and in certain areas reverse-casting to achieve a criss-cross effect. The lifting of the cast (Moon became adept at timing the drying to create surface variegations) has left the colour areas degraded like those of a long-faded and abraded painted surface: a melancholy sign of time.

Moon was closely familiar with John Richardson's classic text on Braque (in the Penguin *Modern Painters* series), where Braque, thinking of Cubism, is quoted as desiring to 'take full possession of things...' in order to get 'as close to objects as painting allowed... as near to the reality of things as possible.'[3] Nothing could more clearly describe the impulse behind the hanging paintings, in which Moon's 'casting' techniques imprint the very surface of the paintings with the 'reality' of their subject – the artist's studio and its components, the arena of artistic thought and action – and enter with the most powerful impact into the modernist (post-Cubist) historical practice and discourse of painting as a means to reflect on the real. (I recall a remark of the great printmaker Michael Rothenstein's on the excitement he felt at his discovery of direct printing: 'I felt as if I wanted to print the surface of the whole world.') The titles of

the two paintings were an unambiguous hint as to the artist with whose thought and practice Moon was most closely engaged: Argenteuil was Braque's birthplace; Varengeville in Normandy was the French master's favourite place of residence and work. Without question, from now and ever on, Braque was for Moon, as he was for a generation of French poets and painters, *le Patron*.

The poetics of painting
Braque's late statements on painting, amply quoted in Richardson's text, are uncannily in line with the language of transcendental (Husserlian) phenomenology, and Moon was certainly aware of a certain way of creative (or philosophical) thinking that emphasised the concentration of the mind upon objects of the given world as a means to discover the unexpected reality behind the banal presence of ordinary

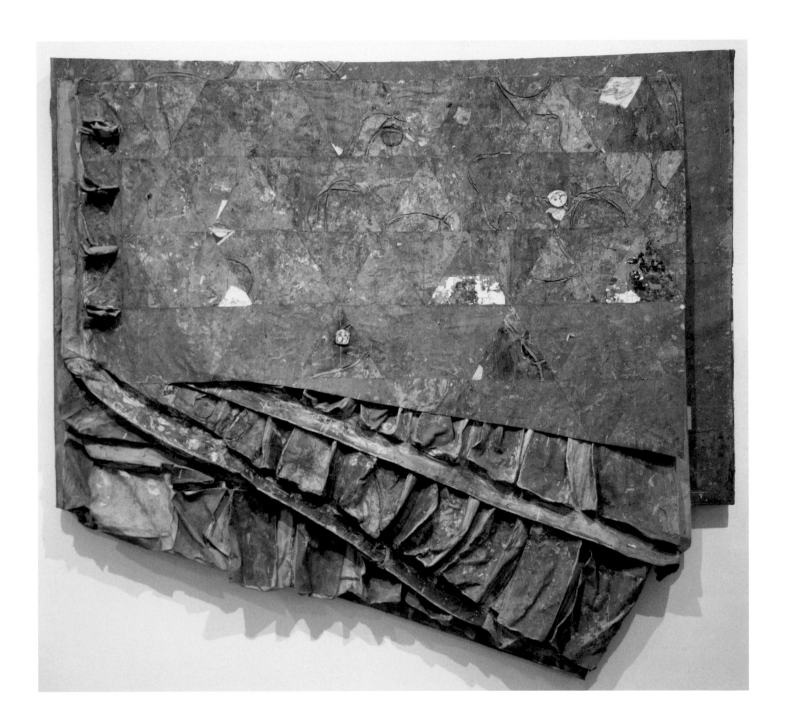

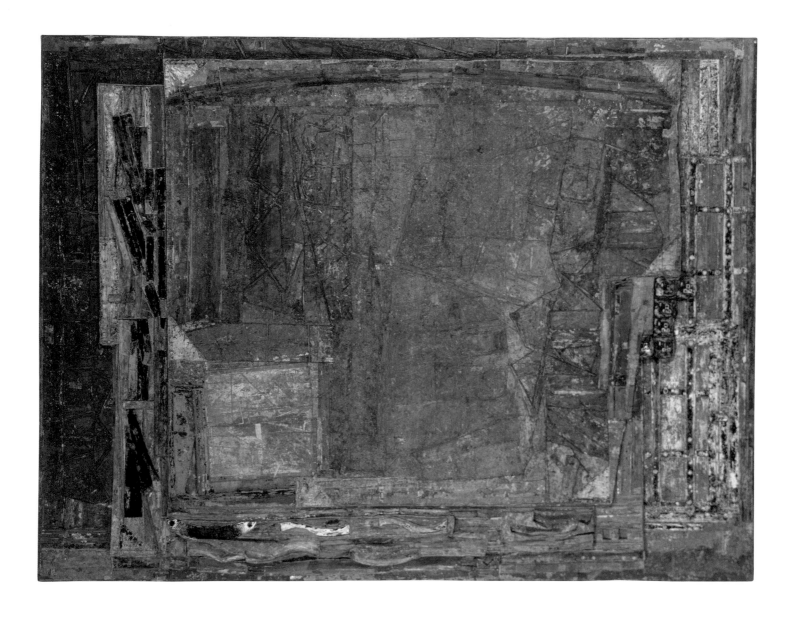

23 *Red Cellar*, 1983
Mixed media on canvas, 223.5 × 290.8 cm
Private collection

things. The task of such a concentrated engagement is, thus, to escape from what Husserl, whose writings Moon was sampling at this time, called 'the natural attitude', the complacent acceptance of everyday actuality as objectively real, a natural arrangement of things that exists 'out there', independent of the experiencing subject. It is 'natural' because it is 'normal'; the natural attitude is an expression of the normative behaviour that is challenged by the phenomenological approach.

The phenomenologist, having suspended his conventional and preconceived notions as to what objects in the world are, and how they 'normally' behave, literally re-conceives them according to his own experience, and inner experience, of them. They transcend their 'natural' meanings and reveal their true

reality. In Husserl's terms, we return, with 'intuition', to *the things themselves*, stripped of any normative overlay of thought and feeling, whether empirical, psychological or utilitarian. (I am reminded of Blake: 'If the doors of perception were cleansed every thing would appear to man as it is, Infinite.' And: 'As a man is, so he sees. [...] You certainly mistake, when you say that the visions of fancy are not to be found in this world. To me, this world is all one continued vision of fancy or imagination...')[4]

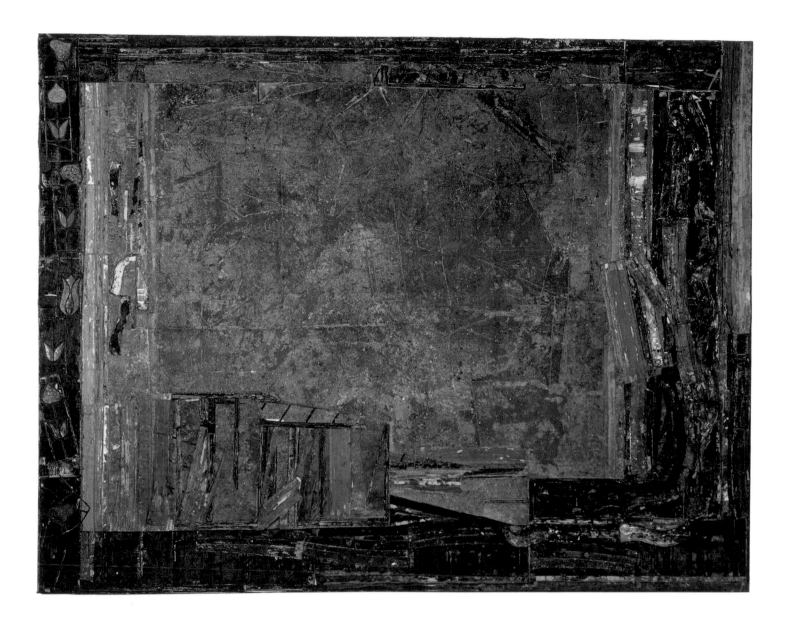

'No object can be tied down to any one sort of reality' wrote Braque; 'a stone may be part of a wall, a piece of sculpture, a lethal weapon, a pebble on the beach, or anything else you like, just as this file in my hand can be metamorphosed into a shoe-horn or a spoon, according to the way in which I use it. The first time this phenomenon struck me was in the trenches during the First World War when my batman turned a bucket into a brazier by poking a few holes in it with his bayonet and filling it with coke'.[5] Braque shows how 'the natural attitude' that addresses the everyday world as it appears, un-transfigured, is transformed into a realisation of deeper possibilities of meaning; commonsense assumptions are shed: 'For me this commonplace incident had a poetic significance: I began to see

24 *Port Grimaud*, 1983
Mixed media on canvas, 231 × 299 cm
Courtesy Waddington Custot, London

things in a different way. Everything, I realised, is subject to metamorphosis; everything changes according to circumstances.'

Moon's coloured casts of floorboards and other ordinary objects, chests of drawers, window frames, transform their 'commonplace' actuality into images of themselves. An image is not an object, it is a representation of the object; it invites interpretation, it proposes other meanings not present to 'the natural attitude'. (You cannot sit in Van Gogh's chair; or smoke his pipe: 'his pipe is not a pipe'.) Tilted into the vertical, those

studio aspects and objects are doubly transformed: they enter the world as aspects of a special class of objects: *paintings* and *pictures*. What is changed is 'the psychic address of the image, its special mode of imaginative confrontation'; and this shift in orientation, as Steinberg would have it, 'the tilt of the picture plane from vertical to horizontal [is] expressive of the most radical shift in the subject-matter of art, the shift from nature to culture.' It is not merely a change in the subject-matter, however; it is a change in definition, a shift that demands a suspension of 'natural' disbelief, and an active *imaginative*

engagement: 'what does this mean in my experience of it?'[6]

'You see,' Braque goes on, 'I have made a great discovery: I no longer believe in anything. Objects don't exist for me except in so far as a *rapport* between them or between myself and myself. When one attains this harmony, one reaches a sort of intellectual non-existence – what I can only call a state of

25 *For Timur*, 1982
Mixed media on canvas, 249 × 290 cm
Art Gallery of New South Wales. Mervyn Horton Bequest Fund 1984

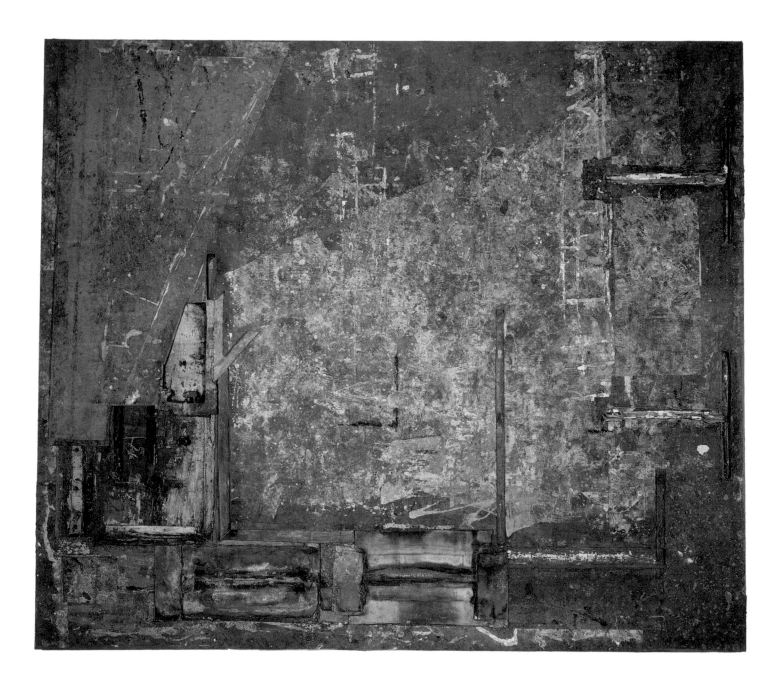

peace – which makes everything possible and right. Life then becomes a perpetual revelation. That is true poetry.'[7] Braque's late studio paintings were certainly greatly admired by that other great phenomenologist, Martin Heidegger, who was obsessed with the relation of painting to thought, of the visual to the ontological:

> In the painter's late work, the difference
> Of what enters the presence, and the presence itself
> Is joined in simplicity; it is 'realised' and
> At the same time handed over to itself
> Transformed into the identity of an enigma.
>
> Does a way open here, that would lead to a common
> presence between the poem and the thought?[8]

'There is certainly more thought', Heidegger remarked, 'in one Braque still-life than in five hundred pages of Sartre.'[9] This is a tart witticism, unfair to Sartre, who happened to think in another way to Heidegger. But the problem remains: what is the nature of the 'thought' to be found in a painting, and how is it possible to articulate it? It is certainly not possible to articulate any kind of 'translation', though it is certainly possible to suggest meanings, or point to allusions, references, resemblances, etc. and to reflect, in thought and words, on those aspects of the work. The discovery by way of 'intuition' of what Husserl called the 'essence' of things, is in the first place and pre-eminently subjective: this 'essence' is a function of inner experience.

With the hanging paintings, Moon discovered the true nature of his practice: that his work should engage the phenomenological concentration of mind in the spectator. Better, perhaps to say, that the spectator should seek that Braquian 'rapport': that he should enter into that 'common presence' of the work and the thought, a harmony, 'a sort of intellectual non-existence'. Adopting the 'phenomenological attitude', as Braque had in the prolonged engagement of his painting – as painting – with objects and their relations to each in space, the spectator might find things revealed in a perpetual new light, become aware of their 'true poetry'.

The painting is, before anything else, an object in the world, and 'no object can be tied down to any one sort of reality.' Moon's hanging paintings confront the spectator with many possibilities of experience, tactile as well as visual: as rough and ready stuff, daubed and coloured, marked and creased, encrusted and smooth, inexplicably inscribed with linear markings; as a kind of screen or curtain, concealing or revealing, as it might be, a wall or a section of floor, or allowing a glimpse of a cupboard door or a drawer in a cabinet; as a kind of picture of whatever has been cast and imprinted in the studio or on the stairs or in the attic or box room. It may

function as a souvenir of a place, appropriately and evocatively coloured and collaged: *Kautylya Marg* in New Delhi (orange-red and green), *Port Grimaud* (fig. 24) on the Côte d'Or (deep blues, floral reminders). It may be presented as a gift or a tribute from far away, *For Timur* (fig. 25), *For Adam* (fig. 31), both painted for his sons, in Australia in 1982. Each painting is an object provoking reverie, recalling the sharp but imprecise realities of a dream, capable of reminding the viewer, involuntarily, of so many things. These works exist to create the experience that gives them meaning.

In paintings such as *First Floor* (fig. 26), *Box Room* (fig. 27) and *Red Cellar* (fig. 23), Moon is still in the studio, or on his way up to it or down from it; we are in the house, from cellar to garret, that encloses what Auden called the 'cave of making'. These great paintings carry not only the cast impressions of floor, wall, stacked canvases and stretcher frames, but also splintered fragments of the boards themselves, unpredictably lifted with the stuck-down canvas of the cast. To these aspects of literal actuality are aggregated colour passages, arbitrary or evocative, and (as in many of the paintings of this period, such as *Port Grimaud*) what might be called fictional elements, or perhaps merely decorations, cast from the stained-glass windows of the artist's house. Moon's 'casting' technique had proved to be at 0once capaciously referential and liberatingly indeterminate. Like Rauschenberg's flatbed picture plane it was a powerful means to contain on one surface, as on a floor or a table top, any number of objects, ordinary and extraordinary things, from different sorts of reality. And to scatter its formal components in any configuration, as they arrived in the unpredictable circumstances given by the immediate environment and the moment.

Although they may carry on their surfaces the actual trace and impression of whatever existed on the floor or wall or turn of the stairs or the box room where they have their physical origin, although they may bear the imprint of objects in a room, these paintings are not exactly pictorial: to be that, so to speak, is not what they are for. They are not transcriptions of the artist's perceptual experience, he has long gone from that particular place, and what he saw or felt about what he saw is irrelevant to the critical or imaginative response of the viewer. Gaston Bachelard quotes the great critic Sainte-Beuve, who after describing to a friend a place he has known and loves, writes: 'It is not so much for you, my friend, who never saw this place, and had you visited it, could not now feel the impressions and colours I feel, that I have gone over it in such detail, for which I must excuse myself. Nor should you try to see it as a result of what I have said; let the image float inside you; pass lightly; the slightest idea of it will suffice for you.'[10] The studio is an archetypal image, as Moon first learned from Braque: an artist's imagination makes of it his own. It is this magically transformed space of the painting that becomes the prompt to an evocation of the imaginary, the world it signifies.

26 *First Floor*, 1980
Acrylic and mixed media on canvas, 223 × 365 cm
Arts Council Collection, Southbank Centre, London

27 *Box Room*, 1980
Mixed media on canvas
Walker Art Gallery, Liverpool

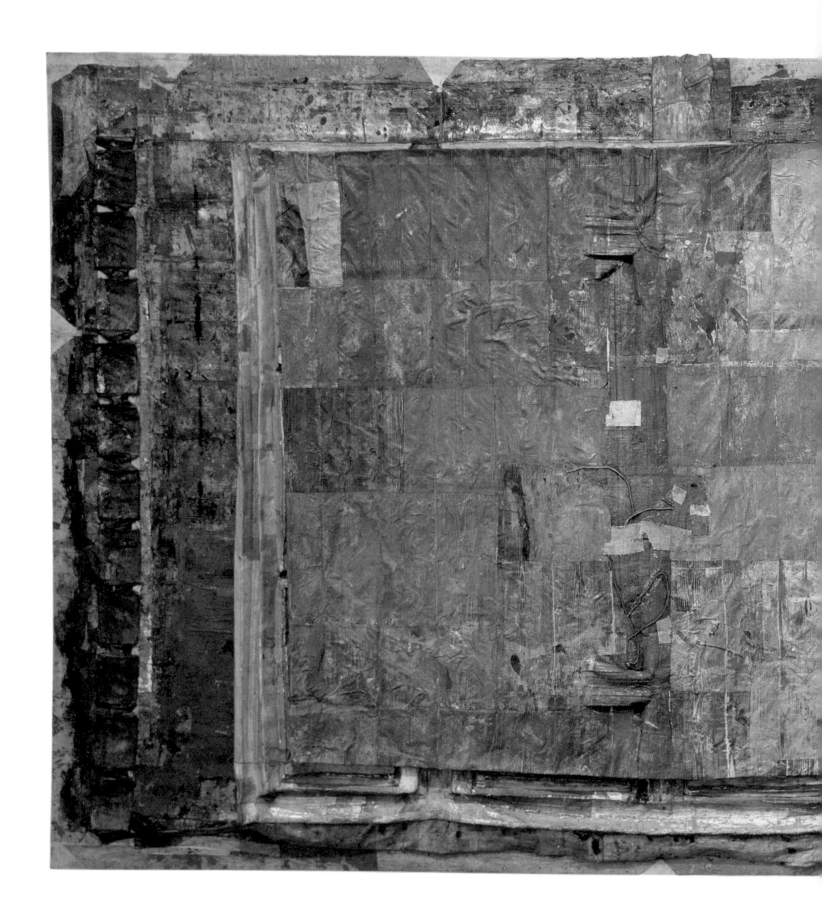

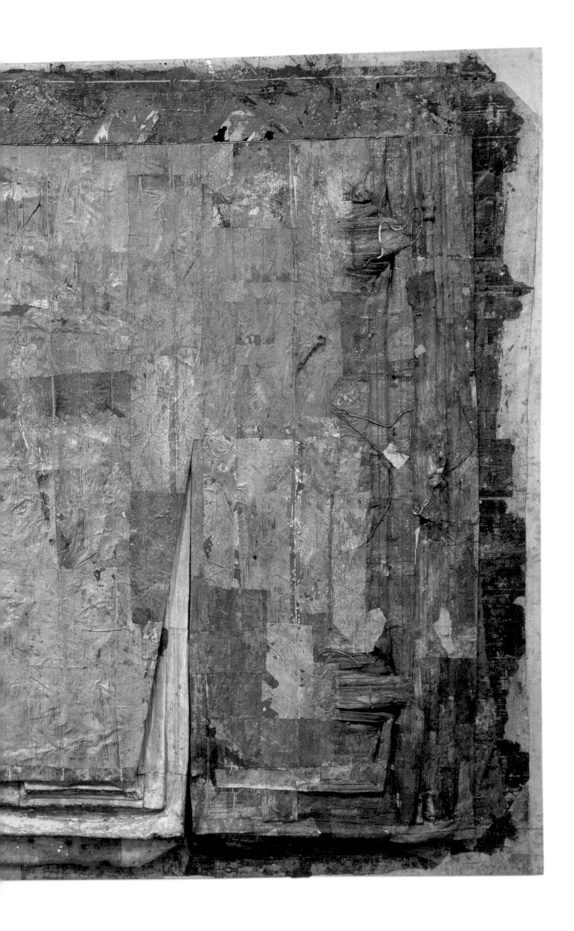

28 *East Light*, 1980
Acrylic and mixed media on canvas,
203.2 × 295.9 cm
Courtesy Waddington Custot, London

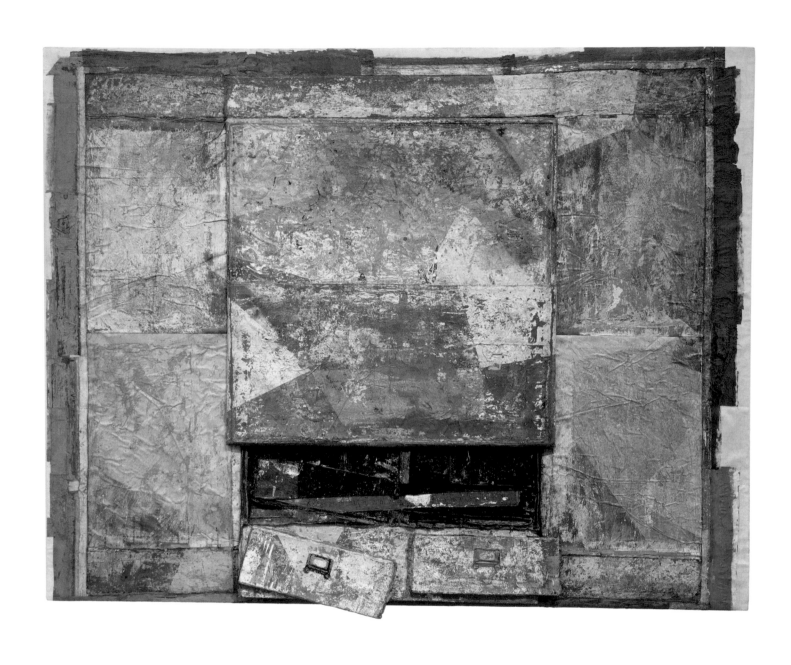

29 *Omega*, 1980
Acrylic and PVA on unbleached calico, 167 × 213 × 14 cm
J W Power collection, The University of Sydney,
managed by Museum of Contemporary Art.
Purchased with funds from the J W Power Bequest 1980

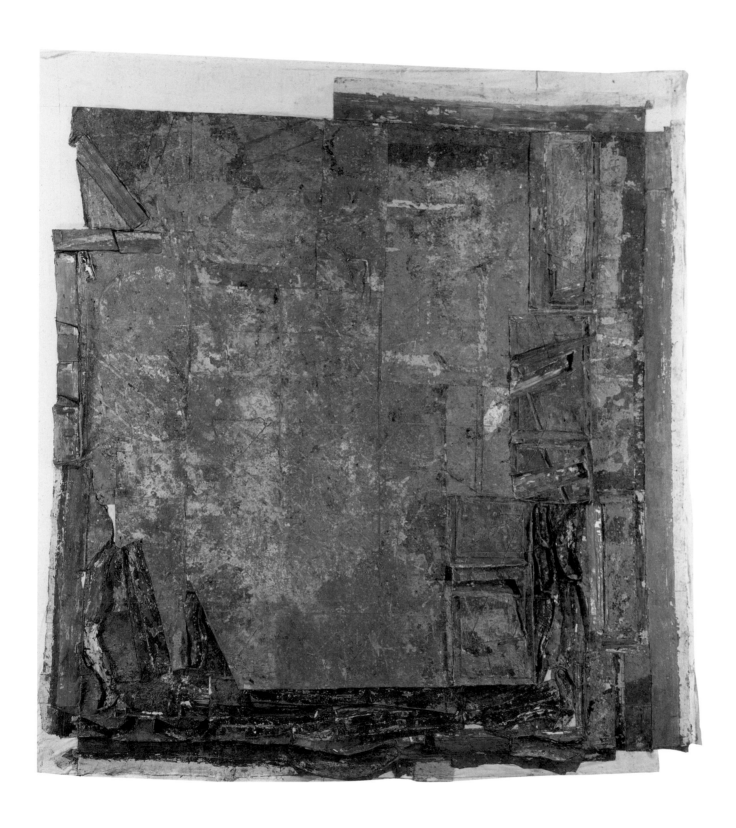

30 *Untitled*, 1981
Mixed media on canvas, 210.8 × 207 cm
Western Australian Museum Collection, Perth

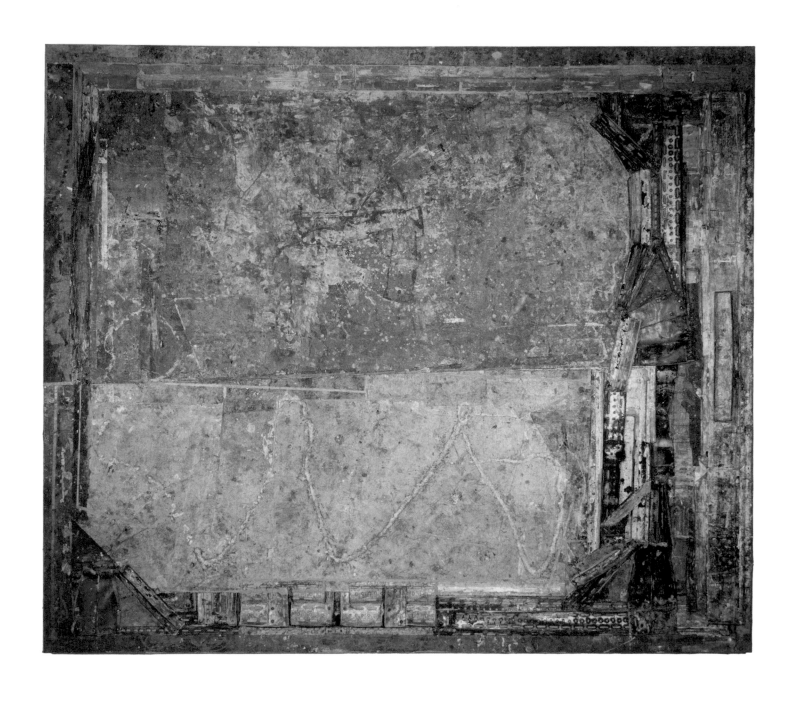

31 *For Adam*, 1982
Acrylic and mixed media on canvas, 246 × 290 cm
Courtesy Waddington Custot, London

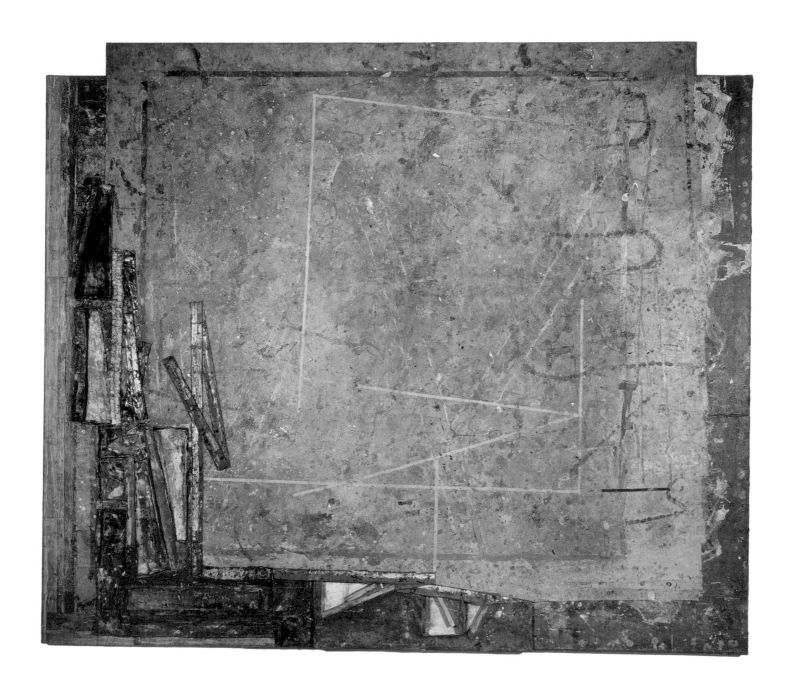

32 *Prahran Square*, 1982
Mixed media on canvas, 252 × 295 cm
Courtesy Waddington Custot, London

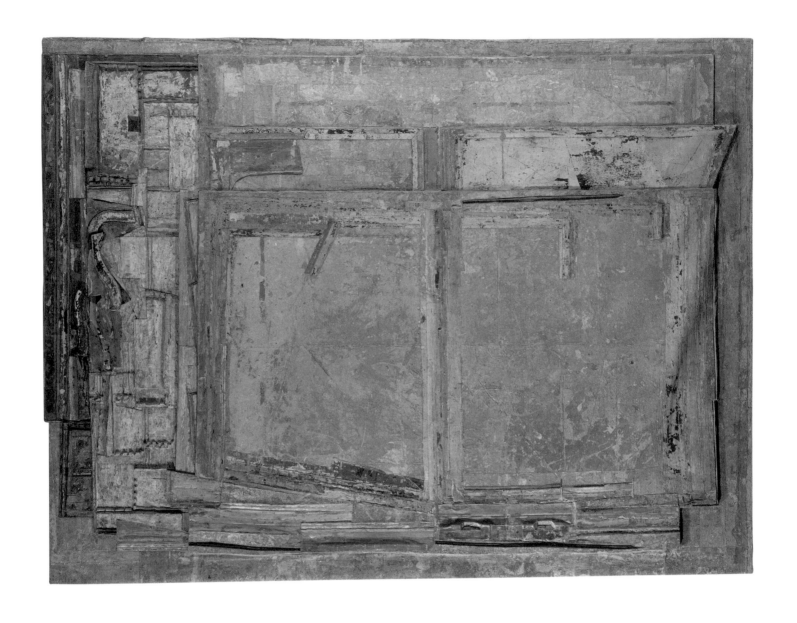

33 *South*, 1983
Mixed media on canvas, 215.9 × 279.4 cm
Courtesy Waddington Custot, London

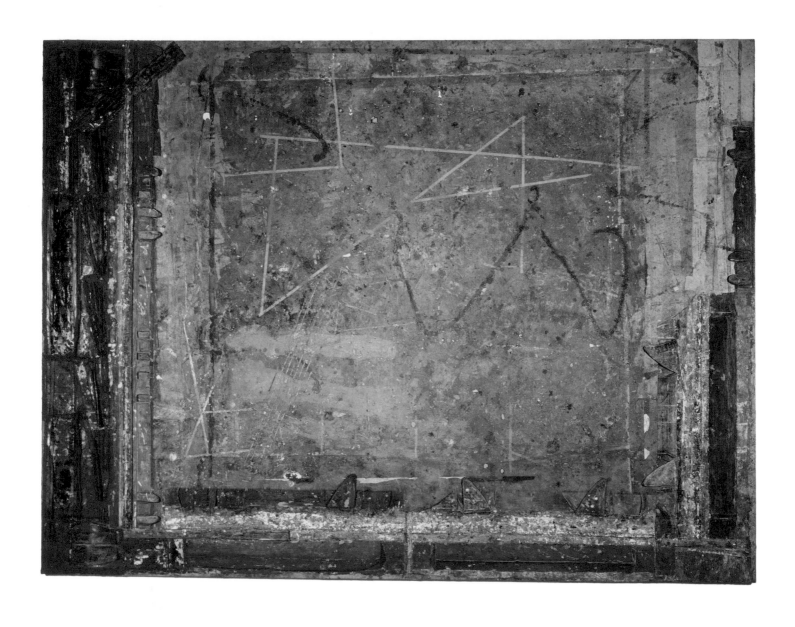

34 *Song*, 1982
Acrylic and mixed media on canvas, 249 × 330 cm
Private collection

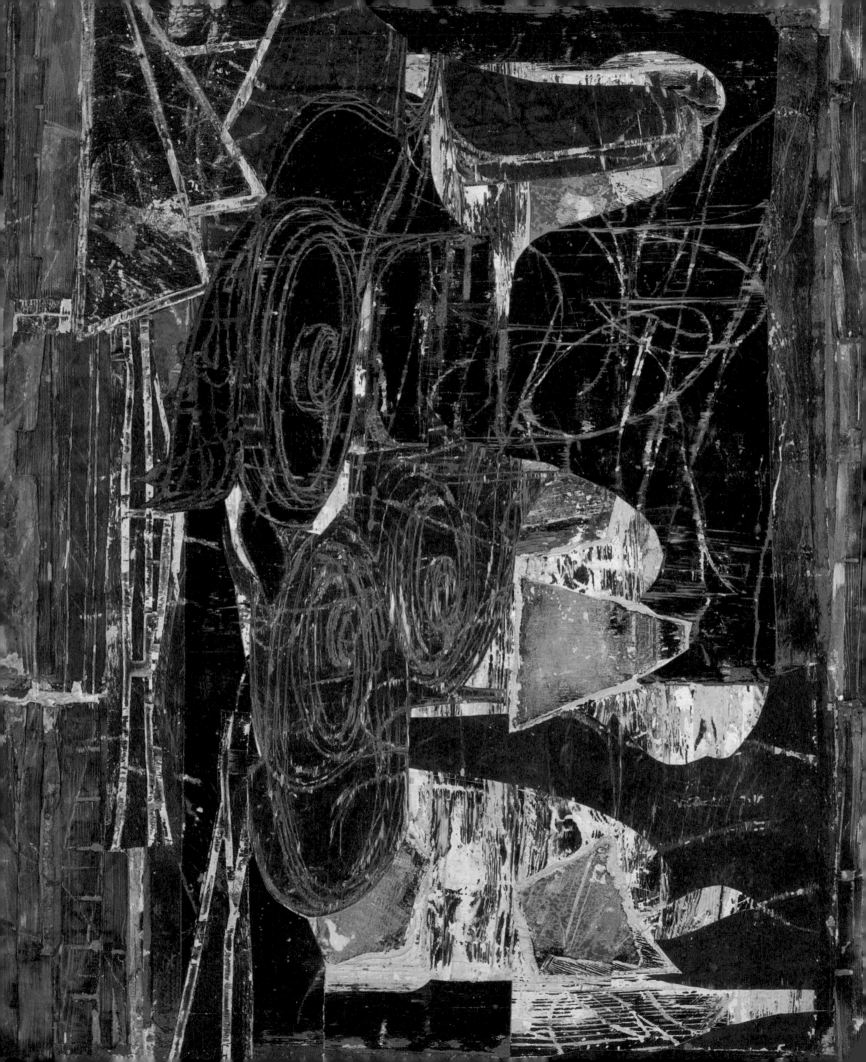

Abstractions, Things, Evocations

'So painting does not imitate the world but is a world of its own.'

Maurice Merleau-Ponty[1]

Rooms for the eye and mind: monoprints with collage
'In our encounter with a painting', Maurice Merleau-Ponty writes, 'at no stage are we sent back to the natural object.' Aesthetically speaking, precision of 'resemblance' to the object portrayed (a table, a pipe, a bunch of grapes, a window frame) is not important, unless it is created – as in *tromp l'oeil* – for ironic or reflexive purposes, rather than, say, for the achievement of the effects of 'naturalism' (itself, paradoxically, an impossible category, and one that has never interested Moon). 'Suffice it is to say', he continues, 'that even when painters are working with real objects, their aim is never to evoke the object itself, but to create on the canvas a spectacle which is sufficient unto itself.'[2] ('Exactitude is not truth' declared Matisse, who certainly believed in the truth of painting to life.) Merleau-Ponty knew well that an apple or a pipe painted by Cézanne will, as we might say, *by definition*, look very different from one painted by Braque, or Picasso, Matisse or any other painter: 'the subject consists entirely in the manner in which [it] is constituted by the painter on the canvas.'[3] Such acts of creative constitution are unique to the agent-artist in question.

In the case of the 'hanging paintings', even as Moon resorted to the process of relief casting – or direct printing – from the objects, he was well aware, as are we, when we look at them, that the imprinted canvas, bearing the *traces* of the 'reality' of those very objects ('*les choses mêmes*') was the (unorthodox) support for 'a spectacle sufficient to itself'.

'And what a spectacle!' we might think, immersed in the joyous excess of the scale, the colour, the sensation of the art-object itself, here present, intractably sensational and objective, in our world. We are present at a transformation, at which we recognise the studio as precisely the arena of dramatic transitions – concrete to abstract, horizontal to vertical, hard to soft, actual to fictional; from a time-bound there-and-then, with its irrecoverable light, to a timeless here-and-now, in the once-in a-lifetime light in which we stand. We know too that we are not looking at a 'picture' (whatever the veridical 'exactitude' of the impressions made in the casting process), and that the arbitrary detail and the incidental/accidental markings and details 'mean' nothing. Nothing, that is, but what we make of them.

Set firmly within the discourses of twentieth-century art, art history and philosophy, those works Moon made between 1973 and 1985 continue to be *sui generis*, and among the most powerful and original pieces of their time. Nevertheless, sometime in the early to mid-80s Moon felt the need to move on. His solution to the problem 'what next?' was, as always, surprising and unpredictable. He had felt, at times, uneasy at the structural looseness that was intrinsic to the format of the hanging works: the intentionality of the work, its predisposition to possible meanings, seemed perhaps too self-directed; gravity is its own law, a hanging fabric may fall as it pleases. We are taken up, enveloped by scale, distracted by the incidental,

the recognisable detail, the chance and deliberate markings, the grand generalising fold and fall of the drapery.

In the early 1980s Moon decided that he would make pictures on a smaller, more domestic scale, in which he could more closely determine the structural constraints, even if his own intentions were to do no more than to let things happen within them. Moon works always with the knowledge that what emerges from the practical processes he uses will inevitably be unpredictable. In this series of works, even as he made the initial cast of the primary surface – a rectangular board, often painted black, into which he had inscribed linear motifs or patterns – he was aware of the fact (and welcomed it) that the stripping away of the canvas or calico from the board would leave the surface of that support pitted, marked and defaced, 'interesting' in its own right, but in itself nothing more than the *tabula* upon which could be superimposed whatever *directed* marks and superimpositions – collage elements, wood block prints, cut-out shapes – he might come up with.

The chosen space of this operation of aggregation and superimposition was the rectangle of conventional painting (almost invariably in vertical, 'portrait' format), and Moon's adopted procedures were such as to lead to an extreme visual complication of the picture surface. What were gone were the direct references to the studio workspace that were intrinsic to the method of direct printing employed in the hanging paintings – floorboards, window frames, work tables, cupboards, etc. The collage-monotypes (as Moon designated this body of work) are unique works that have the richness of facture and the complexity of surface that we associate with oil painting, and their imagery is utterly abstract.

Seeking a complete autonomy of image, Moon had taken a decisive step away from the literal re-presentation, in direct-printed form, of aspects of the 'artist's world', its surfaces and paraphernalia; he had eliminated the poetic quotation of the familiar motifs of the 'cave of making' with all its associations and its metonymic connotations. The intention of these new works was, rather, to free the mind from any consideration of the creatively unproductive and mundane 'facts' of normative actuality: they intended, rather, to present a space – a room, perhaps – within which the mind could freely play, and unidentifiable objects with which it could inventively and 'intuitively' engage. The mind could leave behind the 'natural attitude' and avoid any contact whatsoever with the banality of everyday things. It could encounter mystery.

Marcel Proust has been called the 'phenomenologist of experience itself': his exhaustive (and sometimes exhausting) observations of phenomena do not merely reflect on things themselves but reflect on the reflections themselves. There is a passage in *In the Shadow of Young Girls in Flower* (the second volume of his great novel) in which the young protagonist enters the studio of Elstir, the painter; it is the nearest thing I

can think of that catches, uncannily, at the way in which these monoprint-paintings of Moon's work:

'...once in the studio itself, I paid no attention to the chocolate coloured mouldings on its skirting boards:

I was perfectly happy among all the studies ranged about, for I glimpsed in them the possibility that I might rise to a poetic awareness, rich in fulfilling insights for me, of many forms which I had hitherto never distinguished in reality's composite spectacle. Elstir's studio seemed like a laboratory out of which would come a new creation of the world: from the chaos made of all the things we see, he had abstracted, by painting them on various rectangles of canvas now standing about on all sides, glimpses of things.... The blinds being down on most sides, the studio was rather cool, and, except where daylight's fleeting decoration dazzled the wall, it was dim; the only window open was a small rectangle... so most of the studio was in half-darkness, transparent and compact in its mass, but moist and glistening at the angles where the light edges it, like a block of rock crystal with one of its sides already cut and polished in patches, so that it shines like a mirror and gives off an iridescent glow...'[4]

At work, the artist himself assumes the true phenomenological attitude: 'The effort made by Elstir, when seeing reality, to rid himself of all the mind contains, to make himself ignorant so as to paint, to forget everything for the sake of his own integrity (since the things one knows are not one's own), was especially admirable in a man whose own mind was exceptionally cultivated.'[5]

The complicated, quasi-automatic technical procedures that Moon employed in the making of these (and all his later) works precisely served the purpose of suspending intentional operations of the mind, allowing him to set aside 'all the mind contains... the things one knows [that] are not one's own'. Significantly, in writing of them for a catalogue in 1986 it was these technical matters on which he concentrated, without the slightest hint as to 'subject' or thematic concerns:

'The materials for these works are provided essentially by two methods of printing, the first being that of conventional monoprinting in the workshop. In this case, any smooth-surfaced plate, which can be either cut into or will take a sharp line or mark, can

Opposite: **35** *Broken Green*, 1986
Monotype with paper and calico collage elements printed in acrylic and cellulose filler from wood blocks, 156.5 × 137.7 cm
Private collection

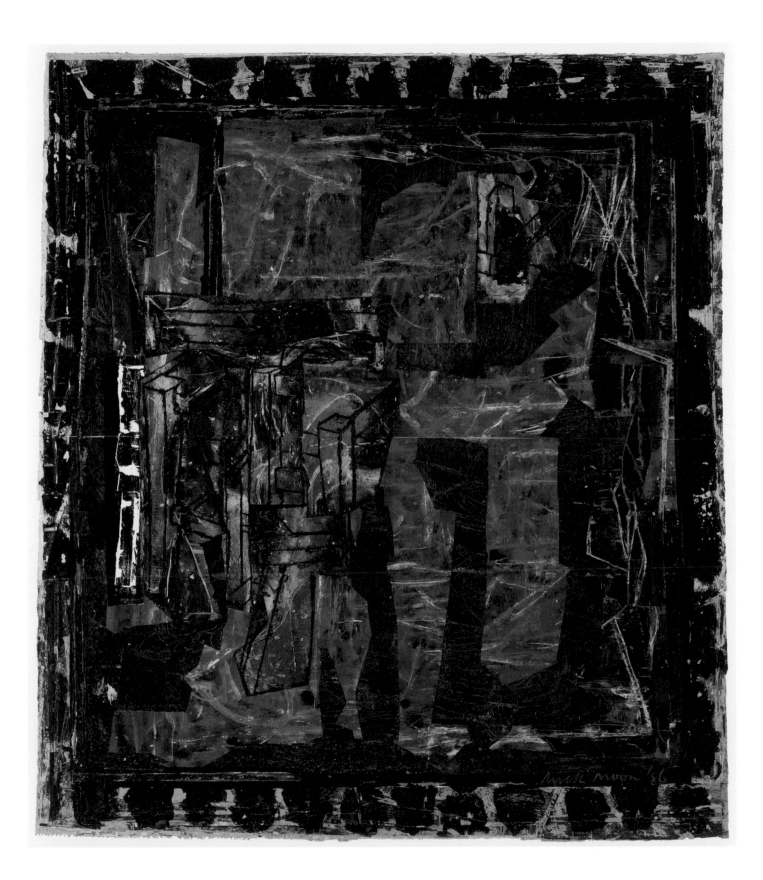

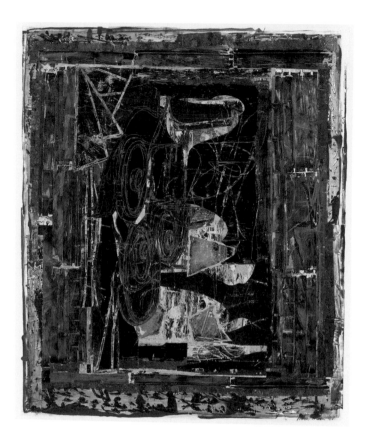

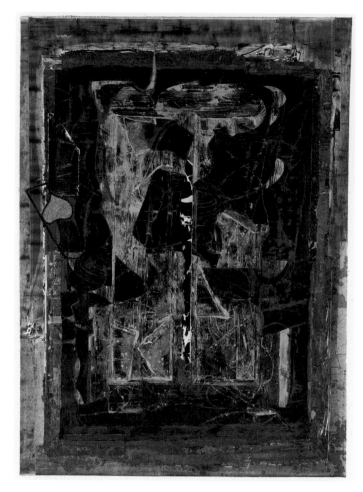

be used. Suitable plates are usually Formica, lino or thin plywood which will pass through the press, the image to be printed into paper in lithographic ink. The second method I use is less conventional but still remains within the definitions of printing; i.e. the laying down of material onto a surface and lifting off to produce an image. In this case, the printing takes place in my studio where woodblocks substitute the lighter weight plates used above, an acrylic/filler takes the place of lithographic ink, and calico is used instead of paper. Here the woodblock is coated with acrylic paint which has been mixed with cellulose filler or Polyfilla, and covered with painted calico. The calico is then peeled off the woodblock, but only when completely dry.... Modifications in the colour of the acrylic mixture can be achieved by the paint covering the calico. For example, a layer of blue paint on the woodblock will finally appear tinged with green when the calico has been coated with yellow paint....'[6]

Left: **36** *Night Sounds*, 1985
Mixed media and collage on monotype base, 137.8 × 116.2 cm
Private collection

Right: **37** *Testing*, 1986
Monotype with paper and calico collage element printed in acrylic and cellulose filler from wood blocks, 146.8 × 105.8 cm
Private collection

There are three hundred and fifty more words of this deadpan, feinting exactitude. Only at the end of the passage does Moon suggest, in a strangely impenetrable formulation, that the images he creates might have any sort of 'content'. In any case, it seems then to be seen as a purely formal matter: 'I'm never quite certain with any one piece whether the image in my mind will promote the sort of material I print, or the other way round. The process is so closely intertwined that this question might be considered *part* of their content.'

The titles of these complex works are of little help in establishing any kind of field of reference, abstract or

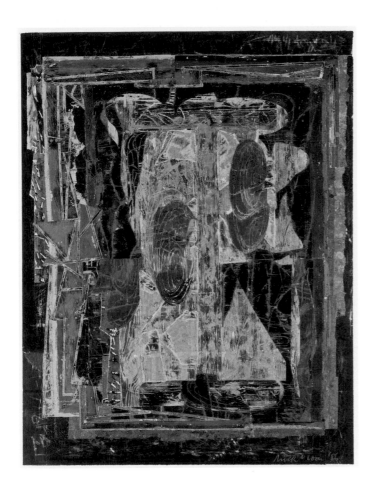

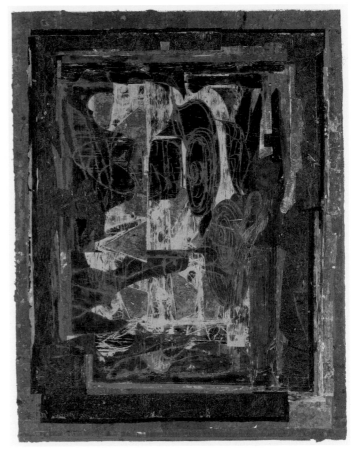

circumstantial. All seem more or less random or arbitrary, although some are clearly suggested by some formal rhythmic or structural aspect of the image: *Dance, Broken Green, Insert*; some by a dominant colour or atmospheric suggestion: *Furnished Orange, Red Sound, Night Sounds, Night Light*; some by an accidental resemblance of some element within the image to something else: *Tepee, Arranging the Furniture*; some are merely verbal abstractions or common phrases: *Testing, Between Times, Shifting*. And so it goes on: no title of any of these works will be anything more than a label, a late-thought identification; perhaps, if you wish, an invitation to play games with the words in their irrational and arbitrary relation to the works, the object-images they designate.

Each collage-monotype is a picture of itself and nothing else, with only the most fortuitous (and irrelevant) connections with anything beyond its own strictly defined borders. Each is a work of abstract art referring only to the inner nature of art, one that it is at once 'empty' and 'full'. Each is therefore an object of phenomenological contemplation rather than for interpretation.

Left: 38 *Lighting*, 1986
Monotype with paper and calico collage elements printed in acrylic and cellulose filler from wood blocks, 146.4 × 112.9 cm
Private collection

Right: 39 *Soundings*, 1986
Monotype with paper and calico collage elements printed in acrylic and cellulose filler from wood blocks, 151.9 × 117.1 cm
Private collection

These are works that defy hermeneutics. All this is indicated – unambiguously for this viewer – by the persistent pictorial device of framing. The object as a whole presents itself as an exemplary work of art, a 'picture' for the wall. Within the frame of its rectangular edge it presents the simulation of another frame; within this inner frame no picture, but a complicated overlay of abstract motifs without the definitions of descriptive shape, or of pure or descriptive colour. None of these 'frames' are 'windows' opening on to a fictional world; they serve, rather, as enclosures of the interior spaces – imaginary rooms?

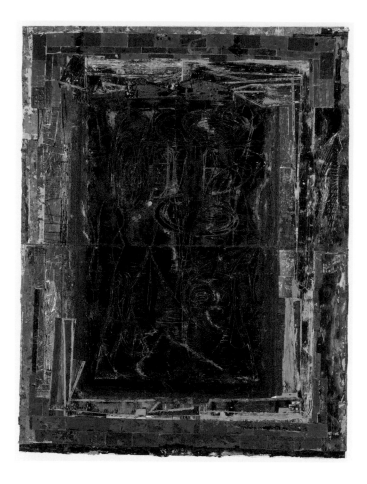

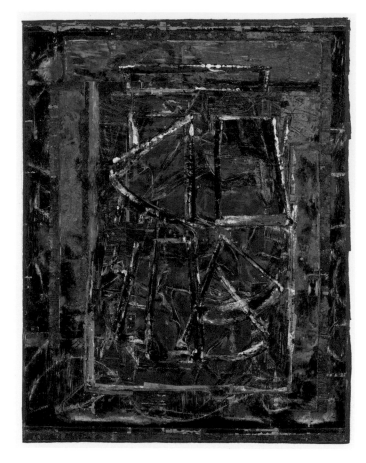

– where the mind may play as it pleases. No other act of the mind is required than description without words.

These works are among the most radical abstractions in post-war late-twentieth-century British art. They present so much material (Moon's own term) for the eye, with so little that might distract the mind by reminders of other things, associations, allusions, likenesses, and resemblances between things (this last, as Wallace Stevens would have it, 'one of the significant components of the structure of reality',[7] by which he means the way we habitually, 'naturally' see the world). In them, the artist's handiwork is materially present, spectacular; the artist himself is absent. This feat of what Husserl called *epoché* or 'phenomenological reduction' – the setting aside of everyday actuality – has generally been achieved, or attempted, by mid-twentieth-century abstract artists by means of elimination and emptiness.

We may think of Ad Reinhardt: 'Art is art-as-art and everything else is everything else';[8] of Patrick Heron: 'I hate all symbols, I love all images'; and above all, perhaps, of Agnes Martin, who wrote: 'My interest is in experience that is

Left: **40** *Red Sound*, 1985
Mixed media and collage on monotype base, 172.7 × 133.4 cm
Private collection

Right: **41** *Tepee*, 1985
Mixed media and collage on monotype base, 133.6 × 103.5 cm
Private collection

Opposite: **42** *Furnished Orange*, 1986
Monotype with paper/calico collage element printed in acrylic and cellulose filler from wood blocks, 167.6 × 151.2 cm
Private collection

wordless and silent, and in the fact that this experience can be expressed for me in art work which is also wordless and silent.'[9] Unconstrained by theoretical or spiritual desiderata, or by any species of philosophical idealism, it is extraordinary that in the collage-monotypes of the mid-70s, Moon should have made artworks so seemingly full and busy, and yet so devoid of any signifying intent that as we contemplate them they become still, wordless and silent, grand emblems of nothing in particular.

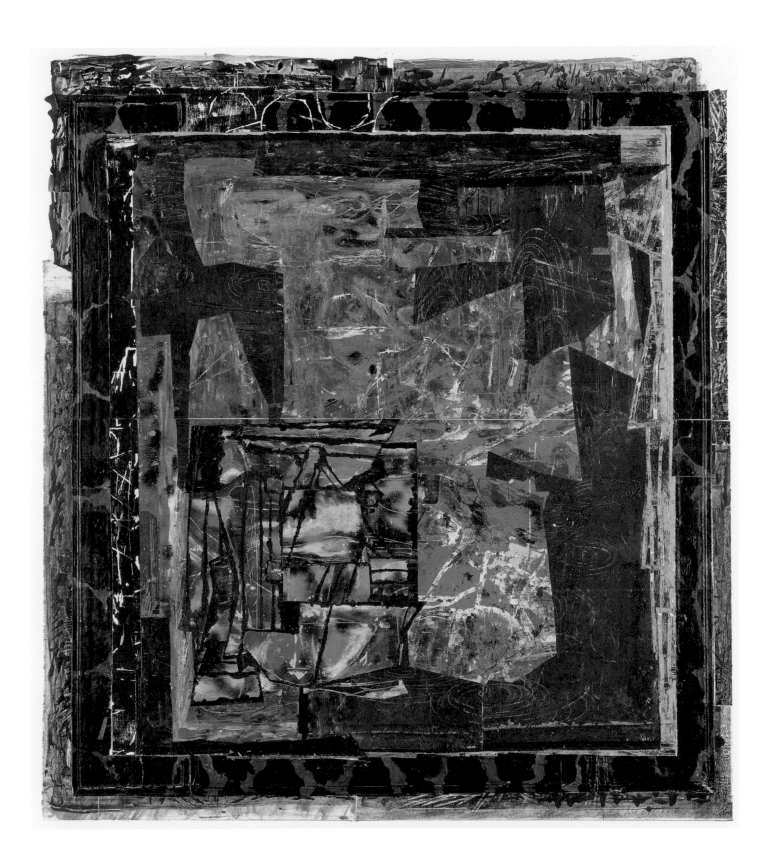

Apparitions: the return of the object

After the early strip paintings, which certainly achieved a spectacular emptiness by means of a systematic constraint and a purely formal – and minimal – support device, Moon has never conformed to any *a priori* idea of abstraction, that is to say, to any particular determinations of shape or colour, symmetry or asymmetry, geometries or architectonics, equilibriums or coherences. He has sought no formal essence, shown no interest in versions of 'significant form'. He has sought, rather, to create objects that have the feel of the actual about them, things that *belong* in the world, however strange and disconcerting they may be, things that take their place beside all the other things in the world. They are, of course, things of a very particular kind: 'One thing to say about art is that it is one thing,' wrote Ad Reinhardt. 'Art as art is nothing but art. Art is not what is not art.'[10]

This freedom from preconception or given stylistic tendency, and from any rigid attachment to limiting rule or reductive principle, gives Moon's work as a whole a marvellous non-generic quiddity. A painting by Moon always has a present and unmistakeable actuality: each work has the distinctive feel of a thing in itself. In ordinary talk about art (and in a great deal of occasional reviewing) it is common to remark the likeness of one artist to another, or one kind of painting to another. We see, immediately, that a given painting 'resembles' a Mondrian, for example, or a Picasso, or that a particular motif is like, say, a Braque bird, or a Matisse fig leaf. It is not often that we feel that about any image of Moon's work (except when he deliberately exploits quotation, as in the 1994 paintings on the theme of Miró's 1937 *Still-life*). To the accustomed eye, it may be that a work by Moon is instantly recognisable since we cannot imagine whom else it might be by.

The critical relation of Moon's work to that of other artists is always complex and in some way disguised. His own practical disavowal of any signature style, indeed of 'style' as such; his idiosyncratic use, and misuse, of conventional technical (printmaking) devices, mostly those of direct printing in which the impression is unpredictable; his resolute non-alignment with any recognisable tendency in art (abstract or representational); his periodic, extreme shifts of manner and technique: these are the manifestations of a singular creative temperament, an intensity of concentration on the job in hand, a job that is essentially philosophical. But the paradoxical outcome of this concentrated attention is, as in Zen meditation, the achievement of a state of mind like that of the Zen swordsman or archer, or the ecstatic Sufi dancer (or, we might add, Proust's painter, Elstir): the condition of *no-mind* (or *mushin*). As an artist, he is uninterested (except tangentially) in the discursive or the overtly thematic; the philosophical aspect of painting is, for Moon, by definition non-discursive. More than that, it is an attempt to bring into the experience of the viewer that which is beyond words, beyond 'ideas'.

Reinhardt comes again to mind: 'Only a bad artist thinks he has a good idea. A good artist does not need anything.'[11] By 'anything' Reinhardt means that what is 'art-as-art' is without preconceptions, without any clutter of ordinary thought to impede its realisation as an object that will bring some kind of transcendent thought and feeling into the heart and mind of the spectator: Proust's 'poetic awareness, rich in fulfilling insights for me, of many forms which I had hitherto never distinguished in reality's composite spectacle'.[12] Such a response cannot exist without the art itself; such thought and feeling cannot exist outside the perceptual experience of the art: no art, no such 'thought and feeling'.

The critical discourse that takes off from such experience is, of course, something else, part of the 'everything else' that is necessary to the life of the art object in the world, but *is not in itself art*. Merleau-Ponty, in his inaugural lecture in 1953 as professor at the Collège de France, remarked that the philosopher is at once concerned with *what is to be described and defined as a fact* (that is his job, certainly as a phenomenologist) and *what is beyond description*, and must remain ambiguous. This contradictory – or paradoxical – stance might neatly describe the practice of Moon the painter as his art turned once more to engage with recognisable objects in the world.

In the early 1990s Moon embarked upon a new series of rich and complex collage-paintings. After making the 'frame within a frame' collage-monoprints of the mid-1980s, Moon at last allowed aspects of the 'everything else [that is] everything else' to enter his paintings. There now appeared in the work the apparition of real objects, ghostly presences of *things*, as if the world of contingent phenomena had demanded admittance, to challenge the pure elements of abstraction (shapes, geometric or otherwise, colours, textures) but without unnecessary distraction. These paintings are works of strange and compelling originality. Moon maintained their production for several years, ringing changes in the arrangements of the objects, and complicating their settings, in diverse ways, with abstract linear motifs, graffiti-like scribbles and richly worked and textured, coloured grounds, distressed purple, gold, orange, sharply vivid blue and emerald green, complex reds, siennas, earth browns. In some there are suggestions of other motifs, vague cityscapes, a fragment of Indian printed cloth.

It was as if having exhaustively considered the nature of perception itself, creating non-naturalistic forms and abstract objects whose purpose was to provoke an intensity of perceptual engagement, a kind of reflective reverie, free of any consideration but that of the meaning and purpose of the phenomenon of art itself, Moon determined to take account of the natural world ('natural' here including human activities, artefacts and architecture). But simply picturing the world, a

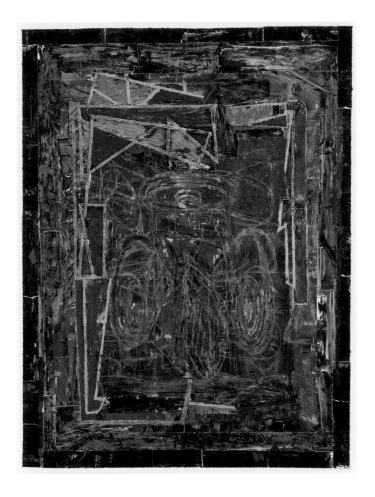

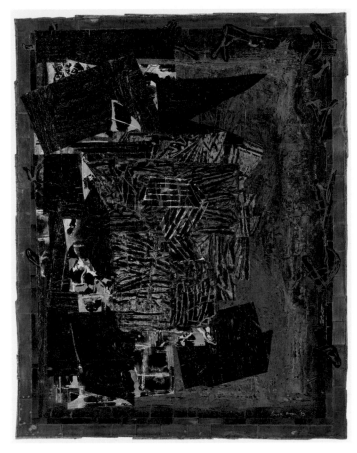

resort to *mimesis*, was not on the cards, though its achievement was well within his descriptive powers as a painter. What was 'out there', phenomenologically speaking, was interesting only insofar as it is the object of the perceptual gaze, the process whereby it might be brought 'within', become an object of bodily consciousness, something possessed by the mind. How best to achieve the distancing that would remove from the objects thus perceived the sense of an irrelevant fictional presence, a *mise-en-scène*? As he knew, 'the subject consists entirely in the manner in which [it] is constituted by the painter on the canvas'.[13]

The objects that are imaged in these paintings (their 'subject' in Merleau-Ponty's terms) consist usually of Indian bidriware vases, bowls, hookah bases and trays, or of crystal and engraved glassware, drinks tumblers, champagne flutes. (Bidriware, unique to Bidar in central southern India, is an intricately worked metalware, in which a silver filigree is inlaid onto a blackened and polished copper-zinc alloy ground in patterns of complex tracery.) These beautiful handcrafted accoutrements of gracious subcontinental society are by no means the everyday table tops, bottles and cheap glasses of the café and bar. Unlike those common motifs of classic Cubist still-life – 'things the

Left: **43** *Night Light*, 1985
Mixed media and collage on monotype base, 154.9 × 111.8 cm
Private collection

Right: **44** *Arranging the Furniture*, 1987
Hand-painted monotype with collage, 189 × 149 cm
Private collection

mind already knows' – they are not the interchangeable pretexts for exercises in mind-eye perception, for games with the problematics of how we know what our eyes see.

On the contrary, these phantasmic objects – albeit spectral – are seen with crystal clarity and a kind of cool objectivity, a disconcerting exactitude. It is clear that the traditional purposes of still-life as such are not of interest to the artist: the heavily determined forms of the metalware and glassware (objects replete with intention, utterly stylised utility or ornamental elaboration) are not seen, so to speak, in natural spaces, in a given place, in a time-bound light. They seem, rather, to be illuminated by a light from within.

Neither can they be said to bear any 'symbolic' function; they do not 'stand' for anything else; they are not emblematic

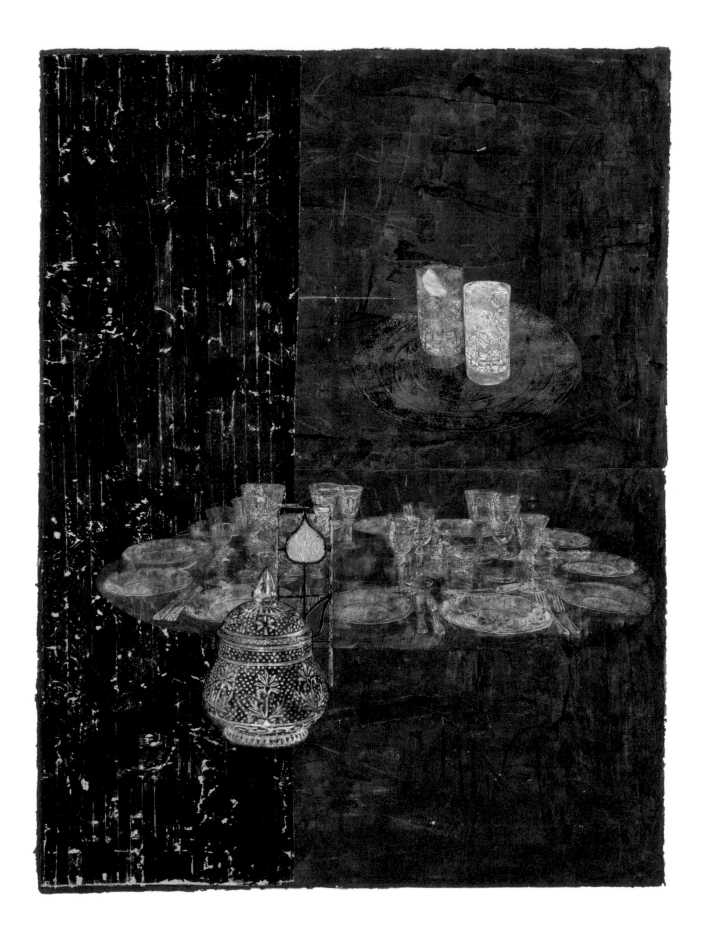

of wealth, say, or the 'good life', or even 'Indian-ness'. In what way *could* they perform these thematic functions in paintings that provide no context, that seem to be devoid of what Roland Barthes called the *studium* of an image, those signifiers within it of a 'field of study', of an 'application to a thing', or 'a kind of human interest': something culturally understood, recognisable? Their undeniable facticity is embedded in the matrix of the concrete (and abstract) surface of the work itself, an undifferentiated mass of colour, matter, arbitrary marks and motifs. In *Embers* (1991–92; fig. 46), *Ethnic Touches* (fig. 45) and *Decanters* (both 1993; fig. 4), as examples, they are pictured with great exactitude, but as if floating, or laid into, and at one

Opposite: **45** *Ethnic Touches*, 1993
Acrylic on calico mounted on canvas, 163 × 123.5 cm
Collection of the artist

Below: **46** *Embers*, 1991–92
Acrylic on calico with silk screen collaged and mounted on canvas, 165.5 × 125 cm
Private collection

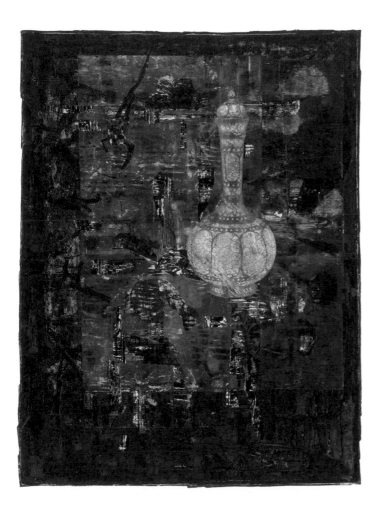

with, the indeterminate, ambiguous space of the picture plane.

They are, moreover, the first indicators in Moon's work of an abiding personal interest in things Indian. The artist's father had served for many years in the Indian Army, and his son's reveries from childhood had been haunted by images and ideas of the subcontinent as it was in the period just before the Raj ended in the mid-1940s. In 1977 Moon had married Anjum Khan, an Indian whose family was long settled in London. In 1982 he spent a long vacation travelling with her in the Punjab and Rajasthan, and visits to India at various times later in Moon's life (he was especially taken by the graceful 'pink city' of Jaipur) have intensified this interest and the complex feelings that attach to it. 'The twilight in India is fantastic,' he remarked in 1992, '– with the dust hanging in the air and the sun going down... I don't do anything as literal as saying "I'll try and get some of that diffuse Indian light in here" ... but a sense of diffusion is something I like in paintings... It's mood and atmosphere I'm after but with nothing specifically stated.' The objects in these paintings 'tend to be Indian' Moon said, 'perhaps because at home I am surrounded by Indian objects... But I also wanted them to evoke India and old, ancient objects at the same time. They are *traces* of real objects... Old objects tend to fade into the background, so there is this sense of emergence in placing them against painterly backgrounds.'[14]

To introduce these still-life motifs into the abstract space of the paintings, Moon created of them a repertoire of woodcuts, as intricately worked and beautifully precise as their subjects, taken from catalogues of classic Indian ware. They are deployed at will, occupying the abstract pictorial stage as figures without signifying character, only their own shimmering, glittering, translucent essence. (They have something of the enigmatic presence of the *trompe l'oeil* still-life objects in the late paintings of his friend Patrick Caulfield, but their function is altogether different: they have no ironic resonance, no societal or artistic *studium*.) Their perfect execution (the work of long periods of concentration and great ingenuity) and their susceptibility to perfect reproduction give these motifs an inexpressive objectivity – a emergent stillness and grace – that enables them to operate within the turbulent textural/gestural theatre of these collage-paintings as the focus of the meditative mind.

An impressive suite of screenprints, made at Advanced Graphics in London in 1991–92, constitutes the earliest deployment of this device of contrast. Moon regarded it as a purely formal solution to the problem of reintroducing *image* onto a *surface* of abstract material traces, but from it there emerged a powerfully affective metaphor. Each print presents a potent and inexplicable complex: a rich painterly surface of thickened viscous ink; a tracery of grid-like but irregular scaffolding or convoluted free-drawn linear elements (dislocated and fragmentary in *Hybrids*; fig. 48); a co-presence of darkness and light; a scattered black flower motif (not

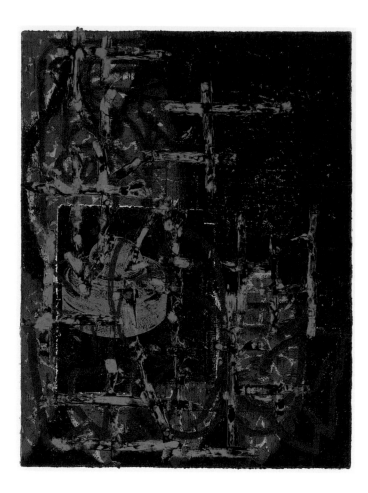

47 *Mixed Spice*, 1990-91
Screenprint and woodblock, 127.5 × 109 cm
Alan Cristea Gallery

Opposite: 48 *Hybrids*, 1990-91
Screenprint and woodblock, 127.5 × 109 cm

present in *Mixed Spice*; fig. 47). In each of them, in the midst of this chaotic *furore*, is placed the same woodcut motif of a perfect Iranian Islamic casket, a recurring presence of a kind of perfection, a human artefact, an enclosed container, an object of perfect integrity. It is a reproach, a reminder, a mystery: make of it what you will. As you contemplate this representational sign of perfect order (the perfect woodcut itself an example of the perfectly wrought thing it represents), the enclosed imprinted universe around it comes to anarchic life, assumes its own present reality with perfect confidence. It seems to say: you can't have one without the other.

Having started with the repertoire of bidriware vases and boxes, Moon become more ambitious. A note is revealing, both of his method and of aspects of his state of mind, his unconscious assumption of the 'phenomenological attitude':

'It was at this stage [the early 1990s] I introduced more complex still-life elements. The quality of the Indian pots of which I had made a considerable dictionary of woodcuts led me to explore other elements I might use. It wasn't such a leap to think of cut glass, wine glasses, champagne flutes to full-scale dinner table settings. The process was more accidental and irrational than I might think now. I made a large-scale – six foot or so wide – wood cut of a dinner table setting. I was able subsequently to use it complete in two or three paintings, or sections of it in smaller monoprints. Another was made of a tea table with a lace table cloth.'[15]

His note touches on the way a particular and moving contingency might impinge upon the particularities of the work in progress: 'It was at this point in time, 1993, that my mother died. Some of the paintings were then combined with formations of candles.'

What is true in that paradigmatic series of prints of 1991-92 is true of all the collage-paintings made around that time: in some the music of visibility is clear and immediate, in others it is clouded and complicated. All are utterly distinctive, and in all of them the ineluctable modality of the visible finds a frame, is held as if for a moment, and the insubstantial and contradictory reality of the material world finds an enigmatic and fleeting correlative. Immediate impression (the tangibility of material experience) and memory are alike inscribed in these works, and their common fugacity finds equivalence in both the apparitional shimmer of the still-life representations and the shadowy ambiguities and indeterminacies of the surrounding space. We are involved with a complex presentation, in which two distinct experiences of seeing, two ways of being, are held in a moment of dynamic poise. There is nothing quite like this in post-war painting.

Encounters with the world at large: 'reality's composite spectacle'

There is behind all Moon's work the pressure of subjective experience, a delight in the memory-traces of things past and in the specificity of the immediately visible and tangible. These things may be disguised and filtered through the objectifying procedures of elaborate and distancing techniques, automatic processes and enigmatic imageries. He is happy to use what comes to hand, to exploit accident and chance, to allow the imagery of his painting to emerge from the activity of making without preconception. It is characteristic of Moon's artistic *modus operandi* that he seeks to eliminate any conscious thematic intention (though *not* associations, which may resonate in the receiving mind in various and complicated ways, as we shall see). The violence of certain aspects of his habitual procedures – the ripping away of the calico support from the original painted base to which it is stuck; the scribble and scrawl of his graffiti

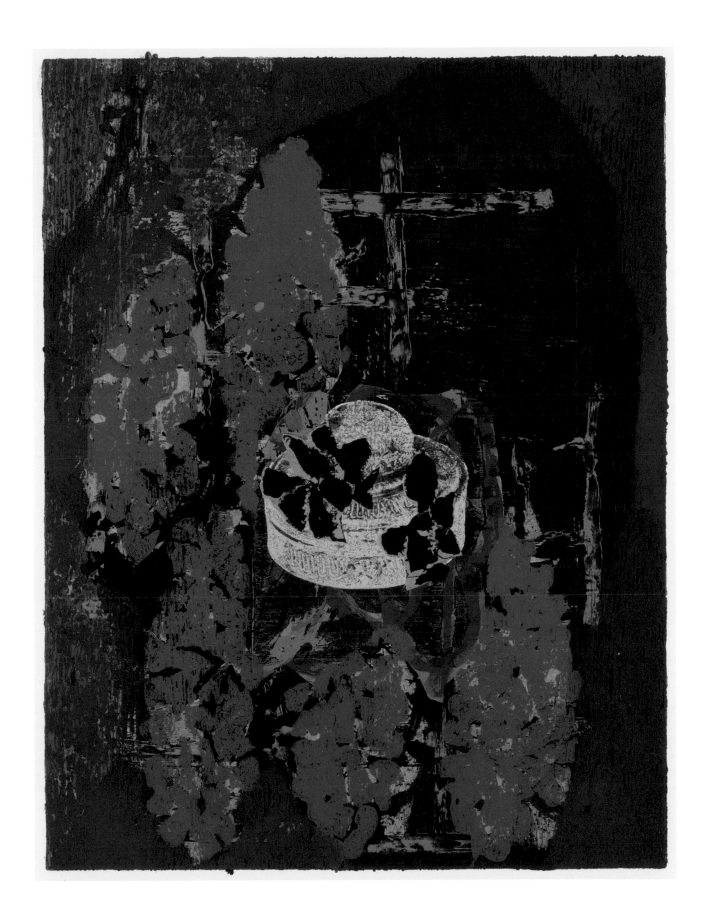

gestures; the use of a blowtorch to achieve a pungent blackness in the imprinted traces etc. – create outcomes that cannot be finely controlled, but are welcomed for their expressive effects.

Of the works featuring the woodcut images of Indian artefacts he has said: 'The Indian thing is autobiographical for me – my sensibility has been affected by my knowledge of India and Indian things, very much so, but it offers no social or political comment. I could envisage that one might make social or political points out of this engagement – though it would have to arise organically through a further deepening of interest. I suppose, though, I do think of the objects in a rather elegiac way. It's a celebration of these objects, certainly, but in painting them I sometimes feel a slight wistfulness for them, a certain sadness for them.'[16] It is touching to think of the artist so feelingly engaged with these motifs in his painting (as we imagine Braque must have felt about his jugs, easels, *guéridons* – not to speak of his magical birds!), objects and arrangements whose purposes *within* the works had to do rather with their precise objectivity, their ghostly otherness, their cool aptness for contemplative attention within a maelstrom of painterly activity, their contained stillness in formal coexistence with the visually active and haptic surface.

For all his commitment to a kind of formalist discipline – 'I view my painting in essentially formal terms, and in terms of Western painting'[17] he wrote in 1992 – Moon has never been unaware of the emotive power of colour or the atmospheric poignancies of texture, nor of the personal and cultural evocations of particular artefacts: Indian ware, glassware, inlay trays and bowls, domestic stained-glass motifs of hearts, leaves and tulip flowers. Braque certainly used such referential cues, things both familiar and strange, in his studio and room interiors, as Moon knows, to add affective and intellectual complexity to philosophical or metaphysical intent. 'Reality only reveals itself when it is illuminated by a ray of poetry' wrote Braque in his *Cahiers*. 'All around us is asleep.' And: 'I am governed by sensations that do not admit of predilections.'[18]

For Moon, without doubt, when the work is made its intention will be intrinsic. It is what it is: the freighted consequence of energies channelled, of actions performed on materials in and over time. And what it intends is unpremeditated and un-programmatic. It is the work that communicates, not the artist; and what is communicated (if that is the appropriate word) is, paradoxically perhaps, a function of the viewer's response. The work has no ulterior motives; indeed it cannot be said to have any motives at all. Of the collage-paintings, *Casement* (1991-92; fig. 49) was regarded by Moon as particularly successful: it was simpler, less complicated than others, 'less messing about going on' he said; and the yellow seemed to him to recall the dusty light of the desert of Rajasthan. Thinking with admiration of the muted palette of Braque's studio paintings, 'very French and very clear', he remarked tellingly of

the difference: '[My] methods are more indirect. Take the yellow in *Casement*, it is muted by the processes of how it's made rather than being muted in itself and that's, I suppose, why I work in an indirect way rather than in a completely direct way. I would find colour like that very difficult to achieve with direct painting.'[19]

Its 'recollection' of Indian light is, of course, a matter of a perceived atmosphere rather than of naturalistic anecdote; a happy outcome, but of no great significance: the title is literal, the window device a rare recurrence of the organising 'framing' principle of the monoprint-collage works of the previous decade. We may think it an indication, a clue, that the works of this period are essentially 'interiors' (as the settings of still-lifes almost invariably are), but that also is irrelevant: the idea of the 'interior' is of no more interest to the artist than that of still-life as such. The Indian light and colour, like the choice of the bidriware for the woodcut motifs is, as Moon put it, 'autobiographical': they were elements, so to speak, at hand.

They came out of his immediate world and memorable experience; they have an interest because of that, a compelling presence, and the stamp of a particular and distinctive aesthetic sensibility. We respond to that. But the world of the paintings is the world of the paintings themselves, only marginally and circumstantially that of Moon's autobiographical experience. The paintings are beautiful because Moon wants them to be, because he knows they have a decorative function as well as a philosophical purpose, indeed because the beauty of the work enhances and intensifies its philosophical purpose. It deepens and gives piquancy to the essential mystery of the work. It demands attention: we might rise, after all, as did Proust's young narrator, 'to a poetic awareness, rich in fulfilling insights... of many forms... hitherto never distinguished in reality's composite spectacle'.[20]

That last phrase perfectly describes the subject of a series of paintings made in 1994-96 that embodies a significant change in the approach in Moon's art to the given reality of the world. 'The real liberating idea at this time' Moon has written, 'was the introduction of the imagery of tea chests. I liked them for their Indian connection, but even more for their combination of lettering, weight values and man-made black inks against organic wood. They seemed right for imprints.'[21] The change in the nature of the imprinted base, with colour and tonal values differing according to the plywood used in the box's construction, whose surface lettering, signs and trademarks, transferred to the painting's calico support (itself an Indian fabric, with rich cross-cultural implications), made an immediately evocative connection to the complex historical world of East London's imperial industry, colonial

Opposite: **49** *Casement*, 1991-92
Acrylic on calico, collaged and mounted on canvas, 201 × 125 cm
Private collection

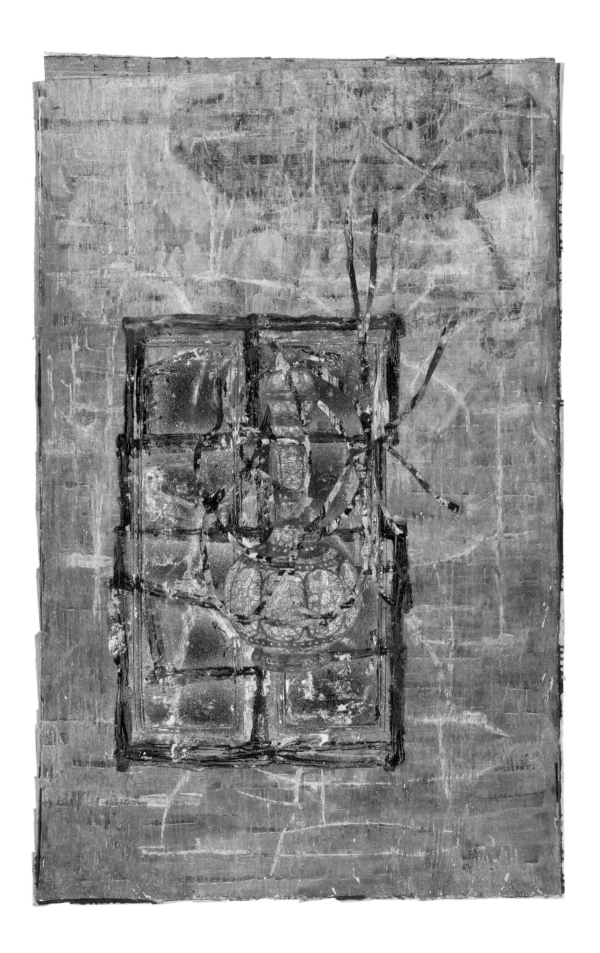

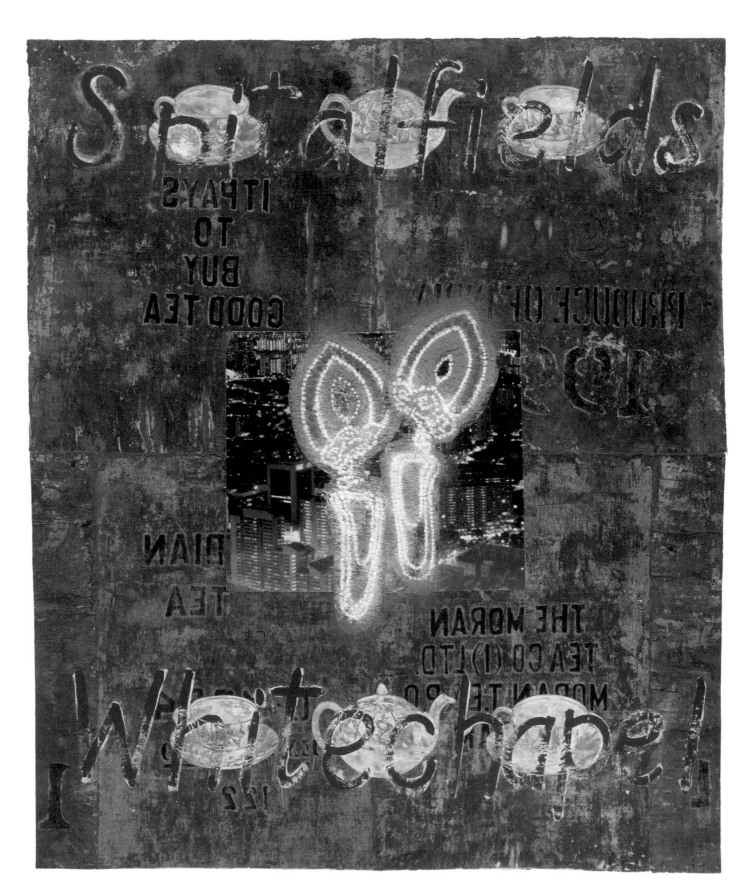

trade and commodities, imports, and the commercial affairs and cultural life of the great port's dockland.

At a stroke Moon had introduced a referentially freighted context to whatever imagery or additional lettering he introduced. To his formal predilections for abrading, augmenting and complicating the surface, there was now added an associational substratum of visual evocation, historical reference, and cultural complexity. The apparitional table-top *ensembles* of woodcut bidriware and glassware are retained and re-utilised in these works, but the presence of such luxury items, previously neutral in their relation to the atmospheric space around them, now seem inevitably charged, however faintly, with irony. Their role in the pictorial theatre is certainly altered: set against the textures, lettering and signage of the tea-chest imagery they no longer exist simply as focal points for concentrated reflection so much as objects that seem to speak of cultural and class contrast.

It would be misleading, however, to suggest that these thematic implications are primary. For it is crucial to the effect and purpose of these paintings that the surface is regarded as a single plane across which the innumerable surface features – image and sign alike – are spread or 'scattered', as in Leo Steinberg's 'flatbed horizontals': 'The flatbed picture plane makes its symbolic allusion to the hard surfaces such as tabletops, studio floors [!], charts, bulletin boards – any receptor surface on which the objects are scattered, on which data is entered, on which information may be received, printed, impressed [!] – whether coherently or in confusion.'[22] This definition uncannily prefigures the *modus* of the brilliant series of 'paintings' under consideration here. It also brings into focus the deep underlying connection between these works with major formal (and incidentally informal) aspects of Moon's earlier work (the hanging paintings, the collage-monoprints etc.). Above all, it elucidates with sharpened clarity the philosophical coherence of the entire project.

In these paintings, the unified 'flat-bed' surface equalises (just as a pin board might) a plethora of quite distinct features scattered across it; these include: the lettering-reversed printed labels, logos and stencilled commercial signs of the tea chest surfaces (the tea chest is of course a cube, whose stencilled lettering may occur on any face, horizontal or vertical), the familiar woodcut Indian still-life motifs, the black flowers, the crudely graffiti-style handwritten place-names – Spitalfields, Whitechapel, Silvertown, Darjeeling – and enigmatic linear doodles, offset photographs of city skyline and wharfside, and reversed-out prints of sections torn from the London A-Z. These paintings might be described as maps of a complex mental reality whose coordinates are temporal, geographical,

topographical, historical, spatial, semiotic and objectively visual. In them, sensational impact and sensuous impression, memory and recognition, knowledge and puzzlement are compacted in the enigma of appearance.

'Layered' here is not the word: the different kinds of information that these paintings might be said to 'contain' are not laid one upon the other, but *co-exist* in a dynamic simultaneity, a moment of immediate perception with an infinite and indescribable array of possible consequent associations and involuntary thoughts (as well as inevitably triggered emotions, memories and half-memories). And what kinds of information are we considering here? Certainly not those of Surrealist collage in which one object, image or fragment of stuff may strike a spark of dreamlike connection to another while retaining its own separate integrity. Those 'features' itemised above are no longer of a class, generic, they are not *exemplary* of anything; they are imprinted traces of the actual, subsumed seamlessly within the material reality of the work – its imprint of a world – and its ideal imaginary.

The flat plane of the picture surface is the experienced world, so to speak, in its mode of action, at any moment of its perpetual revelation. In *Spitalfields* (fig. 50), for example (the earliest of the series), the cityscape obscured by the bright jewels is inlaid into the calico, flush with its surface, as is the A-Z print-out in *Imports* (fig. 82) and the ghostly table setting of bowls and glasses in *Old Power* (fig. 51), and so on. On this vertical plane everything is held at once, as in a diagram, in visible suspension. We may recall Steinberg's emphatic insight that 'such pictures insist on a radically new orientation, in which the painted surface is no longer the analogue of a visual experience of nature but of operational processes'.[23]

These paintings are, in fact, vivid presentations of a condition of the mind at its most creative and uncertain, like that of 'the phenomenological attitude': at such moments the mind is free of the dead hand of habit and of the dull revisions of actuality that Proust called 'voluntary memory'. This latter, as Samuel Beckett described it in his little (and often impenetrable) book on Proust, 'is the uniform memory of intelligence; and it can be relied on to reproduce for our gratified inspection those impressions of the past that were consciously and intelligently formed. It has no interest in the mysterious element of inattention that colours our most commonplace experiences. It presents the past in monochrome.'[24] Proust himself invokes the grey limitations of the successive static black and white images in a photo album. On the other hand, 'Involuntary memory is explosive': 'it is [in Proust's own words] "an immediate, total and delicious deflagration"... it abstracts the useful, the opportune, the accidental, because in its flame it has consumed Habit and all its works, and in its brightness revealed what the mock reality of experience never can and never will reveal – the real.'[25]

Opposite: **50** *Spitalfields*, 1996
Acrylic on calico, 120 × 100 cm
Private collection

51 *Old Power*, 1995
Acrylic on calico, 228 × 180 cm
Alan Cristea Gallery

52 *Dance*, 1986
Monotype, 166 × 151 cm
Private collection

53 *Shifting*, 1987
Hand-painted monotype with collage, 185.5 × 145 cm
Private collection

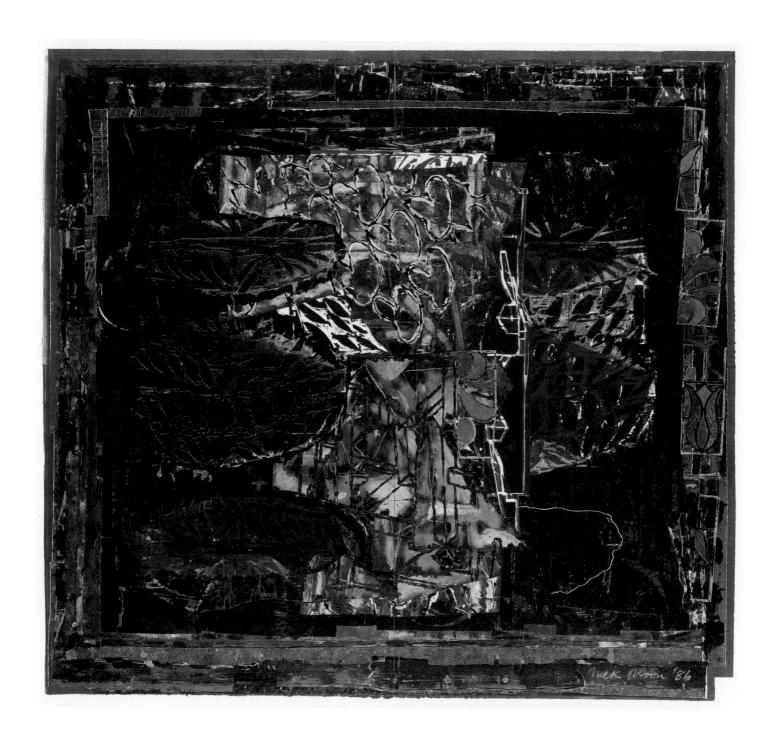

54 *Between Times*, 1986
Monotype with paper and calico collage elements printed in acrylic
and cellulose filler from wood blocks, 179 × 168 cm
Private collection

Opposite: **55** *Noon*, 1985
Monotype with mixed media and collage, 135.9 × 95.9 cm
Private collection

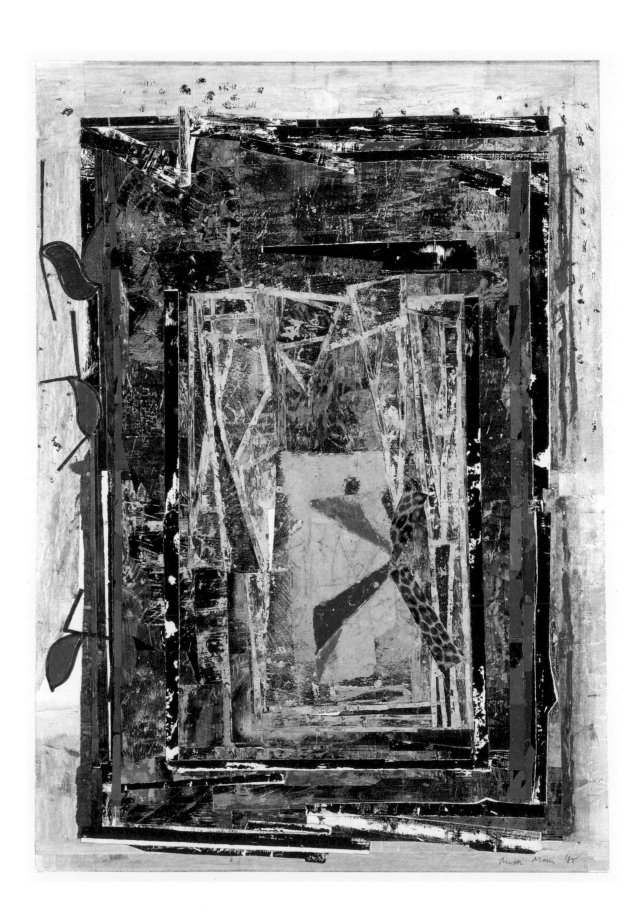

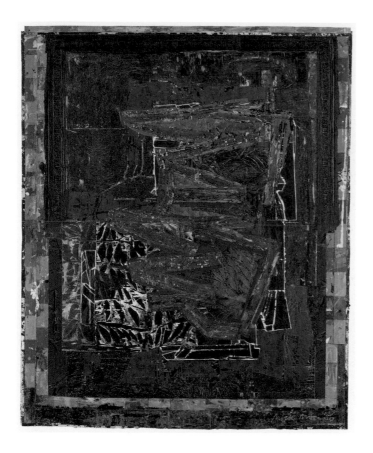 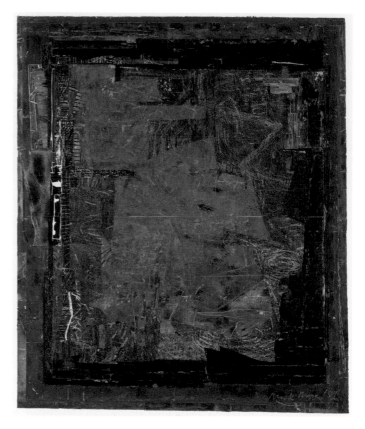

Left: **56** *Beside the Fire*, 1986
Monotype with paper and calico collage elements printed in acrylic and
cellulose filler from wood blocks, 153 × 185 cm
Private collection

Right: **57** *Oriental Room*, 1986
Monotype with paper and calico collage elements printed in acrylic
and cellulose filler from woodblocks, 165.2 × 139 cm
Private collection

Opposite: **58** *Approach Work*, 1986
Monotype with paper and calico collage elements printed in acrylic
and cellulose filler from wood blocks, 163.5 × 188 cm
Private collection

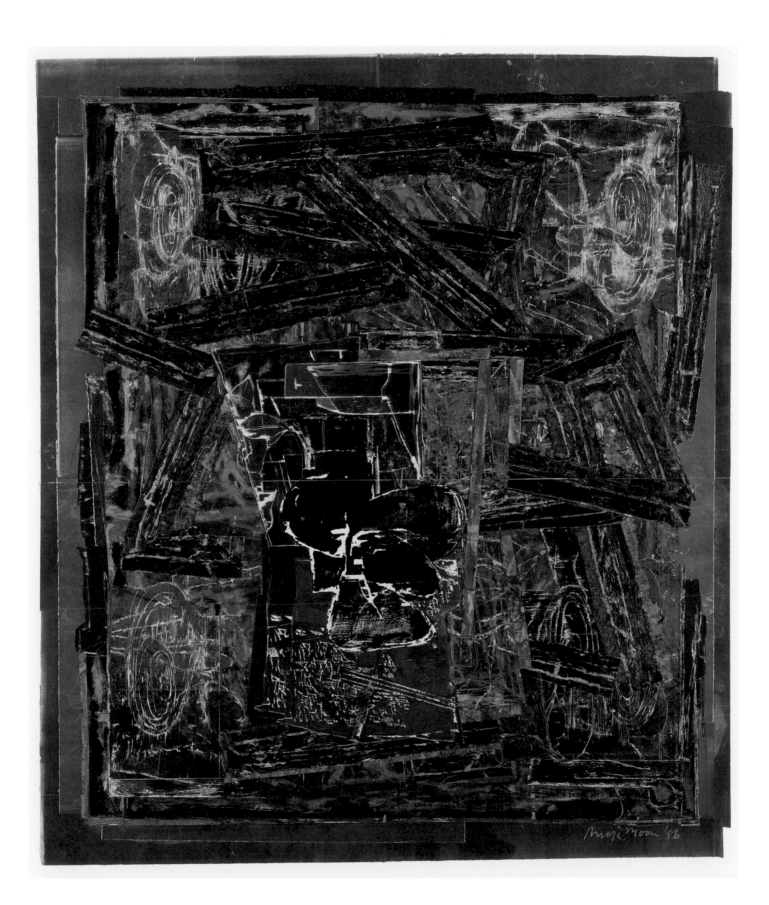

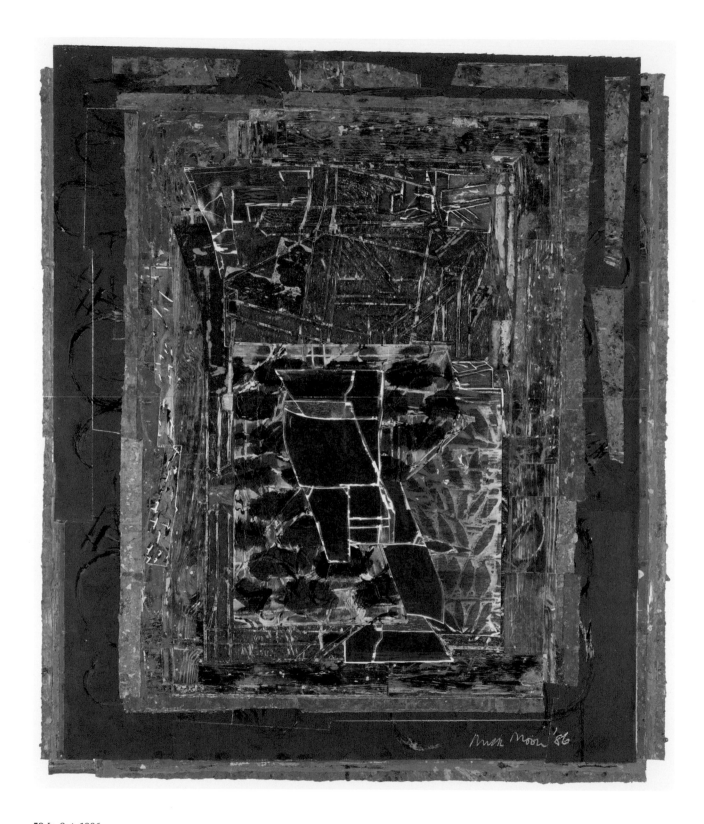

59 *In-Out*, 1986
Monotype with paper/calico collage element printed in acrylic and
cellulose filler from wood blocks, 153 × 178 cm
Private collection

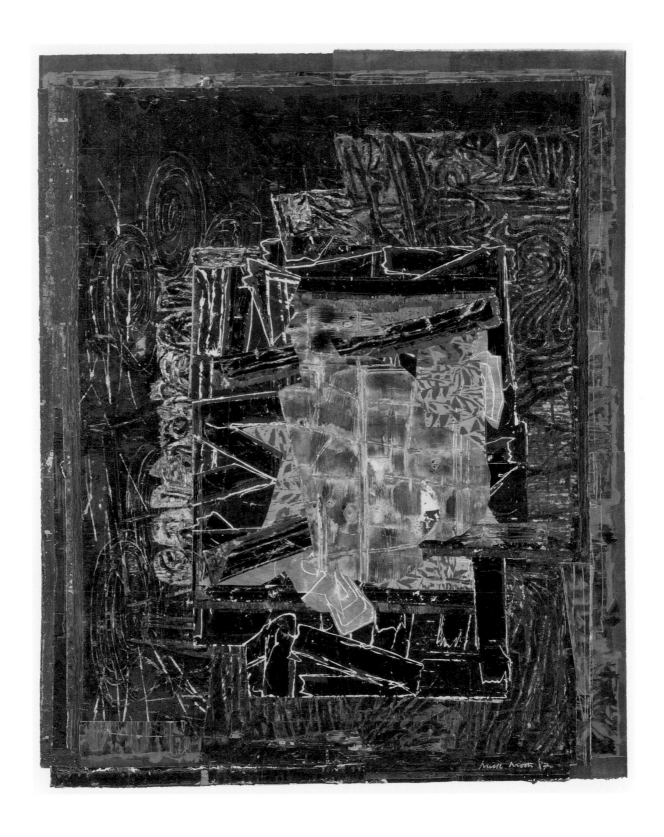

60 *Japanese Box*, 1987
Hand-painted monotype with collage, 179 × 144.5 cm
Private collection

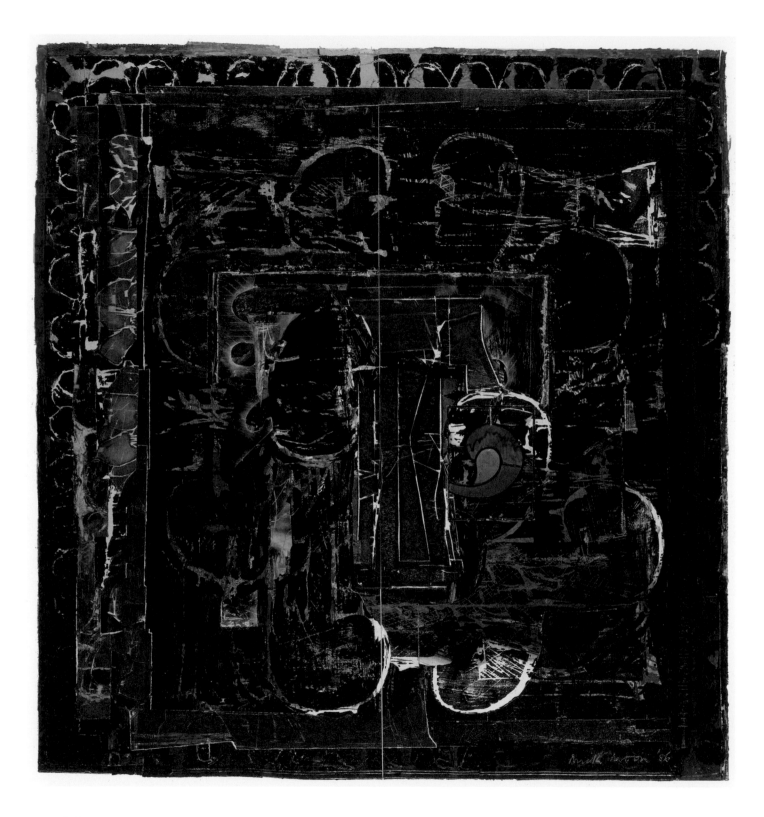

61 *A Dark Place*, 1986
Monotype with paper and calico collage elements printed in acrylic
and cellulose filler from wood blocks, 175.9 × 166.7 cm
Private collection

Opposite: **62** *Varengeville*, 1987
Hand-painted monotype with collage, 194.5 × 154.5 cm
Private collection

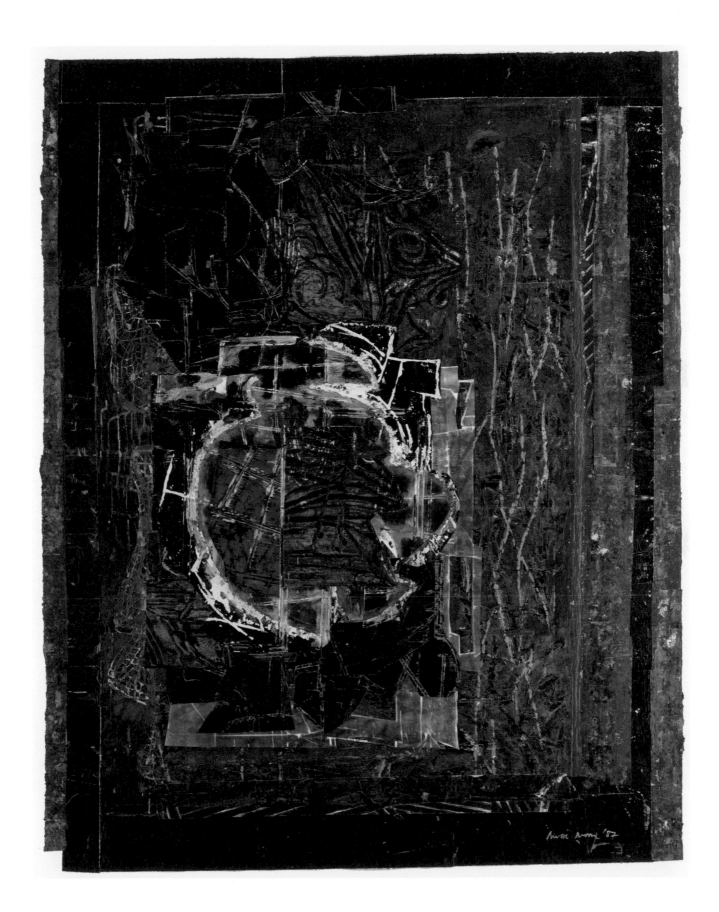

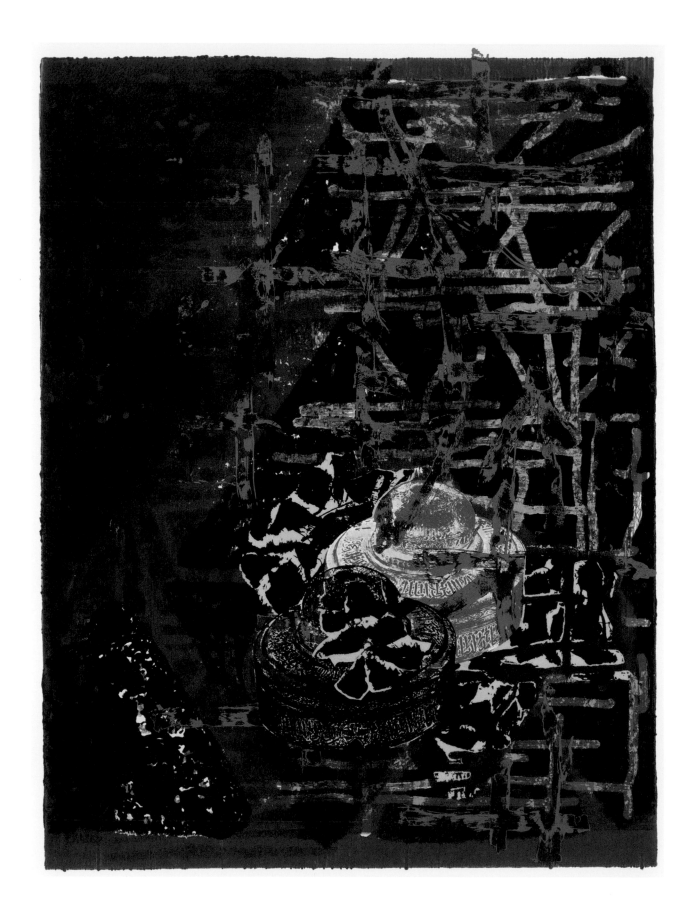

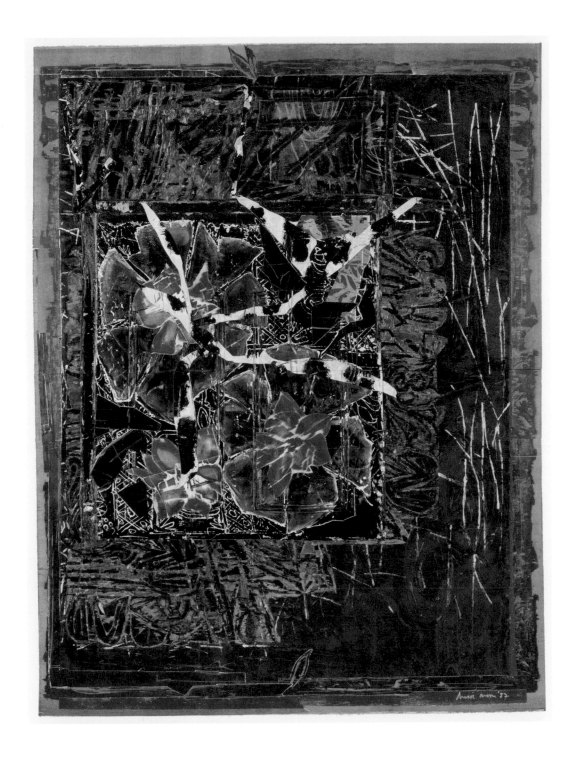

Opposite: **63** *Marriage*, 1990–91
Screenprint and woodblock, 127.5 × 109 cm

Above: **64** *Big Flowers*, 1987
Hand-painted monotype with collage, 179 × 138.5 cm
Private collection

Overleaf, left: **65** *Meeting*, 1987
Hand-painted monotype with collage, 179.5 × 141 cm
Private collection

Overleaf, right: **66** *Top Light*, 1987
Hand-painted monotype with collage, 183 × 138.5 cm
Private collection

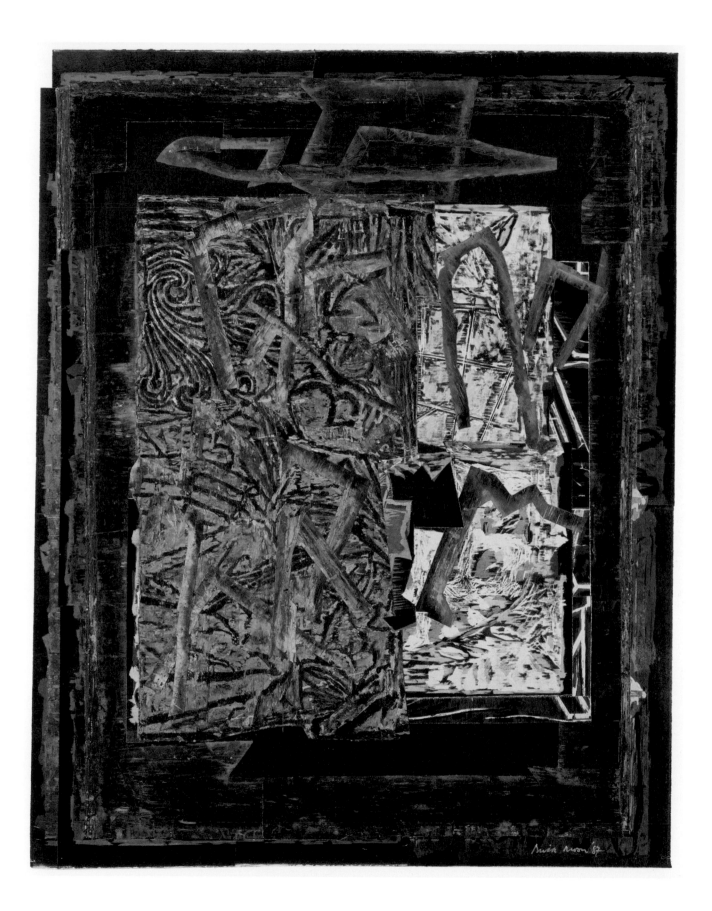

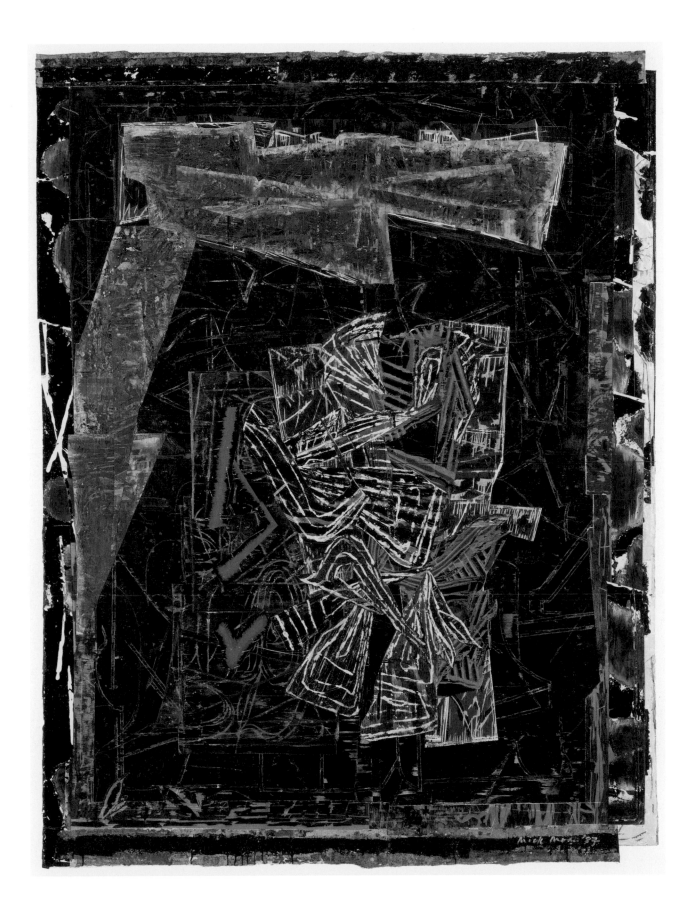

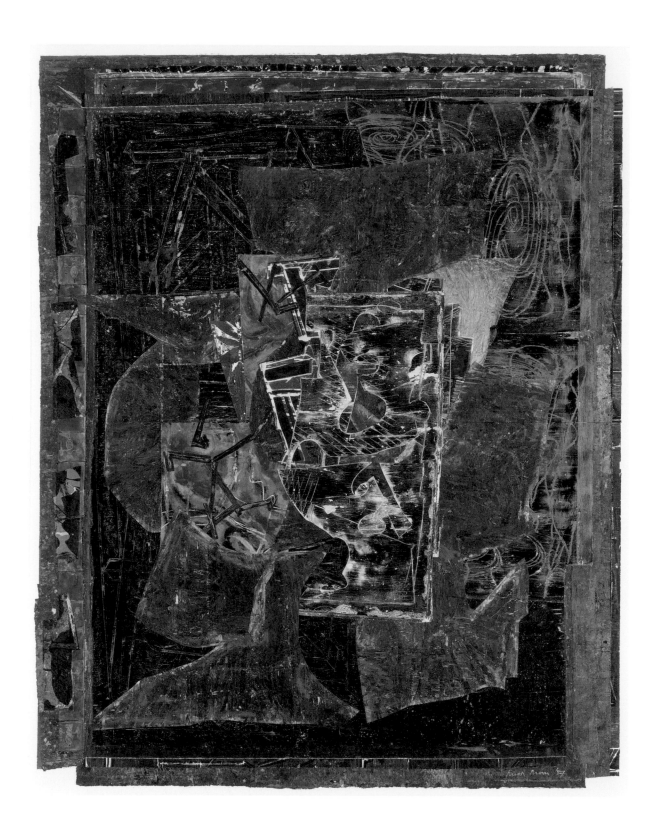

67 *Musical Chairs*, 1987
Hand-painted monotype with collage, 190 × 152 cm
Private collection

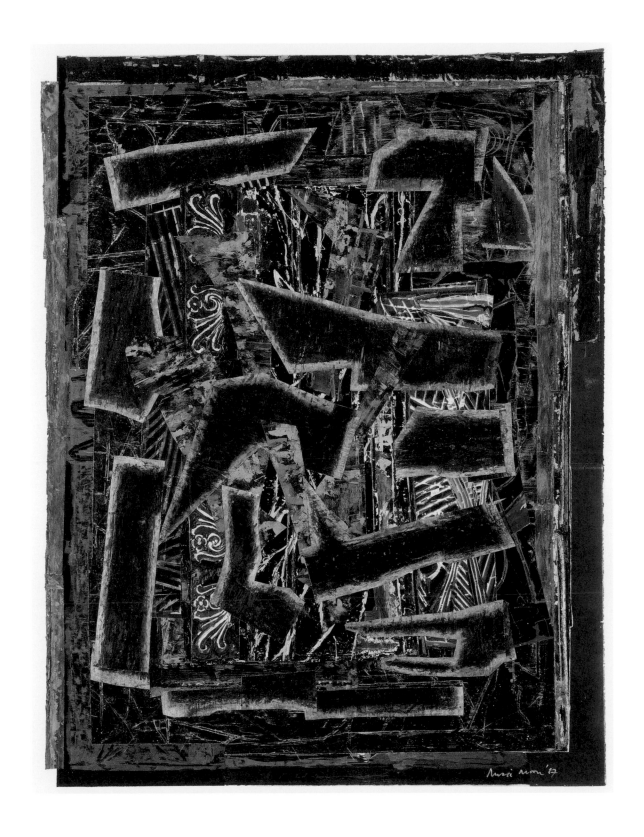

68 *Japanese Room*, 1987
Hand-painted monotype with collage, 182.5 × 141 cm
Private collection

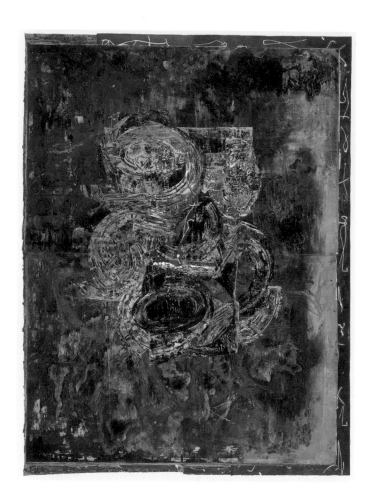

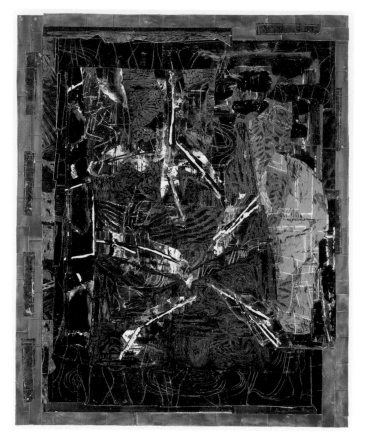

Above, left: **69** *Gold Plate*, 1991
Monotype, 67 × 51 cm
Private collection

Above, right and detail opposite: **70** *Fall*, 1989
Monotype and collage, 68 × 54 cm
Private collection

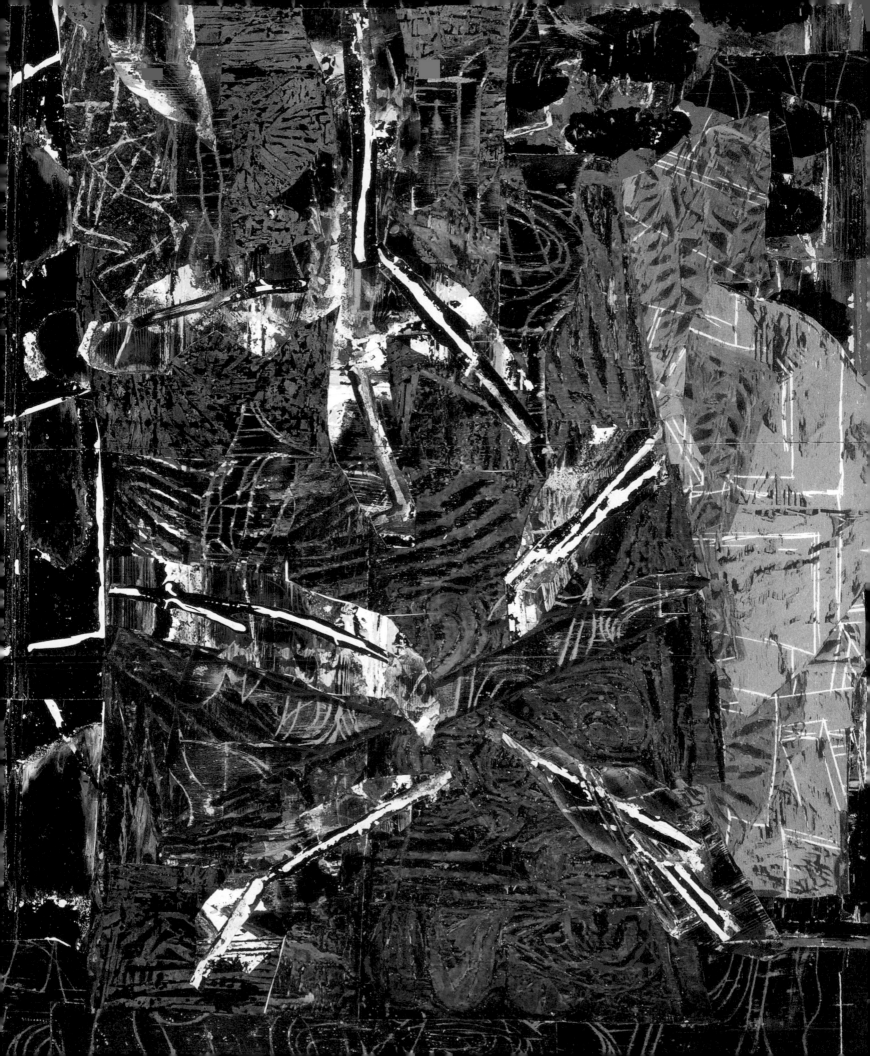

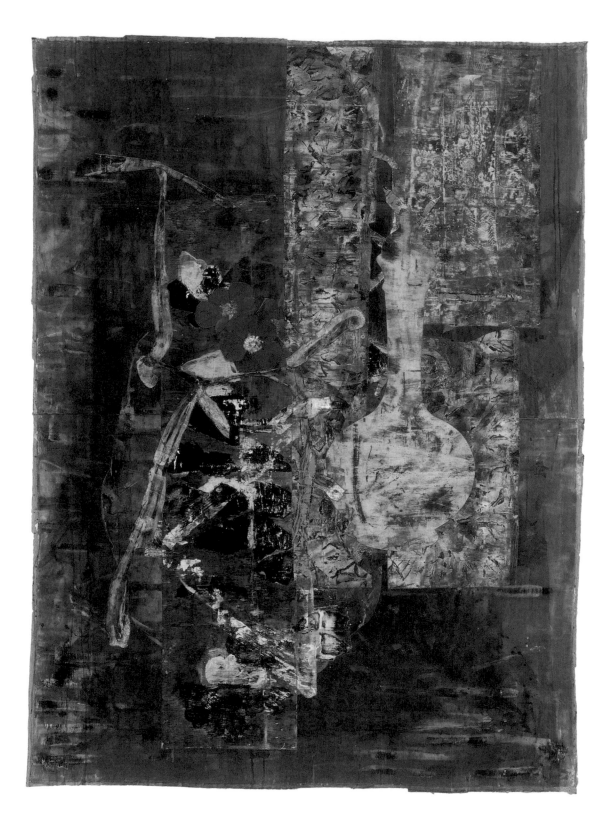

71 *From the Pink City*, 1991–92
Acrylic on calico, collaged and mounted on canvas, 167 × 123.7 cm
Private collection

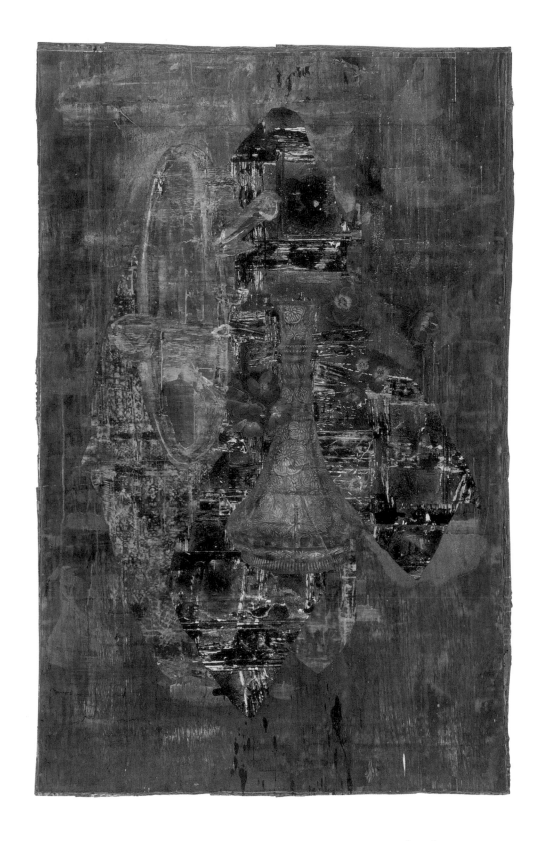

72 *About the Mirror*, 1991–92
Acrylic on calico, collaged and mounted on canvas, 196 × 125 cm
Private collection

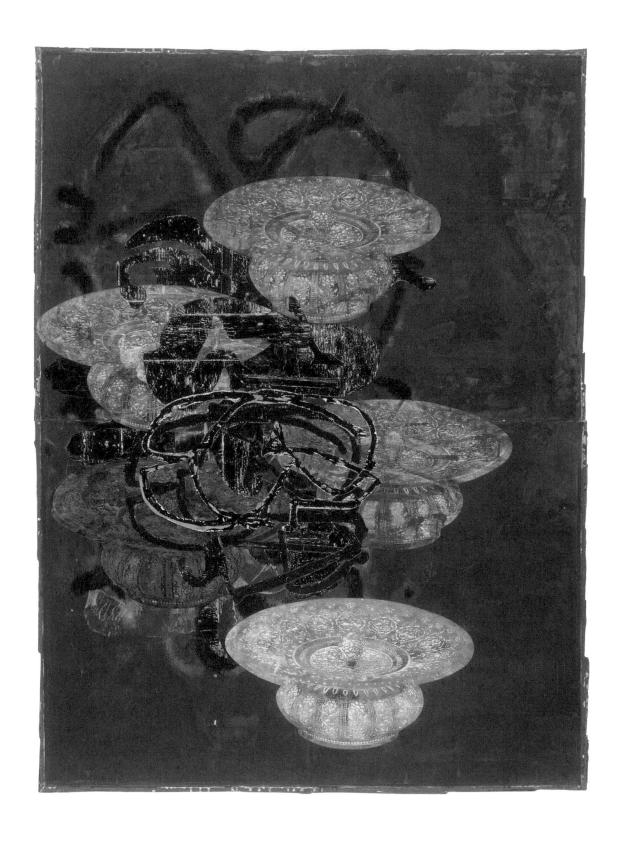

73 *Water and Wood*, 1991–92
Acrylic on calico and woodblock with collage, 167 × 127 cm
Private collection

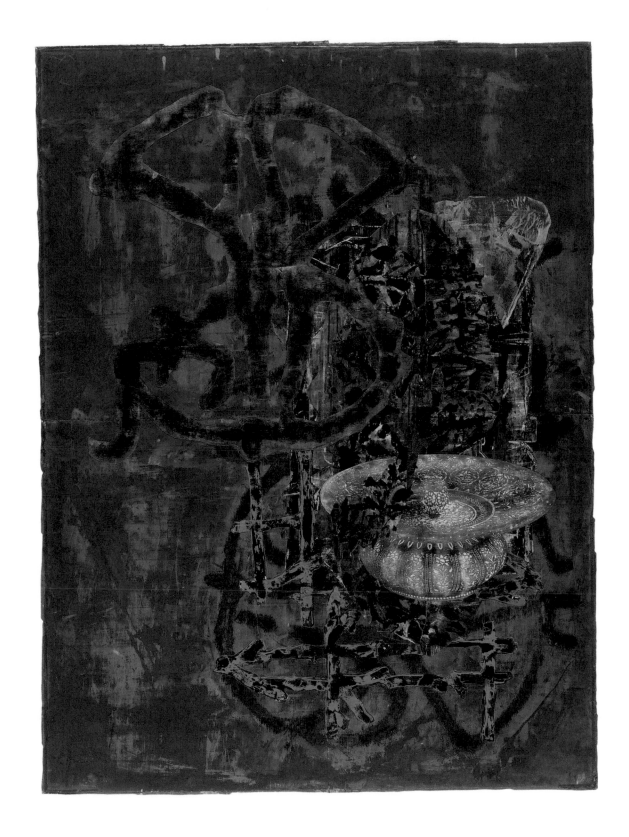

74 *Pool*, 1991-92
Acrylic on calico, collaged and mounted on canvas, 165.5 × 123 cm
Private collection

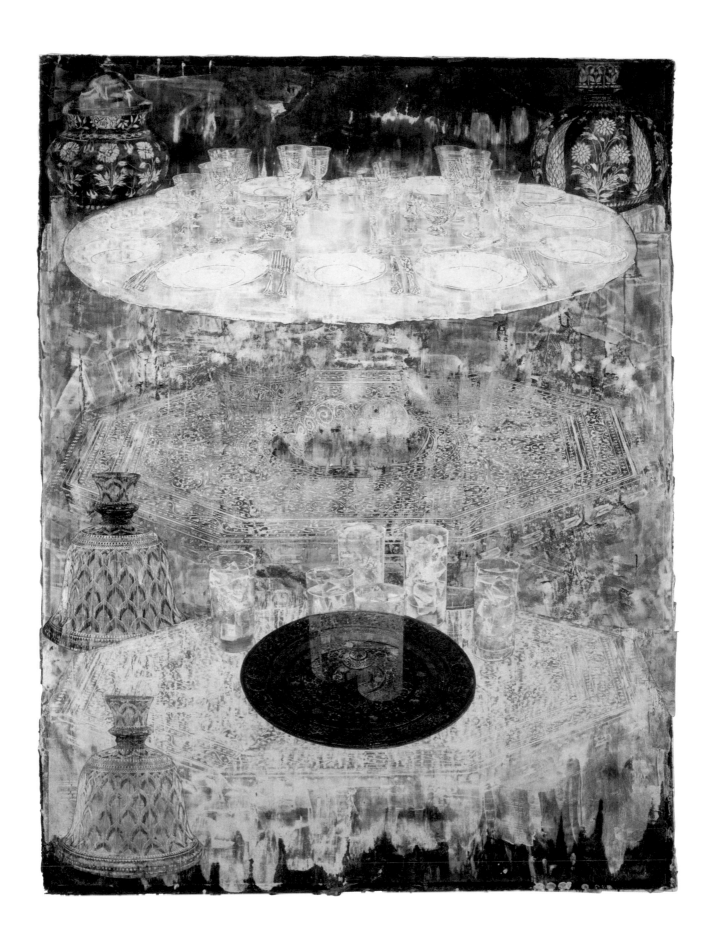

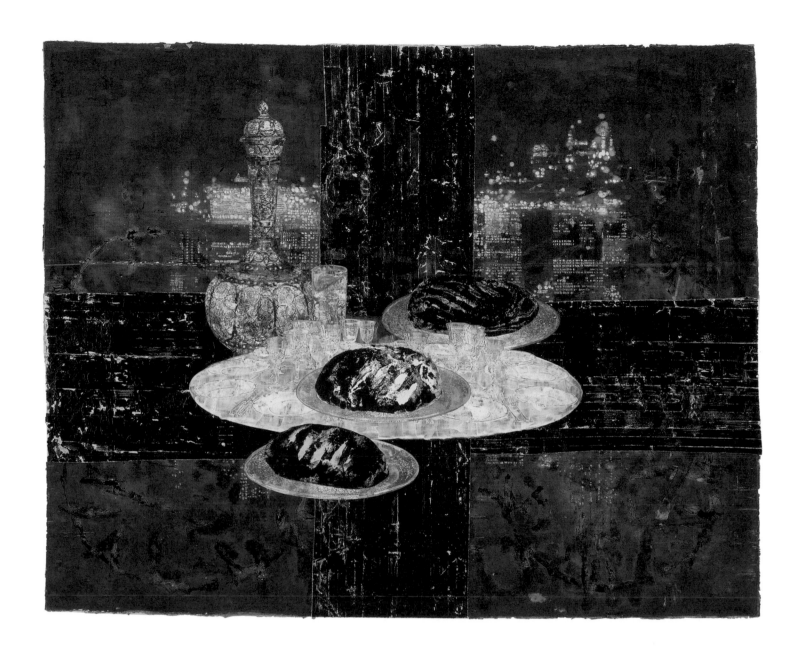

Opposite: **75** *Old Colonial*, 1993
Acrylic on calico mounted on canvas, 150 × 122 cm
Private collection

Above: **76** *Two Still-lifes – East End*, 1993
Acrylic on calico mounted on canvas, 160 × 201 cm
Private collection

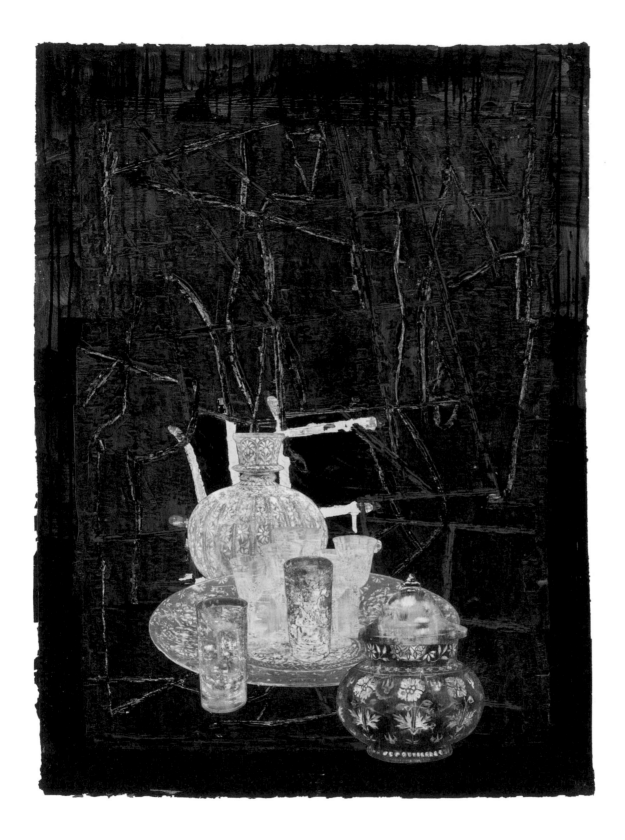

77 *Refreshments against Graffiti*, 1993
Acrylic on calico mounted on canvas, 121.5 × 99 cm
Private collection

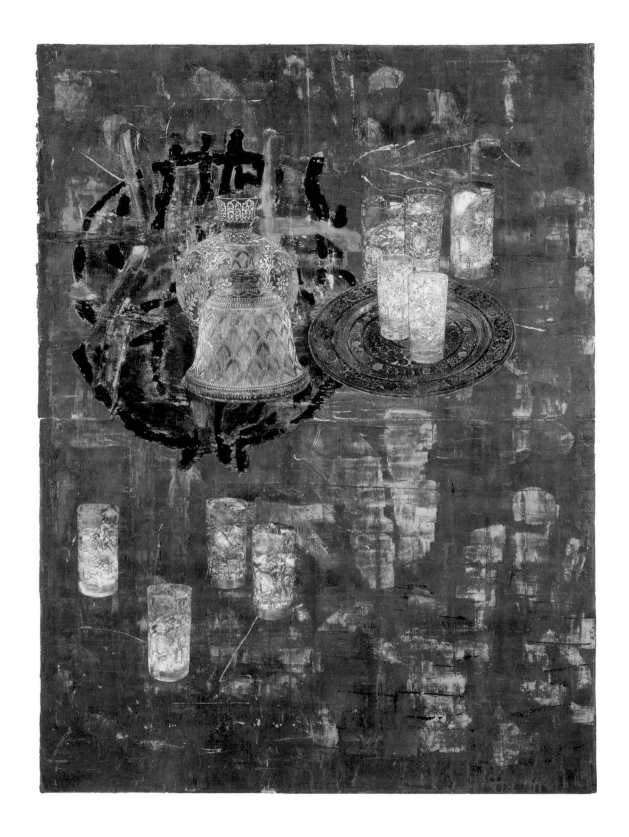

78 *Liquid Refreshments*, 1993
Acrylic on calico mounted on canvas, 164 × 122.5 cm
Private collection

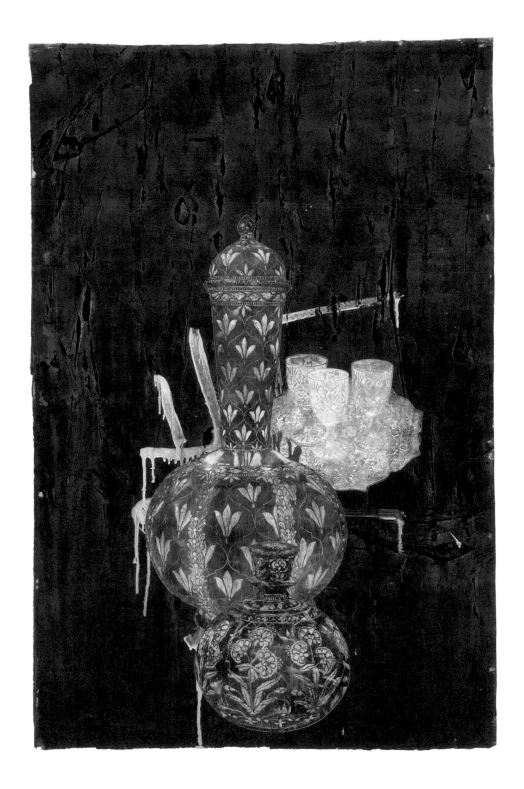

79 *Welcome*, 1993
Acrylic on calico mounted on canvas, 124 × 82 cm
Private collection

80 *Indian Artifacts with Drinks*, 1994
Acrylic on calico mounted on canvas, 164.5 × 123 cm
Private collection

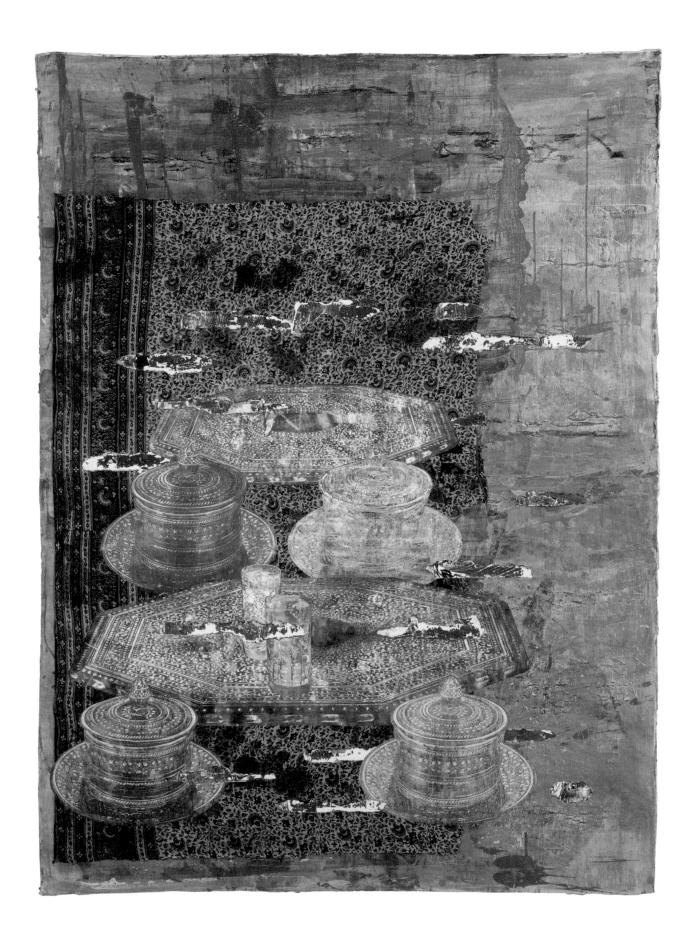

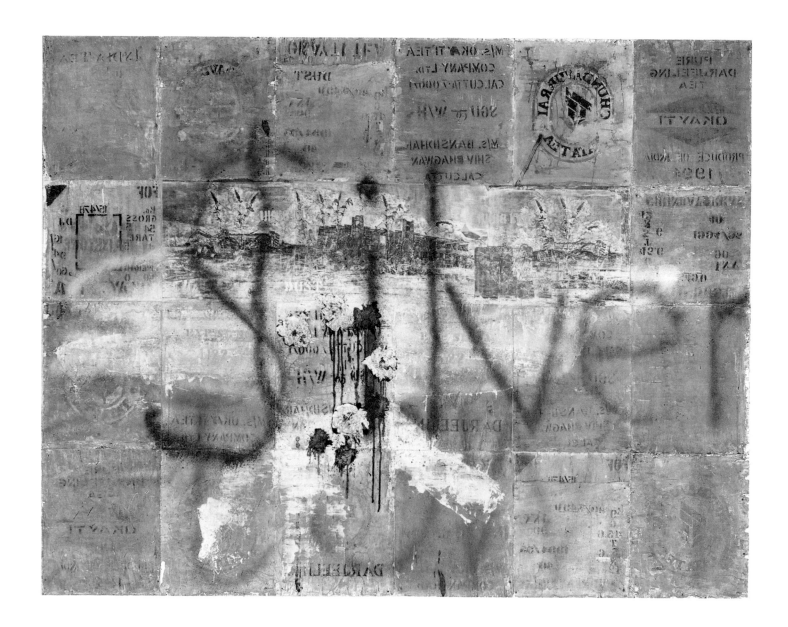

81 *Letters to India Silvertown*, 1996
Acrylic on canvas, 188 × 239 cm
Private collection

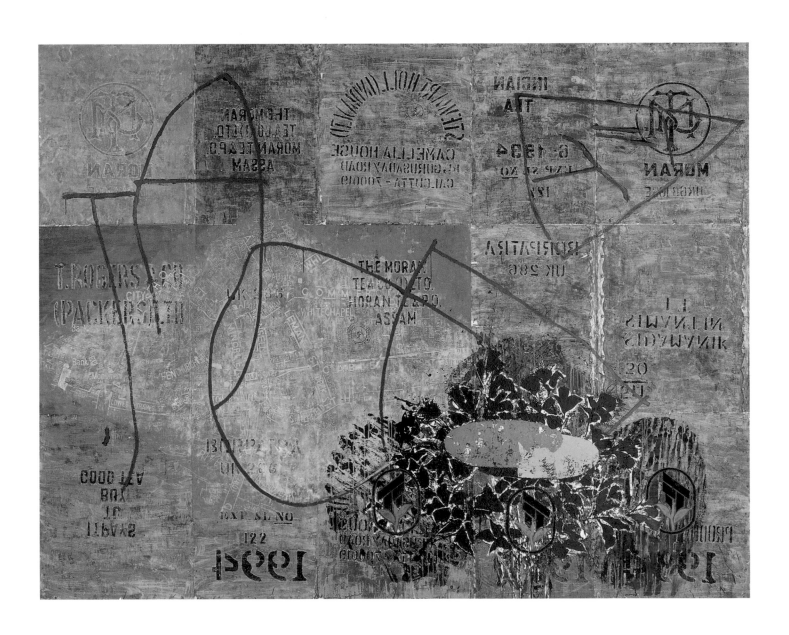

82 *Imports*, 1996
Acrylic and collage on calico, 180 × 228 cm
Private collection

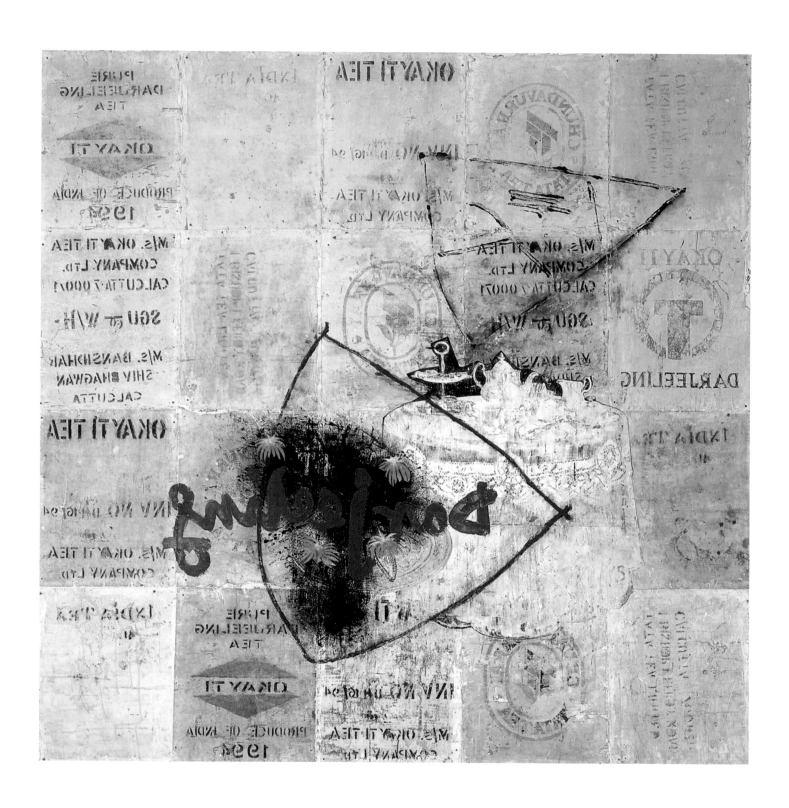

83 *Letters from India*, 1996
Acrylic on calico, 197 × 199 cm
Private collection

Opposite: **84** *Commodities*, 1996
Acrylic on calico, 237 × 177 cm
Private collection

The Late Works

'We must invent the heart of things if one day we wish to discover it.'

Jean-Paul Sartre[1]

Mindscapes and memory: Aldgate East and Dungeness

The later 1990s was a period of significant change and disturbance in Moon's personal life. As if in response, his work in various ways began to reflect – and reflect on – aspects of his earlier creative life and of his childhood. A number of ambitious monoprint-paintings and collage-with-acrylic works that date from around the turn of the century have a new kind of evocative complexity. Typically inserted centrally into the picture surfaces are woodcut versions of topographical photographs or painted images (a process familiar from earlier work) that catch, in a shadowy, half-realised vagueness, the equivalents of a kind of *voluntary* memory, as if the experience of recall was as grey and imprecise as that of a dream.

These emanations resonate from specific past experiences, in some cases recent, in some cases from long ago: Moon had become an *habitué* of Brick Lane, absorbed by this bit of India and Bangladesh in what had quite recently been dockland East London; and he carried with him, always, vague and somewhat bleak memories of his seaside childhood at Blackpool, and his schooldays on the Sussex coast. Manifestly troubled and complicated, the compressed, layered and complex images of these paintings seek to locate – to *place* – their author; to define through art his 'home soil', his existential 'dwelling'. As Heidegger puts it: 'To be a human being means to be on earth as a mortal. It means to *dwell*.'[2] They may be said to present psychic topographies of the artist's being-in-the-world, a condition that must necessarily comprehend its past as an ever-present presence.

One trigger to this phase of work had been provided by a photograph of the coastline of Dungeness on the Kent coast.

It had on the instant reminded Moon of a significant childhood experience. As a child he had developed an aversion to a certain kind of seaside architecture. 'From 1948 to 1956 I attended boarding school at Shoreham-by-Sea in Sussex. It was there that I first became aware of English vernacular seaside architecture. The town was divided from the sea by the River Adur, but once crossed you were confronted by bungalow holiday homes, different in detail, uniform in execution. I remember even as a ten-year-old thinking, "Oh my god, I couldn't live here." This has never left me, so that I have felt a gentle nausea when I have driven along parts of the south coast seafront.'[3] This Proustian recollection – shaded by 'a gentle nausea' – found its evocation not in a photograph of Shoreham but one of the more desolate straggle of industrial buildings, ruins, huts and cottages of the Dungeness shingle skyline: 'I discovered Dungeness through a photograph from which I made an elaborate very wide woodcut. It intrigued me as a depiction of typical seaside architecture only more so. Ramshackle, improvisatory, some houses were made of old railway carriages.'[4]

'Recollect' and 'recollection', verb and noun, derive from Latin *recolligere*: to gather again, to bring items from memory into the mind's present play, with a renewed significance. It is a process in which the flush of recall may be prompted in all its unexpected richness – or bareness, or desolation – by an object or image that is not immediate to the object or event thus recalled. The image of Dungeness in these works is one such: analogous to the memory of Shoreham seafront it is what Jean-Paul Sartre called an *analogon*: a means to imagine a phenomenon without perceptual recourse to the object or the event, or to a voluntary memory of it. It gives us the 'more so'

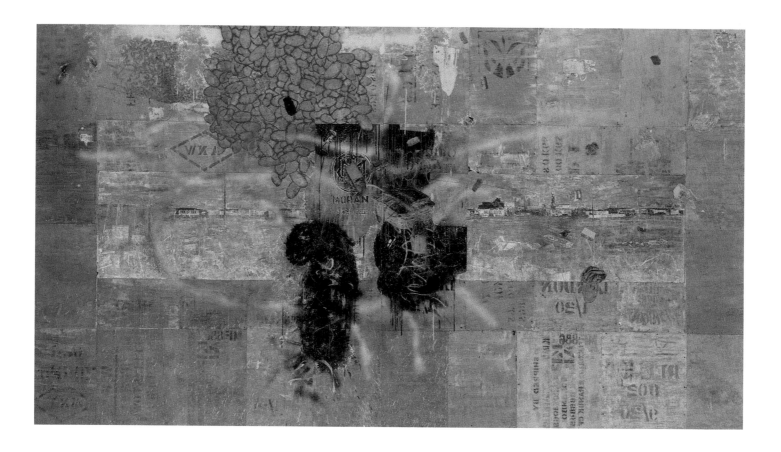

of Moon's account; it may even provoke something like Moon's involuntary 'gentle nausea'.

With different *affects* (but the same kind of effects, pictorial and psychological) the deployment of such *analogons* – apparitional objects with an evocative emotional charge – is a presentational modus in Moon's work with which we have become familiar. *Home Soil* (1998; fig. 85) inlays the Dungeness skyline woodcut as a central debased panorama, the intractable pebble beach and items of luggage memory-signs of an inexplicable unease in an ironically golden recollection. In *Home Soil Two* (1999; fig. 101) the Indian decorative octagon floats alongside a painted fading photograph of two adjacent Brick Lane shopfronts, Megna Minicabs and Shalimar Video Centre (fig. 115): subliminally connected items from different visual universes in a purely imaginary space: a flattened mind-space rudely defaced by the disjunctive scrawled title. *Home Soil Three* (1999; fig. 88) is a variation on the same theme, in this case again utilising the Dungeness woodcut as its central focus. A suitcase and scattered discarded shoes invoke the distant child's travel to the exile of school, or more simply, recurrent experiences of displacement and estrangement. Both use a base print of tea chests, from the world of the artist's most recent body of significant work. Past and present, then and now, coexistent in the neutralising, irrational no-time of painted space.

85 *Home Soil*, 1997
Mixed media painting on canvas, 237 × 425 cm
Collection of the Artist

Opposite, top: 86 *Sunday*, 2001
Monotype, 150 × 200 cm
Courtesy of the Artist and Alan Cristea Gallery

Opposite, bottom: 87 *Aldgate East*, 2001
Monotype, 150 × 200 cm
Courtesy of the Artist and Alan Cristea Gallery

Overleaf: 88 *Home Soil Three*, 1999
Mixed media on canvas, 237 × 425 cm
Private collection

In 2001 Moon returned to these themes in two more 'memory-mindscapes' as we might call them: *Aldgate East* (fig. 87) and *Sunday* (fig. 86). Like the *Home Soil* paintings of two years earlier, these monoprints (made at Hugh Stoneman's studio at Madron in West Penwith, Cornwall) are large-scale works, intended to act almost as vistas in themselves; they have something of the quality of theatrical panoramas, requiring a slow turning of the head, a scanning motion, a necessary physical involvement that envelops the eye and the mind. The strange and disconcerting *trompe l'oeil* painted vegetables –

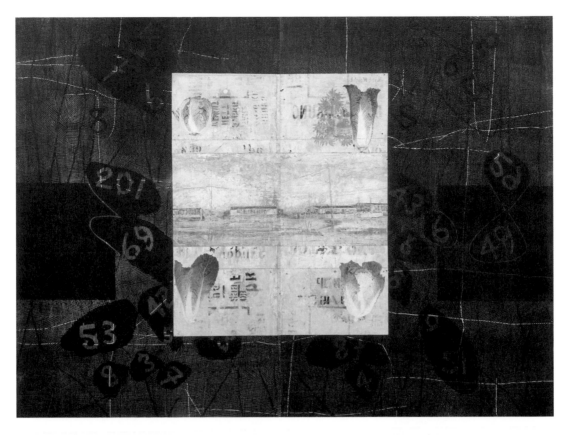

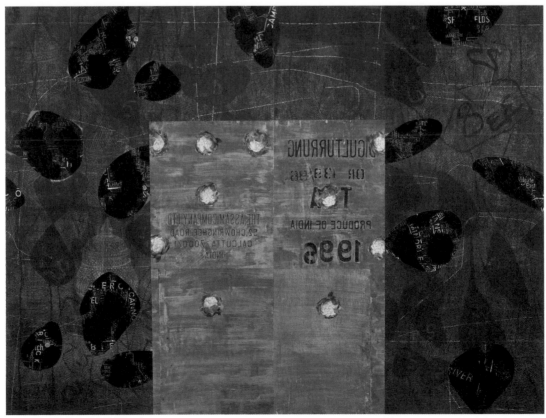

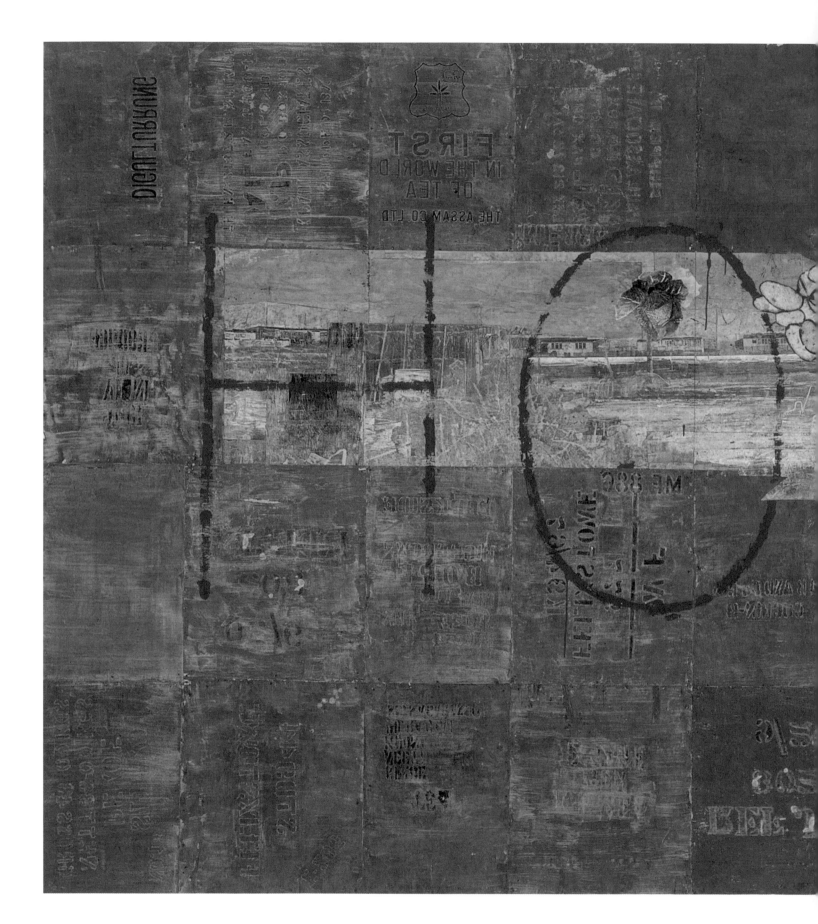

cauliflowers, lettuces, etc. – in these works are analogues of the mental incursions of *involuntary memories*, brought to the mind with the startling clarity – that 'brightness' that Beckett declared to make suddenly visible 'what the mock reality of experience never can and never will reveal – the real.'[5]

In both of these extraordinary monoprints these super-real irruptions are precisely focused: in *Aldgate East*, the vegetables

89 *Still-life I*, 2001
Monoprint, 150 × 200 cm
Private collection

90 *Still-life 2*, 2001
Mixed media, 150 × 200 cm
Private collection

of East London market barrows, in *Sunday*, the lettuces of childhood Sunday teas, the boredom of estrangement. Around these motifs are other, vaguer, mnemonic devices, lottery numbers on potato shapes (Moon had called the numbers in 'housey-housey' sessions during his National Service), ghostly reversals, white on black, from the East End pages of A-Z maps, the recurrent stencilled lettering and signs of the tea chests. These are works in which the problematic relation of *being* (Heidegger's *Dasein*) to memory in its different manifestations is presented as a function of engagement with the world in its material actuality and with the ineluctable modality of Time. For Moon that physical engagement is exemplified in the creative actions of the artist upon the materials with which he works: the artist is the exemplary human being; the outcomes of his engagement are images of the otherwise inexpressible presence of the human being, engulfed in the irreducible simultaneity of past and present, and the encounter of material objects and events with the comprehending and comprehensive mind. Wittgenstein's *Tractatus* famously ends with the proposition: 'Whereof one cannot speak, thereof one must be silent.'[6] These great mixed media monoprints are necessarily silent, wordless panoramas.

Two other, very different, large-scale mixed-media monoprints were made in Cornwall in 2001. These Moon entitled *Still-life 1* (fig. 89) and *2* (fig. 90). Stoneman had supplied him with large sheets of wooden board, and Moon prepared for the work by making small abstract woodcuts to inset in the larger board, and by laying into the plane of the ground almost invisible woodcut motifs – shoes, lottery numbers etc. Hand-painted *trompe l'oeil* vegetables also embellished these motifs. Dominating both images, however, were large cut-out dramatic black silhouette images of leaves, discs and ellipses. The almost subliminal imagery embedded in the surface adds an undercurrent of complexity, as of fading, perhaps painful, memories, these exuberantly mysterious shapes against a pale, almost-gold ground, suggest a radical change of mood, a new clarity and openness, as if the artist had stepped into a clearing in the open air, with a bold new sense of optimism. Around the time of completing these works Moon, who had divorced his first wife in 1999, propitiously met the painter Philippa Stjernsward; a companion in art and life whom he was to marry in 2013.

Bagatelles: Miró, Brick Lane, Venice

Any artist as imaginative, as richly technically inventive, and as unburdened by any overriding thematic or formal programme as Moon, is likely, from time to time, to make smaller works, more playful or experimental than usual, sometimes as variations on a common theme, sometimes as outriders to a larger work or series. The diminished scale of the work may allow for closer and more concentrated focus

91 Joan Miró, *Still-life with Old Shoe*, 1937. Oil on canvas, 32 × 46 cm.
Museum of Modern Art, New York. Gift of James Thrall Soby

Right: **92** *Miró Bottle*, 2002 (detail)
Monoprint with collage.
Private collection

on a particular motif or technical procedure, to bring out its
particular significance or resonance. Such a ploy will allow for
its amplification by the serial cross-referencing that is made
possible by its presentation as a component of a suite, where
the relation between one work and another is not necessarily
sequential, but might be a matter of recurrence, or echo, or
contrast. Such groups of, and individual, 'small works' (as
Beethoven, with his '*bagatelles*' above all, demonstrated) may be
as moving and considerable, if not as ambitious, as the larger,
more symphonic compositions that have made the reputation of
such an artist. Moon has from time to time produced such works.

(i) In 1994, admiration and affection turned his creative
attention to a painting by Joan Miró, *Still-life with Old Shoe*
(fig. 91), painted in Paris between January and May in 1937.
It was a crucially important painting to Miró, who had found
himself trapped in the French capital by the speed with which
the civil war had engulfed his own land and made a return
to Barcelona impossible. Miró was deeply troubled by these
events, and passionately involved in favour of the legitimate
Spanish republic against the Fascist military rebellion. *Still-
life* was in a deeply disguised way an agonised response to the
war: Miró found himself turning – inevitably it seems – to the
expressive history of Spanish still-life-as-allegory. In letters
to his dealer, Pierre Matisse, he declared that he wanted the
painting 'to hold its own against a good still-life by Velázquez.'[7]

It presents a stark juxtaposition of electrically illuminated
objects, drawn from the lives of the common people, isolated
one from another, in a strange swirl of liquefied black and livid

blue-turquoise, as if engulfed in a nightmare. While he was at
work on the painting, in a letter to Matisse, Miró itemised these
things in a matter-of-fact way: '1 empty gin bottle wrapped in a
piece of paper with string around it; 1 large dessert apple; 1 fork
stuck into this apple; 1 crust of black bread; 1 old shoe.' It was
painted, he had said, to discover 'a profound and objective
reality of things, a reality that is neither superficial nor
Surrealistic, but a deep poetic reality, an extra-pictorial reality,
if you will, in spite of pictorial and realistic appearances. The
moving poetry that exists in the humblest of things and the
radiant spiritual forces that emanate from them.'[8] Miró was
aware of his phenomenological attitude: years later he wrote in
a 1953 letter to the American critic and collector James Thrall
Soby: 'Despite the fact that while working on the painting I was

thinking only about solving formal problems [!] and getting back in touch with a reality that I was inevitably led to by current events, I later realised that without my knowing it this picture contained tragic symbols of the period... the bottle like a burning house spread its flames across the entire surface of the canvas.'[9]

Moon's treatment of what Miró called 'the tragedy of a miserable crust of bread and an old shoe, an apple pierced by a cruel fork and a bottle' is disconcerting. These various 'humblest of things' are abstracted separately from the original image; taken out of their tragic and violent context, they are isolated as highly stylised items – carefully painted simulacra of the originals – and placed incongruously against a quite different class of articles. These are drawn from a lifestyle that suggests complacent luxury, and recall the richly laid tables of Moon's own 'apparitional' still-life paintings of the early 1990s: a lace tablecloth, inlay bowls, a glittering plate and, cruelest of ironies, a sparkling glass of gin and tonic, with ice and a slice. The irruption of crude reminders of peasant suffering (sometimes with a black swirl of Miró's smoky wartime shadow) into the civilised peace of these settings, deepens the bleak irony of the Spanish master's own engagement with the darkly symbolic still-lifes of his native tradition. Moon's hommage to Miró had the negative quality that Miró had demanded of his own great painting: 'No sentimentalism.' It caught also the positive quality that Miró had always sought: 'the magic sense of things.'[10]

(ii) In 2005, happily installed in a new studio in a small terrace house in Peckham, Moon cast about, as artists do, looking for a new subject, a new way of working that would suit his mood. As always he found that his own past work provided a key: there was more to be discovered in his experiences of Brick Lane and Whitechapel, where he had explored that familiar world in the most complex and disconcerting way, as a cross-cultural topography in which memory, the vagaries of personal history, and the phenomenon of being-in-time had concatenated in the simultaneity and silence of the flat surface. The limitations of description, 'expression' and style had been avoided by an entirely arbitrary scatter of items in a random disorder analogous to that of a mind without intention, a mind made purposefully ignorant: a mind, in fact, like that of Proust's Elstir, 'that forgets everything for the sake of his own integrity (since the things one knows are not one's own).'[11]

Now he determined to *un*-complicate matters, to change scale, medium and support: in short, to simplify. This was another way to clear the mind. The *Brick Lane Suite* (2005) consists of seven small paintings, executed on paper onto which

Below, left: **93** *Bricole e Barene*, 2007
Acrylic on board, 61 × 61 cm
Private collection

Below, right: **94** *Eustatismo*, 2007
Acrylic on board, 61 × 61 cm
Collection of the artist

Moon has rubbed down a ground of faint, almost invisible A-Z pages of the Whitechapel area, sometimes overlaid with drawn-in graphite roundels that suggest the ghosts of coins from the trading transactions that characterise the historical area. The effect is both atmospheric and subliminal: these are phantasmal vestiges, maps of a fading past. Onto this ground he placed banal images from everyday life: rubbings of sliced white bread, a meticulously hand-painted cream cracker biscuit. Moon once again indulged his talent for *trompe l'oeil* photographic exactitude in three images of Brick Lane shops. These little works are *jeux d'esprit*, playful evocations at once comic, nostalgic, ironic and enigmatic: an oddly moving lyrical septet.

(iii) Invited to Venice in 2007 to make work to raise money for the English Church there, Moon created three small paintings, two of which were to have a major impact on the future direction of his career as a painter. The first painting, entitled *Bricole e Barene* (fig. 93) features a view across the lagoon to the distant horizon line of the city, as through a notional window, sketchily suggested by a linear frame. (*Bricole* is the local word for the mooring stakes and channel markers characteristic of the lagoon; *barene* are the sand and mud banks that occupy the lagoons and channels.) The view is that seen from a Venetian water taxi as it emerges into the Lagoon from the channel leading from the airport. Starkly stencilled over the palely fading view is the word *Eustatismo*, designating global changes in sea level. It implicitly warns of the threat that hangs over the city. The second painting (fig. 94) takes that word as its title, and features the same roughly stencilled, ominous warning. At the centre, the cross hairs of a telescopic gun sight target an inset detail of a tourist map of the main islands of the city. In the third painting a pale woodcut of a Chinese vase (fig. 107) – a reference to Venice's ancient trade links with the Orient – overlays the view across the Lagoon. In these latter paintings an acrylic direct imprint of floorboards in Moon's Peckham studio imitates the surface of the water. In art, one things leads to another: this visual correspondence was to launch Moon into an astonishing new phase of paintings of a kind unprecedented in his diverse career.

Intimate immensity: trees, wood as water

Moon's restless practical creativity is characterised by the intensity of its artistic address to the world, a world apprehended as a continuous field of being in which what is external, in all its phenomenal complexity and beauty, is inescapably drawn within, encompassed and assimilated to his artistic (and philosophical) purposes. This might imply an autobiographical centre to his artistic preoccupations, but this would be a misunderstanding of his actual *modus operandi*. It is true of course that any practical engagement with the given world (including personal and social interactions) must be particular and local. How could it be otherwise?

As we have seen, however, it is in the nature of Moon's art that personal references and the recurrence of particular images and objects that relate (usually tangentially) to his personal life are treated as purely exemplary, and their significance limited to the artistic expression of the work itself: their connections to each other exist in the dynamics of the presentational surface; the plane of the work is the plane of its meanings. It is the work of the eye and the mind, of the observer's perception, to find or create those meanings in the work. 'Space, outside ourselves, invades and ravishes things,' wrote Rainer Maria Rilke:

'If you want to achieve the existence of a tree
Invest it with inner space, this space
That has its being in you.'[12]

Between 2009 and 2013 Moon made a series of related paintings featuring trees whose genesis and development might perfectly (and paradoxically) exemplify the freedom of his practice from any kind of autobiographical determination, egotistic expression, or documentary intention. We have seen how often it is the preparation (often laborious and essentially meditative) of the working surface that, for Moon, begins the essentially intuitive process of image-making. The seemingly arbitrary disposition of recognisable objects across the image-surface comes later. In the latest work in this series, Moon allows a cryptic reference to a personal history, but the opposition of architecture to nature speaks of a broader theme beyond the personal reference.

Each of these paintings is the outcome of complicated, intricate and ingenious procedures, in which the extraordinarily complex beauty of the finished surface of the calico support has a material history that has involved combining meticulous techniques of drawing, printmaking and painting. *Tree Line* (2009; fig. 95) involved 'casting' and imprinting from incised wood blocks; in *Tree* (2010) the entire elaborate (and mystifying) surface reticulation was cut into the original template baseboard. In *Towpath* (2011; fig. 99), the late addition, along the bottom, of a new imprint of a plank of wood, incised and painted, becomes the path at our feet, its flowers created by fanciful splotches of colour and impressionistic stippling. In *Redwoods* (2012; fig. 96) the lunar reflection, bottom left, is a witty signature that suggests the purely natural objectivity of the artist's presence. *For Patrick (His Villa)* (2013; fig. 98), a beautiful *hommage*, remembers a coolly objective painting, *Concrete Villa, Brunn* by Moon's old friend Patrick Caulfield (1963; fig. 97), who died in 2005. Moon floats a perfectly rendered reproduction of the modernist villa, painted by Caulfield against an impeccably geometric abstract grid, behind a complex tracery screen of wintry twigs, foreground by the bars of improbably tall vertical birch trunks:

95 *Tree Line*, 2009
Mixed media, 122 × 122 cm
Private collection

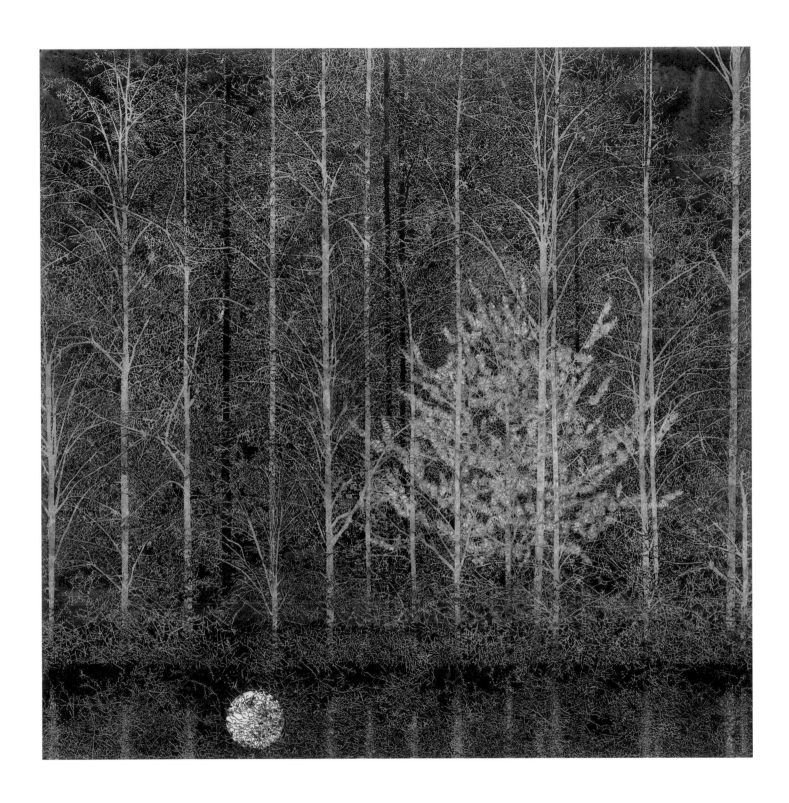

96 *Redwoods*, 2012
Acrylic, 122 × 122 cm

a utopian dream is succeeded by nature in the seasonal passing of time. In the original painting, Caulfield had fancifully placed himself on the villa balcony veranda. In Moon's elegiac version, Patrick has disappeared.

Moon was 're-complicating the surface' with a vengeance. He allowed these painstaking procedures, and the subject-matter disclosed by near-automatic procedures – trees and the light and dark of winter thickets – to determine the direction of the works towards the completion of an unpremeditated but coherent image, independent of any personal expression. As they progressed he was pleased to discover (as are we) vivid recollections of the woodland landscapes of Gustav Klimt. In *Birch Forest* (1902; Staatliche Kunstsammlung, Dresden) and *The Park* (1910; MoMA, New York), for instances, Klimt's treatment of the shallow view into the trees is flattened against the vertical surface of the canvas, presenting the image not so much of a picturesque 'vista' as of a kind of screen, defined by insistent verticals and a massing of leaf and twig. The horizon here is brought up close to the picture plane and the viewer's eye. Moon's beautifully drawn vertical birches and young alders, and complex tracery of overlapping branches and twigs seem to pick up on this effect. The near-square format, as opposed to a conventional horizontal (landscape) presentation, and the emphatic and arbitrary cropping of the picture edges, bring an almost abstract formality to the images.

In his chapter in *The Poetics of Space* on 'intimate immensity', Bachelard provides us with a perfectly apposite phenomenological perspective:

> 'To take a precise example, we might make a detailed examination of what is meant by the *immensity of the forest*. For this 'immensity' originates in a body of impressions which, in reality, have little connection with geographical information. We do not have to be long in the woods to experience the always rather anxious impression of going 'deeper and deeper' into a limitless world. Soon, if we do not know where we are going, we no longer know where we are... the following passage, marked with rare psychological depth, from Marcault and Thérèse Brosse's excellent work, will help us to determine the main theme: "Forests, especially, with the mystery of their space prolonged indefinitely beyond the veil of tree-trunks and leaves, space that is veiled for our eyes, but transparent to action, are veritable psychological transcendents."'

Bachelard adds a paradoxical and uncanny gloss: 'If one wants to "experience the forest," this is an excellent way of saying that one is in the presence of immediate immensity, of the *immediate immensity* of its depth. Poets feel this immediate immensity of old forests:

97 Patrick Caulfield, *Concrete Villa, Brunn*, 1963. Oil on board, 122 × 122 cm. Private collection

> Pious forest, broken woods...
>> Dense with pinkish straight old stems
>> Infinitely serried, older and greyed
>> On the vast deep mossy bed, a velvet cry.'[13]

Both Moon and Klimt have noted Pierre Jean Jouve's 'pinkish' light in the vertical forests of their reveries; both achieve a lichenous complexity of picture surface. So far from representing landscape as the circumambient horizontal and perspectival world of 'standing objects, trees, cars, buildings, human bodies etc.', the vertical plane of these paintings presents to the eye and mind, rather, that second world of John McCracken's, 'the world of the imagination, illusionistic space, human mental space, and all that.'[14] It is the world of reverie, the waking dream, Rilke's 'inner space, this space / that has its being in you.'

In 2014 Moon returned, in the way that artists do, to an image that had made an impact on his imagination some years before. It was a guidebook photograph of a silhouetted standing figure in a small boat some way out on the Venetian lagoon: 'In researching the [2007] trip to Venice I found a photograph of the Lido showing a man in a boat shielding his eyes as if looking into the distance.' For some reason the image had maintained an emblematic poignancy. 'It stuck with me.'[15] Moon's response was inspired. He once more took calico cast imprints of his studio floorboards (as he had for *Eustatismo* and

98 *For Patrick (His Villa)*, 2013
Acrylic, 62 × 61 cm
Private collection

99 *Towpath*, 2011
Acrylic, 122 × 122 cm
Private collection

Chinese Vase seven years before), collected them together on a four foot by four foot board, and treated it variously to create the precise pictorial effects he was seeking. Moon is aware that the verisimilitude of the wood grain to water flow and eddy is not accidental: the energies that produce each are identical in their molecular manifestations. The whorl in a seashell is created by the same elemental force that shapes the swirl of a whirlpool, the spiral of a current, the arabesque of wood grain around a knot.

Modified as necessary, the support now bore a perfect simulacrum of an expanse of seawater, an image of its visible swirling currents, its rippling and ruffling, its insistent flowing and waving horizontals, its whorls of disturbance around unseen obstructions or caused by invisible local turbulences of breeze. Onto this punning surface – both image of lagoon and imprinted picture ground – Moon 'imposed' the image of the man in the boat, meticulously painted. His pose in silhouette is ambiguous: he may be looking back at the shore, or looking back at the sea behind him. (In any case the artist is 'looking back' at the effect the photograph first had on him, and to the use he first made of wood-as-water in his little Venice paintings.) 'To fix the space' Moon wrote later, 'I used the horizon based on the shanty town of Dungeness.' (Another look back!)

'All my paintings since then have been concerned with the ambiguity or metaphorical property of wood as water. Full circle. I have used fishermen observed in Goa, Scottish fishing trawlers, sea birds, all as signifiers of this transformation.'[16] In all these beautiful seascapes, the actual point of view is fictional and ambiguous, and deliberately so. They are paintings about the nature of seeing, about perception itself: they are inventions, machines for looking at. They please the eye as they tease the mind. In many of the later paintings using this spectacular conceit of wood-as-water, Moon has used modified photographs directly applied and fixed to the plane. We are aware as we look at these images that the photographic image is itself, like the imprinted impression of the boards, a direct *trace* of reality. Painting the image appropriates the photograph-image and assimilates it to the aesthetic convention of painting by a doubly ironic use of *trompe l'oeil*, which itself seeks the illusion of 'photographic' veracity.

These are paintings about being in light, time and space, and about the ways in which space itself is a construct of the eye and mind, subject always to contingency, within the perceiving body. Paul Valéry wrote: 'The painter takes his body with him.' Merleau-Ponty elaborates: 'Indeed we cannot imagine how a *mind* could paint. It is by lending his body to the world that the artist changes the world into paintings. To understand these transubstantiations we must go back to the working, actual body – not the body as a chunk of space or a bundle of functions but that body which is an intertwining of vision and movement.'[17] Mick Moon is an intensely physical

100 Mick Moon in his studio, Peckham, London, 2019.
Photo by Philippa Stjernsward

artist; as we have seen, his work has always involved strenuous or intricate procedures, and a preoccupation with the transformation of materials that often precedes, and just as often determines, the process of image-making.

His practice has always essentially been to allow materials to intend their own shapes and meanings in the art object, his techniques and formal determinations themselves being indirect and conducive to the discovery of the unpredictable. His work evolves, in each of its phases, only through the logic of play, metaphor and the unpremeditated deployment of materials and images. Merleau-Ponty, the greatest phenomenological aesthetician of the mid-century, understood this *modus* and knew that in modern art this freedom from predetermined abstract principles and prescriptive aesthetic formulae was a necessary evolution towards new forms of beauty and truth: 'The effort of modern painting has been directed not so much between choosing between line and colour, or even between figurative depiction and the creation of signs, as it has toward multiplying the systems of equivalences [analogies, *correspondances*, etc.], towards severing their adherence to the envelope of things. This effort may require the creation of new materials and new means of expression, but it may well be realised at times by the re-examination and reuse of those already at hand.'[18] In a long and fruitful career, Mick Moon has always found himself as an object-image maker by reaching for, and transforming what is near at hand.

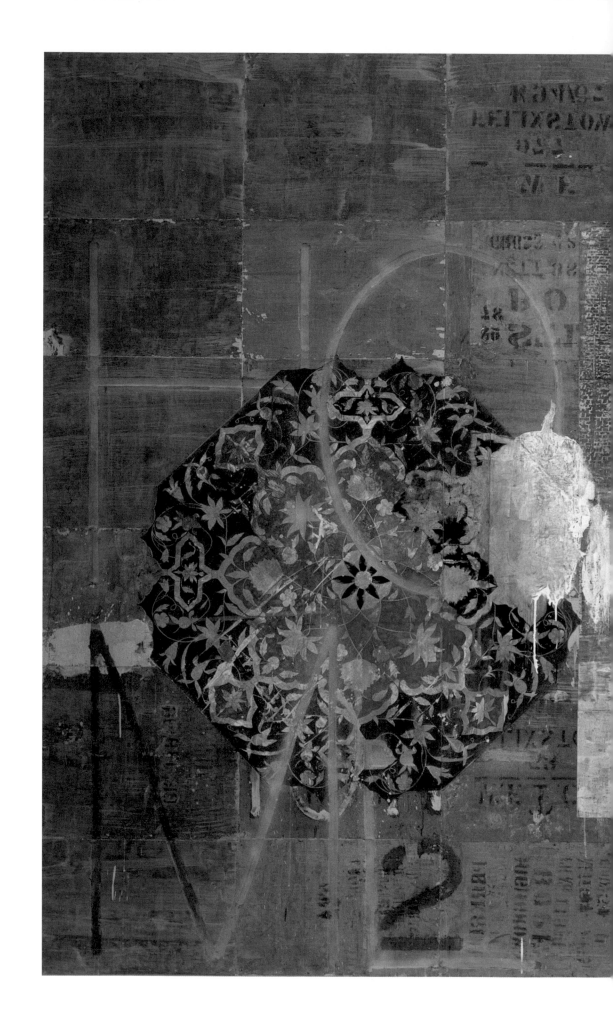

101 *Home Soil Two*, 1999
Mixed media, 105 × 139 cm
Courtesy the Artist

Left, above: **102** *Yellow Flowers*, 1994
Monotype, 50.8 × 47 cm
UK Government Art Collection

Left: **103** *Window*, 1994
Monoprint, 51.8 × 38.7 cm
Courtesy of Deutsche Bank Collection

Opposite: **104** *Inside*, 1994
Monoprint, 54.6 × 39.7 cm
Courtesy of Deutsche Bank Collection

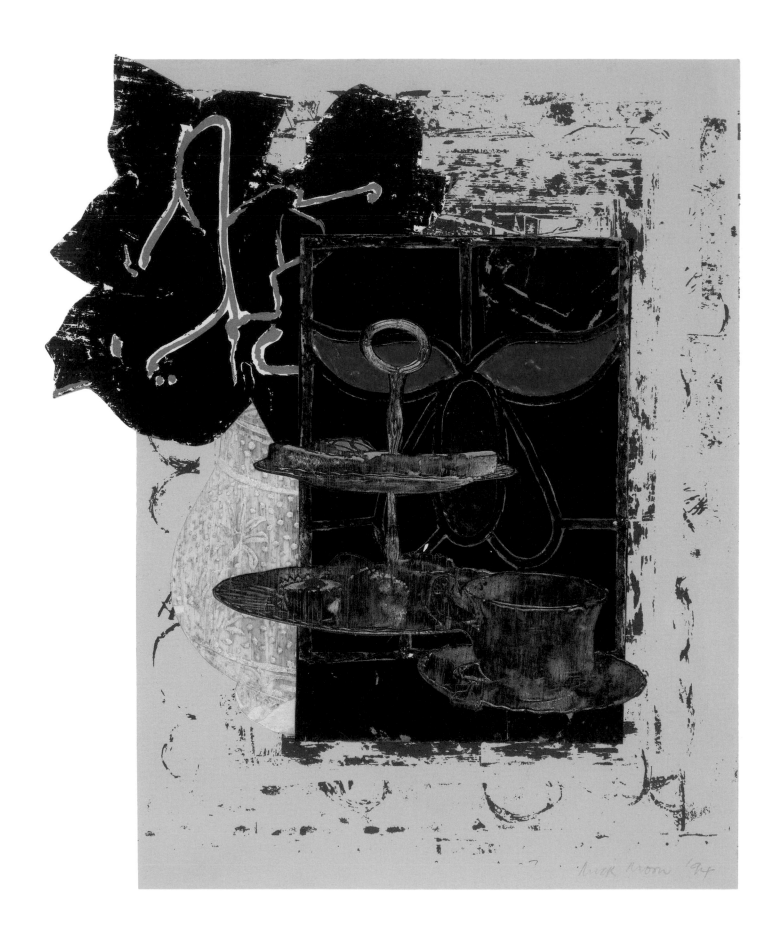

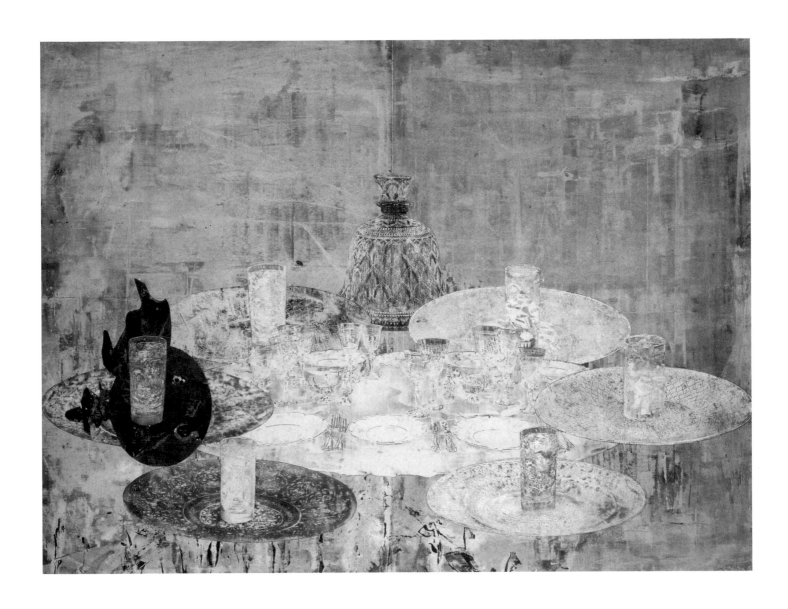

Opposite: **105** *Black Tea*, 1994
Monoprint, 54.6 × 45.7 cm
Courtesy of Deutsche Bank Collection

Above: **106** *Battle Lines*, 1994
Acrylic on calico, 105 × 140 cm
Private collection

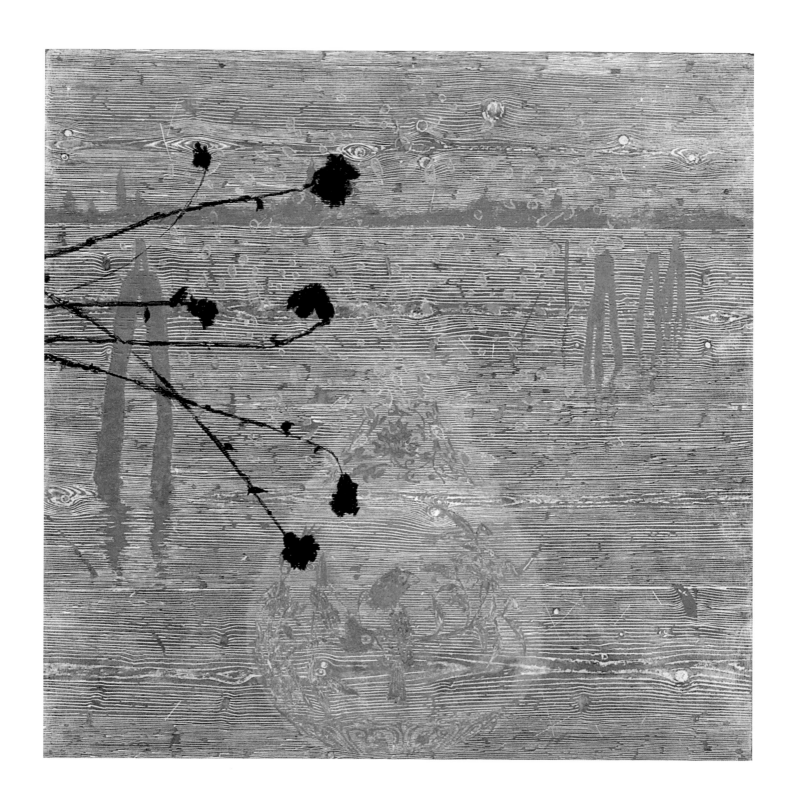

107 *Chinese Vase*, 2007
Acrylic on board, 61 × 61 cm
Private collection. Photo: Dennis Toff

108 *Path*, 2004
Acrylic on paper mounted on board, 61 × 61 cm
Private collection. Photo: Dennis Toff

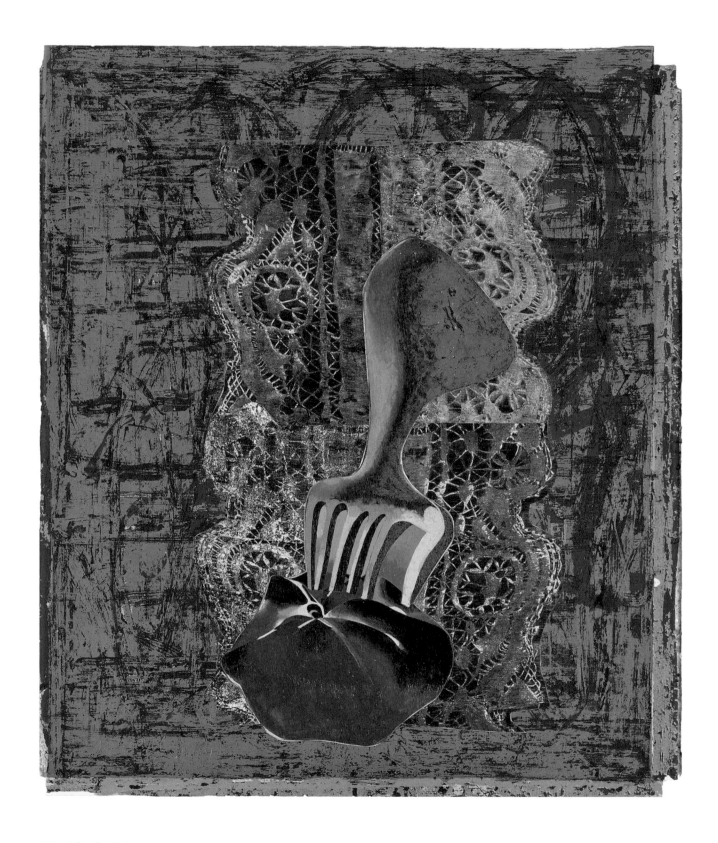

109 *Miró Fork*, 1994
Monotype with *collae* in colours on wove paper
laid onto canvas, 50.2 × 43.2 cm

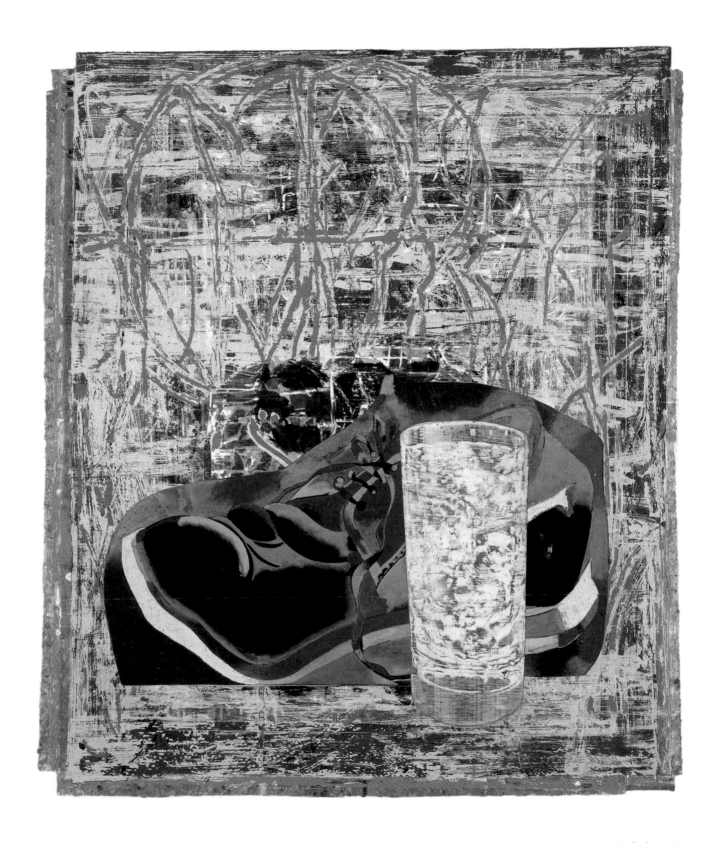

110 *Miró's shoe*, 1994
Monotype with collage, 56.2 × 43.2 cm
Private collection

111 *Apple with Water*, 2002
Monoprint, 72 × 54 cm
Private collection

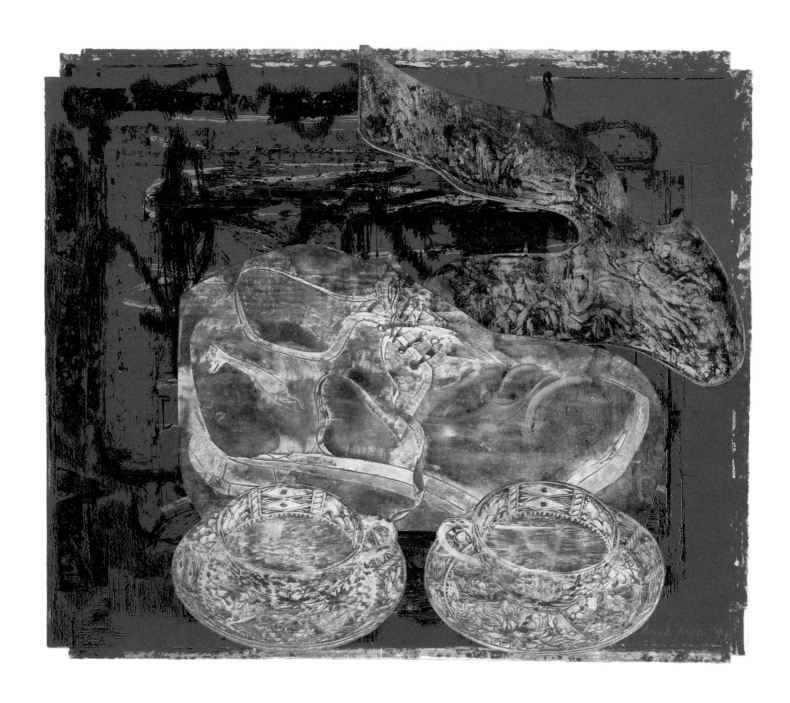

112 *Recalling Miró*, 2002
Monoprint with collage, 43 × 49 cm
Private collection

Opposite: **113** *Salud*, 2002
Monoprint with collage, 51 × 39 cm
Private collection

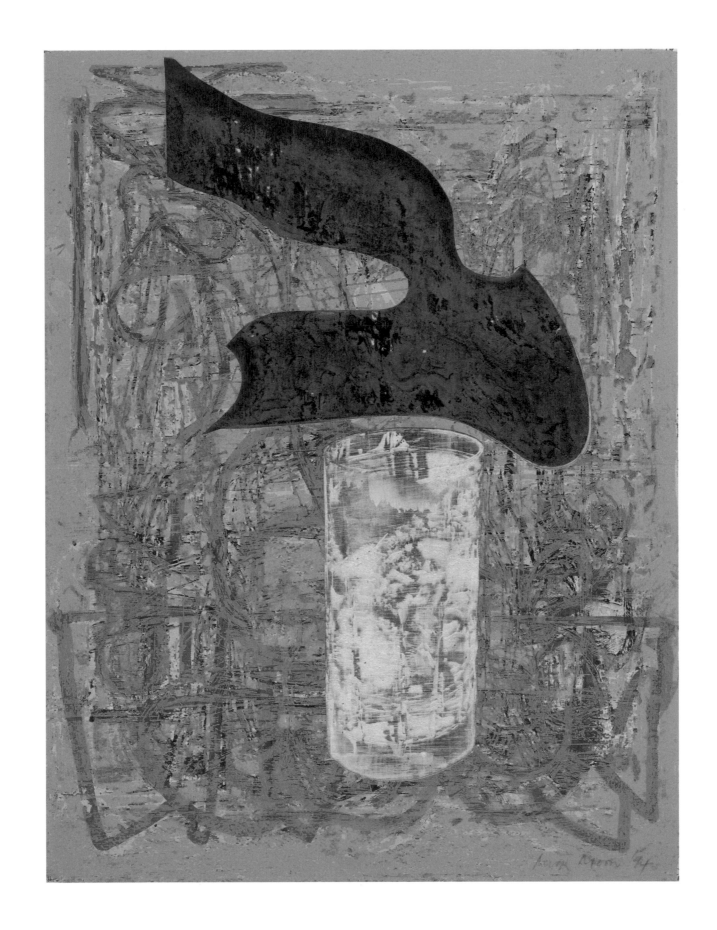

114 *Mirror Mirror*, 2005
Mixed media on paper, 61 × 61 cm
Collection of the Artist

115 *Shalimar*, 2005
Mixed media on paper, 61 × 61 cm
Collection of the Artist

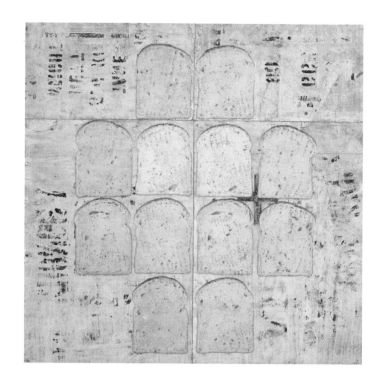
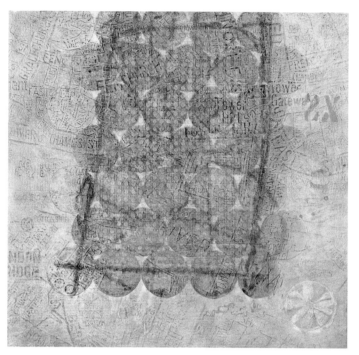

Above, left: **116** *Red Cross*, 2005
Mixed media on paper mounted on board, 61 × 61 cm
Collection of the Artist

Above, right: **117** *Curtain*, 2005
Mixed media on paper, 61 × 61 cm
Collection of the Artist

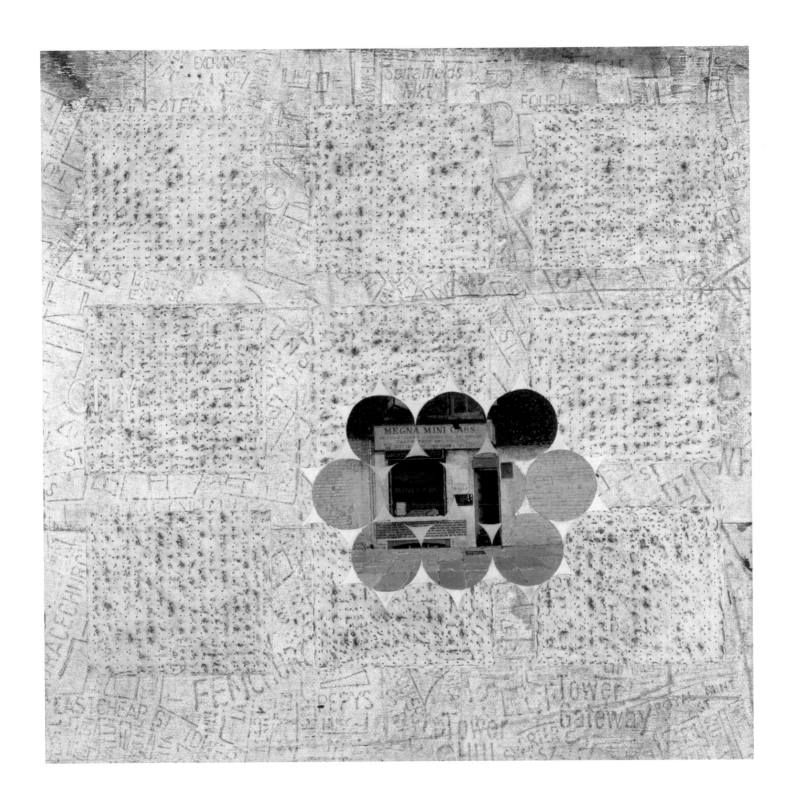

118 *Megna*, 2005
Mixed media, 61 × 61 cm
Collection of the Artist

119 *Cracker*, 2005
Mixed media on paper, 61 × 61 cm
Collection of the Artist

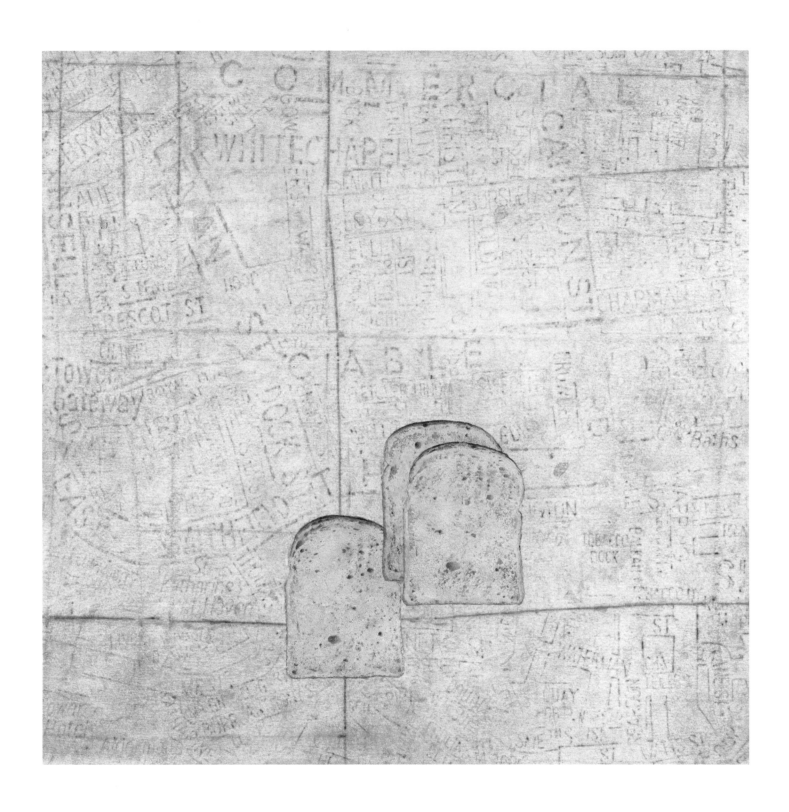

120 *Bread*, 2004
Mixed media on paper mounted on board, 61 × 61 cm
Collection of the Artist

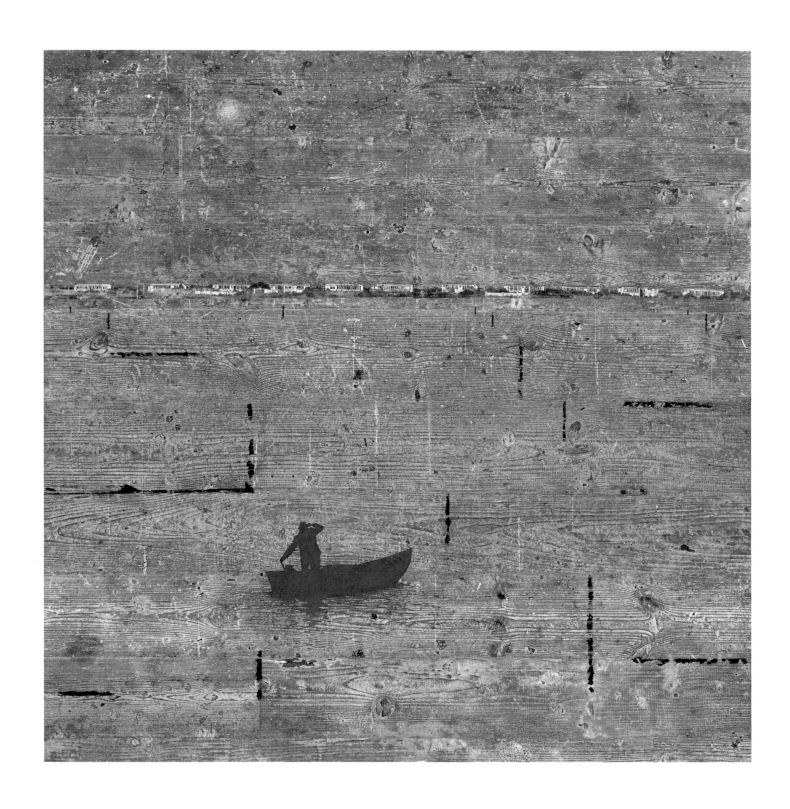

121 *Looking Back*, 2014
Acrylic, 122 × 122 cm
Private collection

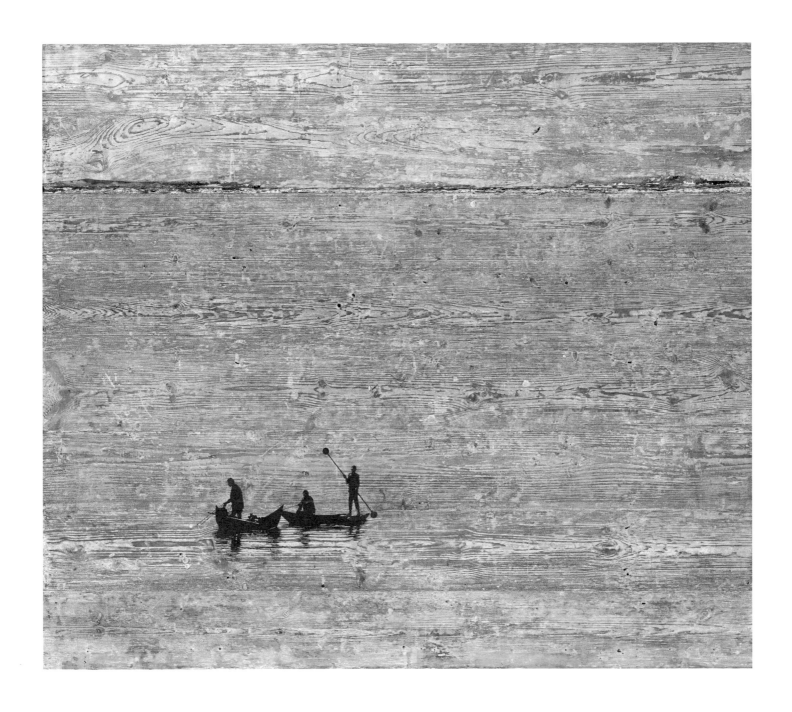

122 *Noon Fishing*, 2015
Acrylic, 122 × 140 cm
Private collection

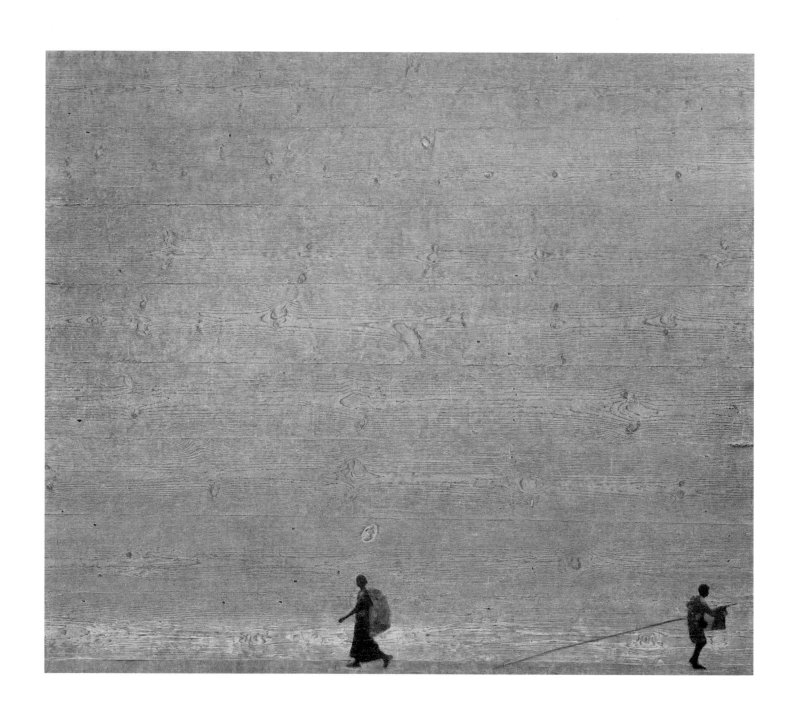

123 *Palolem*, 2018/19
Acrylic and mixed media on calico mounted on board, 114.3 × 139.7 cm
Courtesy of the Artist and Alan Cristea Gallery

124 *Whilst Asleep in Goa*, 2018
Acrylic on calico mounted on board, 121.9 × 139.7 cm
Private collection

125 *Sassoon Docks I*, 2018/19
Acrylic and mixed media on calico mounted on board, 114.3 × 139.7 cm
Courtesy of the Artist and Alan Cristea Gallery

126 *Anticipating*, 2018/19
Acrylic and mixed media on calico mounted on board, 114.3 × 139.7 cm
Courtesy of the Artist and Alan Cristea Gallery

127 *Outward Bound*, 2018/19
Acrylic and mixed media on calico mounted on board, 114.3 × 139.7 cm
Courtesy of the Artist and Alan Cristea Gallery

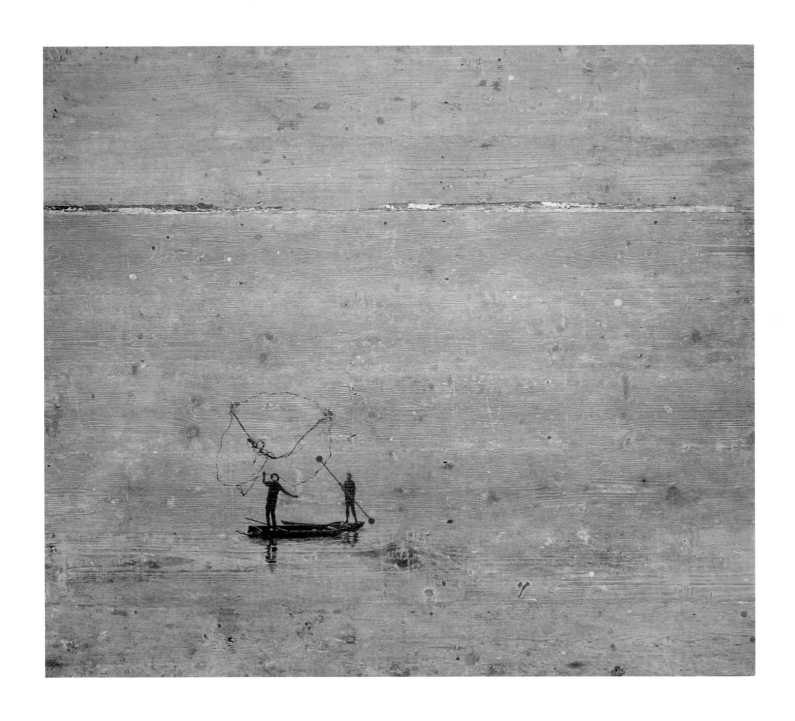

128 *Evening Fishing*, 2016
Acrylic on canvas mounted on board, 122 × 140 cm
Private collection

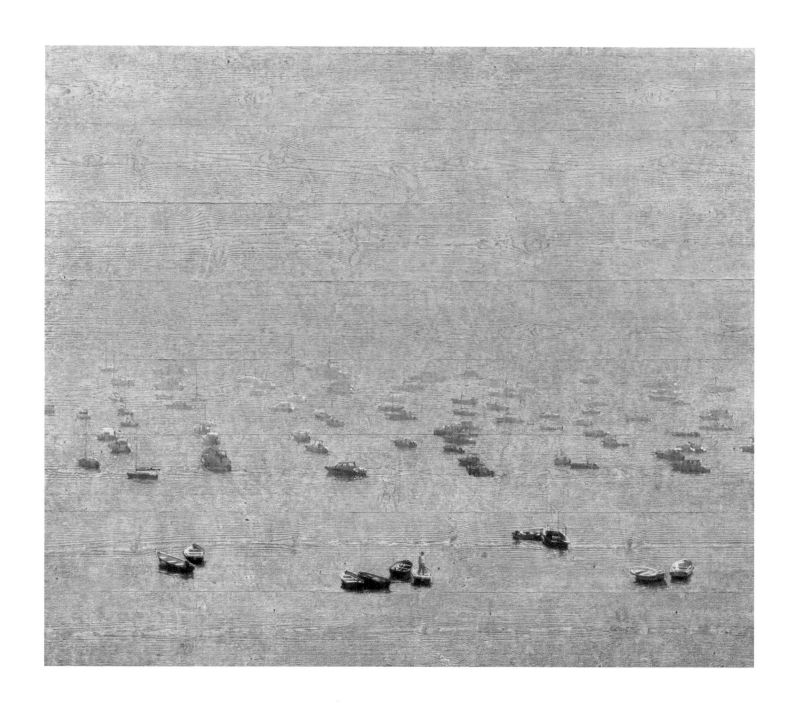

129 *Sassoon Docks II*, 2018/19
Acrylic and mixed media on calico mounted on board, 114.3 × 139.7 cm
Courtesy of the Artist and Alan Cristea Gallery

130 *Northern Lights*, 2018/19
Acrylic and mixed media on calico mounted on board, 114.3 × 139.7 cm
Courtesy of the Artist and Alan Cristea Gallery

Overleaf: **131** *Dusk*, 2017
Mixed media, 122 × 140 cm
Private collection

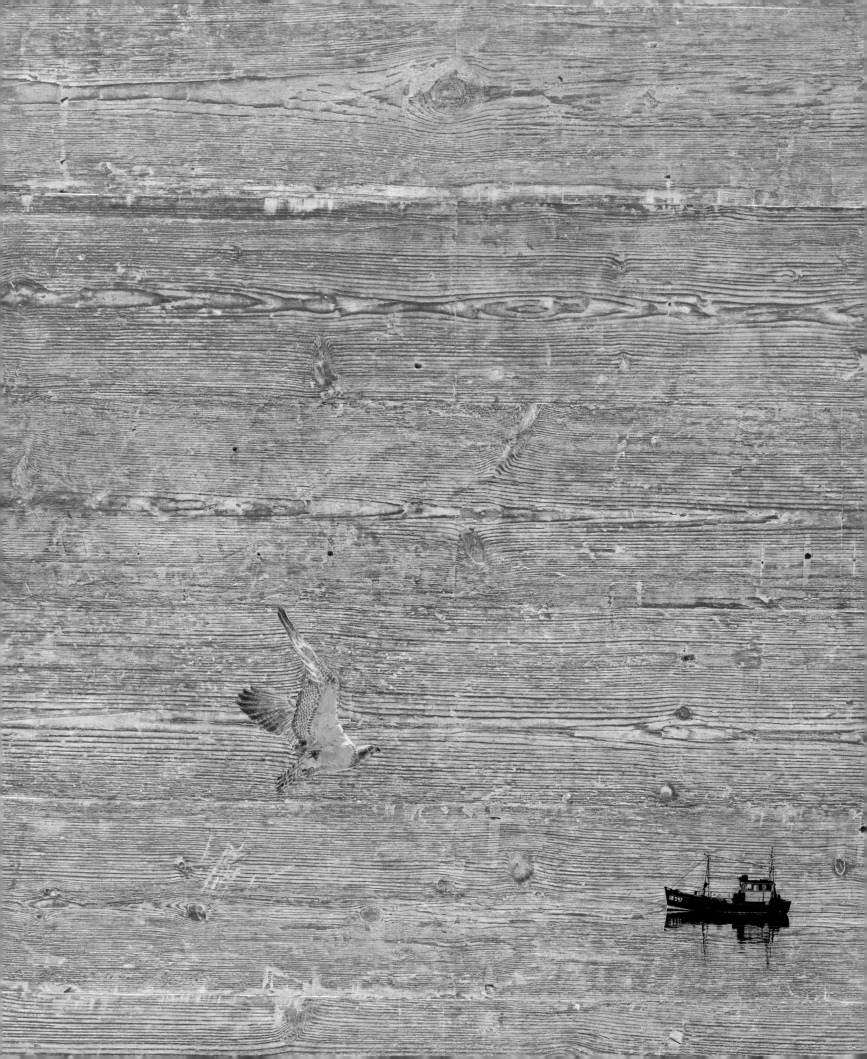

Autobiographical Notes

Mick Moon

1937-55

I was born in Edinburgh in 1937. On the outbreak of war in 1939, my mother moved, with my brother and me, to Blackpool, to live with my grandmother. My father was called up, and this was to all intents and purposes the end of their marriage. My mother was a gifted amateur artist who taught art for a while in a grammar school for girls, until in 1946 she moved to London to start a career as a commercial artist in order to finance our upbringing. We remained with my grandmother. My time in Blackpool was happy, and the beach with all its attractions became a playground in summer. During the winter months I became an obsessive fan of the town's football club, whose Bloomfield Road ground was just around the corner. I was lucky. It was the heyday of Stanley Matthews and Stanley Mortensen.

When my mother moved to London I was sent with my brother to boarding school in Shoreham-by-Sea, West Sussex. My memories are of pebbled beaches and vernacular seaside architecture - Shoreham had many examples both good and bad. My mother was working meanwhile for the *Daily Mirror* as a staff artist, as well as doing freelance illustration work with children's books and comics. When I left school in 1955 she was able to use her influence to get me a job, also working on comics, at the then Amalgamated Press in Farringdon Road. Aside from making tea, I did the lettering in speech balloons.

1956-58

In 1956 I was called up for National Service. As my school qualifications had been good I was able to enlist in the Education Corps. At the end of training I became an Education Sergeant and was posted to Celle in Germany. Serving there at the time, and with the same corps, but older and more senior than me, was John Dougill, an artist who had been accepted for the Royal College of Art when he finished his service. John eventually became an important tutor at the RCA and St Martins, as well as forging his own career as an artist. He was a prodigious draughtsman and the example of his army drawings furnished a growing desire on my part to go to art school.

1958-63

In 1958, on leaving the Army I applied to Chelsea School of Art, mainly because I had been told that the college had an extremely good painting department. In my first two years I did an enormous amount of life drawing and painting. When I had applied I had been advised by the Principal, Henry Williamson, to go for commercial art, but I persisted in my desire to paint. I later learnt that, by coincidence, Patrick Caulfield, then a

student three years ahead of me, had also been advised to opt for commercial art. He too had resisted!

Fellow students included, as well as Patrick, Fabian Peake, and in the sculpture department Peake's future wife Phyllida Barlow. The painting school was run by Frederick Brill. The members of staff towards whom I gradually gravitated were Jack Smith and Michael Andrews. It was Andrews especially who taught me about various techniques that helped you to develop a painting. One such was masking off the whole of a painting apart from one particular section and concentrating on that section for all it was worth. I remember this because the results were gratifyingly surprising.

It was in my third year, when experiment was expected, usually in the direction of abstraction, that I became aware of Georges Braque and particularly his late studio paintings. Following Braque's example led to a love affair with his work that has lasted a lifetime. Under the guidance of Norbert Lynton I wrote my final year thesis on Braque's studio paintings. Norbert never failed to remind me of this whenever we met in subsequent years.

Other tutors who were also important to me were Anthony Whishaw, Prunella Clough, Leon Villancour, Myles Murphy and Ian Stephenson. During my time at Chelsea Lawrence Gowing arrived as Principal, a more important event for me than I realised at the time. In 1963 I was accepted for a place at the RCA. Before taking up that place Lawrence intimated to me - no more - that it might not be the best course to take, and that if after a year I reached the same conclusion I could return to Chelsea and join the teaching staff. Inevitably, as it now seems, after a while at the College I felt his offer was too good to pass up and I accepted it. It was a decision that I never once regretted.

1964-69

At the time I started to teach there, in 1964, Chelsea School of Art was undergoing great changes. The teaching staff had been overhauled and Gowing was encouraging younger artists to join the staff. Among the new staff were Patrick Caulfield, John Hoyland, Allen Jones, Jeremy Moon, Antony Donaldson, Ken Kiff and Brian Young. Alongside them were older artists such as Anthony Hill, John Ernest, Anthony Fry and Craigie Aitchison. It was a starry company and more than justified my taking up Lawrence's offer.

1969

I had been working since leaving the RCA on what I called the 'strip paintings', and by 1969 I had a small collection completed. I had at the same time taken a studio in the London house of Howard Hodgkin in Addison Gardens (fig. 132). Patrick Caulfield had a studio there also, and it was at this time that he and John Hoyland became firm lifelong friends. I arranged a small show of completed paintings in Addison Gardens and

with the kind advice of Norbert Lynton, who came to see them,
I invited John Hoyland to look: Norbert had suggested that he
might help to get me a showing. He was right. Within a week
Bryan Robertson, Bridget Riley, Joe Tilson, the Rowan Gallery
and Leslie Waddington had all come to view the paintings.
What is more, an eminent American collector, Henry Feiwell,
a good client of Leslie's, who had bought paintings from John
through Leslie, purchased a painting. The outcome was an offer
from Leslie Waddington to join his gallery. I had my first show
at the Waddington Gallery in 1969.

1970-73
This first show at the Waddington Gallery was followed up by
two more exhibitions of strip paintings, in 1970 and 1972.
The paintings had by then developed from six strips to eighteen
and were 'large scale'. The Tate Gallery bought from the second
show, in 1970, and the collector Alistair McAlpine bought all
five paintings shown in the 1972 exhibition. Ironically, this
triumph represented the swansong of the strip paintings.

A further showing, this time in Paris, took place in 1972:
a three-man exhibition for Patrick, Howard and myself at
the Galerie Stadler. It was, surprisingly, arranged by a house
guest of Howard's, Radu Varia, a Romanian art critic, who
was surprised on arrival at Addison Gardens to find not just
Howard, but two other painters working in the house. He had
the ear of the directors of Stadler, who through him invited
the three of us to show there. I believe, too, that this show
was to some extent influential in Paris staging the subsequent
exhibition, in 1973, entitled 'La peinture Anglaise d'aujourd'hui'
at the Musée d'art moderne, a large show of English painting.
The three of us also took part in that.

Discontinuing the strip paintings in 1973 I cast around
for new ideas and started to investigate painting from the
direct experience of my everyday surroundings: my studio.
Braque became an emblematic light in this endeavour.
It was also in 1973 that I had an offer, out of the blue,
from Bill Coldstream, to teach at the Slade School of Fine Art,
at University College London. The idea was to oversee the
studies of the undergraduate painting department. Being the
Slade, this was a loose arrangement. The staff I joined at that
time included Euan Uglow, Jeffrey Camp, Tess Jaray, Patrick
George, Noel Forster and Stuart Brisley. It was a nice time to
be in a place where more attention was paid to non-figurative
painting and painting from the imagination than had been
in the past. A further addition to the staff in the early 1980s
was Bruce McLean. He was an important new influence in
the school. His own practice took in sculpture, painting and
performance - a versatility ideal when teaching undergraduate
students. His unbounded enthusiasm and generosity were
hugely beneficial to both students and staff and he made my
time there before I stopped teaching in 1990 a real pleasure.

132 Private view card for the exhibition 'Caulfield, Hodgkin Moon' at
Galerie Stadler, Paris, 1972

Among many talented students I tutored I recall Christopher
Le Brun, Andrew Stahl, Jeffrey Dennis, Anita Klein, Benedict
Pulsford and Nick Hamper.

1976-77
In 1976 I was also invited to mount a small show at the Tate of
some ten or so paintings, works in progress, together with five
earlier strip paintings. This was the first show in public of work
dealing with the theme of the studio. In 1977 I married Anjum
Khan (a marriage that subsequently ended in divorce in 2001).
In 1977 my first son Timur was born. I also moved studios to
my home in Clapham.

1978-80
In 1980 I took part in two significant survey shows: 'British Art
1940-80' and the Hayward Annual, both held at the Hayward
Gallery. There was also a substantial exhibition of British Art
at this time at the Royal Academy: 'British Painting 1952-1977'.
Two one-man shows followed these, at the Ikon Gallery,
Birmingham, and the Chapter Gallery, Cardiff. In 1980 I was
awarded first prize at the John Moores 12, Walker Art Gallery,
Liverpool. The winning painting, *Box Room* (fig. 27), was a good
example of the large paintings hung loosely on their stretchers
that I had been making over the last few years.

During this time I made a print as part of the *London Suite*,
published by Advanced Graphics with Chris Betambeau and
Bob Saitch. The print was called Kautilya Marg. The natural
link between the casts of the floors and walls of my studio that
I had been using in painting, and printmaking as such became
a strong new interest for me. I collaborated at this time with
Alan Cox and Don Bessant of Sky Editions to make monoprints.
Working with these technically brilliant printmakers I was
following in the footsteps of a number of artists I greatly

133 Mick Moon's studio at Addison Gardens, London, 1976

admired, Prunella Clough and John Hoyland among others.

This activity took over much of my time in the 1980s, combining the collaborative activity at Sky Editions with monoprints made on my own in the studio. The latter involved printing my own surfaces, collaging, cutting and pasting. Whilst nominally monoprints, many of these were in many respects smallish paintings, incorporating, more directly, abstract imagery. I had exhibitions of these 'monoprint paintings' with Alan Cristea at Waddington Graphics in 1986 and 1992, and in the former year at the Dolan Maxwell Gallery in Philadelphia.

1982
My second son Adam was born in 1982. That year I was included in the fourth Sydney Biennale, where I showed two paintings. I think on the basis of this I was made an offer of Artist in Residence at Prahran School of Art, Melbourne, which I accepted with alacrity, welcoming the opportunity of a change of scenery for me and for my family. The flight to Australia in June 1982 was surprisingly eventful. It was a 28-hour journey to Melbourne and shortly after a stop in Kuala Lumpur the 707 encountered serious air pollution of ash from a local volcano. All four engines cut out. Eventually the pilot managed to get just one engine to re-engage, and after some 30 hair-raising minutes was able to land at Jakarta. There was much kissing of the runway on landing. Back in England John Hoyland, listening

to breakfast time radio coverage of the incident, wondered out loud, 'wasn't that the flight that Mick was on?' A week later I had a telegram from Leslie Waddington congratulating me on my near escape.

After that, Australia was a breeze. I was given a large studio in the college and made four big paintings in the six months I was there. I exhibited them at the Macquarie Galleries in Sydney and the Christine Abrahams Gallery in Melbourne. The New South Wales Gallery in Sydney bought the painting *For Timur* (fig. 25) for their permanent collection. After I had left Australia I was included in 'Perspecta' at the NSW Gallery, the annual survey for 1982 of work executed in Australia that year. Back in London, I made three more hanging paintings, and these, together with earlier works, were shown at Waddington's in 1984.

1984-92
During these years of the 1980s, I found it difficult to produce a simple, pure and singular image in print, but I had become fascinated by the textural quality of ink on paper. I began to cut up or tear printed material of various kinds, and to re-assemble it into a rich and complex new imagery. These works were

loosely based on the idea of the domestic, and my longstanding interest in Braque and interior space came at last into play. Between 1986 and 1990 this activity became my main concern. I introduced more, and diverse, graphic elements. These complications delighted me, and I was pleased when towards the end of this period they began to morph into an imagery that related to the previous hanging pictures. Still-life too became a preoccupation, a natural development from the themes of rooms and interior spaces.

At this stage it might be useful to describe my own methods of making imprints and/or prints. These methods were first used in making facsimiles of floorboards and walls in my earlier paintings. I found that if I mixed acrylic with sufficient filler and coated the surface to be imprinted, and then covered this with four or five layers of PVA, following that by laying down calico cloth impregnated with acrylic, I could, when this dried out, lift the calico and reveal a perfect imprint of wood. The imprint would be generally the colour used to impregnate the calico. The calico lifts because of the filler.

This is a method I have used consistently from the early nineties to this day. I had a show of paintings at Waddington Graphics in 1992 that exploited this idea with layers of complexly textured integrated imagery. The main development was the use of a direct imagery in the form of woodcuts of Indian bidriware pots. Instead of making simple imprints of floorboards (as in my seventies 'hanging paintings'), these mixed-media works from 1992 onwards combined silkscreen, woodblock printing and acrylic paint, with sections cut and collaged and mounted on canvas. They had the feel of complex paintings. The woodblock elements were cut into plywood from images of Indian vessels. The mix of filler and acrylic colour was then scraped into the cut to provide the image.

I should say something about the nature of the pots. I had travelled to India in 1980 and had been transfixed by its colour and the intensity of its atmosphere and light. The pots from which I chose to model the woodcuts were of a kind described as bidriware, a metalware of which there are spectacular examples to be found in the Victoria and Albert Museum, London. The decoration of these metal pots involves engraving and inlaying metal into metal to create richly detailed patterns. The result is a beautifully clear vessel decorated with organic forms, flowers, poppies, leaves etc. In my works I laid intricate woodcut images onto the imprinted and coloured surfaces of the support. The results of this complicated process were first shown at the Waddington exhibition in 1992.

1992-96

It was at this stage that I began to introduce still more complex still-life elements. I had already made a considerable dictionary of woodcuts. It wasn't such a big leap to think of cut-glass wine glasses, champagne flutes, etc. as components of full-scale dinner settings. The process seemed more accidental and irrational than I might think now. I made a large-scale (six foot or so wide) woodcut of a dinner table setting. I was able subsequently to use this imprint complete in one or two large paintings, or sections of it in smaller monoprints.

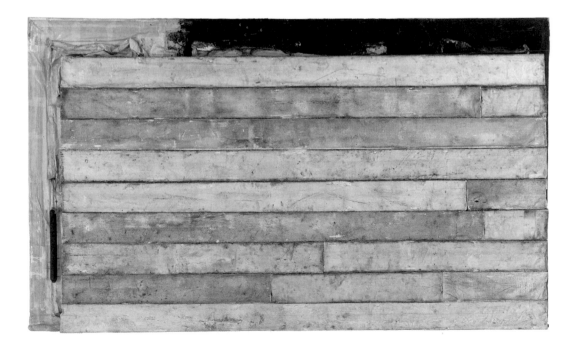

134 *Low Light*, 1978.
Acrylic on unbleached calico,
174 × 292.1 cm
Arts Council Collection,
Southbank Centre, London

1996-2000

Another liberating idea at this time was the introduction of the imagery of tea chests. I liked them for their Indian connection, but even more for their lettering, weight values and the inky blacks of their stencils against organic wood. They were ripe for atmospheric imprints. These gave rise to five medium-large paintings shown by Alan Cristea in 1996. These paintings – *Commodities, Imports, Old Colonial, Letters from India* and *Letters to India, Silvertown*, represented the culmination of something, and the beginning of a new phase. Saatchi bought four of them. Subsequently, of course, they were sold off.

One other element of these paintings was the A-Z map. It came from thinking of Indian artifacts, not from the point of view of India itself but India transposed to England and the East End in particular. The maps gave a detailed edge to the work, and were formed from woodcuts of sections of the A-Z, reversed so that they would read when printed.

In 1994, while still making the works described above, I created a series of small monoprints that explored other content. A painting that had intrigued me since my student days was Joan Miró's *Still Life with Old Shoe* (1937; fig. 91), a response to the Spanish Civil War. In my forties and fifties I had read extensively on the war itself – I believe I was affected by a common psychological desire in people to acquaint themselves

135 *Philippa's Screen*, 2012
Screenprint, 29.5 × 29.5 cm, from *The London Suite II*
Printed and published by Advanced Graphics London

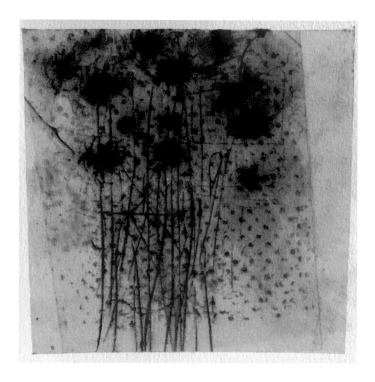

with events that have occurred around the year of their birth. Also, I liked the brutality of Miró's painting enormously. I made a series of small monoprints using elements of his work: the bottle, the bread, the fork, the apple and the ominous shadow. Against these I juxtaposed more benign elements of life: decorated Indian trays, iced water or a gin and tonic, the dinner table, glasses. The contrasts ironically emphasised the savagery of what happened in Spain. Importantly for me, these small works were my tribute to a wonderful artist.

In 1998 I started three large paintings with a background of tea chests but which introduced one new main element, the seafront at Dungeness. For most of my early life I lived close to the sea, and it has subsequently formed a primary image in my work, along with the architecture that fringes it.

I discovered Dungeness through a photograph from which I made an elaborate woodcut. The photograph showed a series of buildings near the shoreline: some hinted at vernacular seaside architecture, others were ramshackle, improvisatory, some were even made of railway carriages. The paintings of Dungeness I made (*Home Soil 1, 2* and *3*; figs 85, 88, 101) utilised the woodcut. In one there were scattered items of luggage and on both, depictions of vegetables, potatoes and cauliflowers. These were I think references to my childhood: what one ate during wartime and the following austerity, and the constant travelling between home and boarding school. I think these paintings, each no less than fourteen feet wide, are two of the most interesting and important works of my career. A third painting, also large, was a direct follow-on from those previous works, and shows a shop in the East End advertising Bollywood films, with a large octagon of Indian decoration.

2000

In 2000 I spent a holiday in Andalucia with Patrick Caulfield and Tony Whishaw, their respective partners, and the painter Philippa Stjernsward. This marked the beginning of a long-term relationship, and Philippa and I were married in 2013. In 2001 I moved to Peckham and created a studio in my new home. The move created a natural break in my work. My first attempts at picking up the traces again were a number of small paintings, again using imagery from the East End. Foodstuffs, Ryvita, cream crackers, a newsagent shop, a car hire firm and a Bollywood video shop were set against faint A-Z maps. At roughly the same time, after a print-making session with Hugh Stoneman in Cornwall, I made a small series of large monoprints adjusted with painted inserts. Two, with large, bold leaf shapes, were entitled *Still-life* (figs 89, 90). Two more successful ones incorporated lottery numbers and an A-Z, with tea chests on one and the Dungeness skyline on the other. Both featured *trompe l'oeil* painted vegetables. The title of one was *Sunday* (fig. 86). For someone of my generation I felt that title said it all. Those childhood Sundays – lettuce and cabbage!

2007

In 2007 I travelled to Venice, invited with other artists, among them Christopher Le Brun, Ivor Abrahams, Bill Woodrow and Nigel Hall, to make work in support of the upkeep of the English Church there. On my return I made two small paintings – one using maps of Venice, the other a view of the Lido (figs 93 and 94). Both dealt with the sea, the water represented by the grain of the wood, which had been drawn and then cut into plywood from rubbings, before being printed with the technique described above. These paintings led directly to the work that I have been engaged with for the last few years.

Researching the trip to Venice I found in a guide a photograph of the Lido showing a man in a boat with his hand shielding his eyes, as if looking into the distance. This image stuck with me. To develop the idea of wood as water I began again to imprint floorboards. In the first painting of this subject I embedded the photo of the boatman in Venice. This began

the long recent series of paintings equating grain of wood with the wave and ripple of water. All my paintings since then have been concerned with this resemblance. The imprints have come full circle from those of my first studio floorboards. I have incorporated images of fishermen observed in Goa, Scottish fishing trawlers of the sort I remember from Fleetwood, seabirds, etc. – all as signifiers to imply the transforming of wood into water.

This is where I stand now. If there is a common thread through all of this it is that your own concerns are very important, and more likely to produce something valuable than too much of an awareness of what is going on artistically, socially and politically at any particular moment. I take this attitude from Braque – especially the Braque of the great studio paintings: his deep immersion in his own private obsessions and philosophy, translating objects and spaces into art through his uniquely personal vision. It is this example that has fed me throughout my career.

Top left: **136** (l-r) Mick Moon, Patrick Caulfield and Joe Tilson at Alan Cristea Gallery, London, *c.* 2000

Left: **137** Patrick Caulfield and Mick Moon, El Gastor, Spain, 2000

Above: **138** Mick Moon and Philippa Stjernsward, El Gastor, 2000

Endnotes

'Introduction: Starting with What You See' (pages 11-13)

1 Gaston Bachelard, *On Poetic Imagination and Reverie*, Dallas, 1987.
2 René Magritte, letter to Alphonse de Woelhens, 28 April, 1962; quoted in *The Merleau-Ponty Aesthetics Reader*, Galen A. Johnson (ed.), Evanston, 1993.
3 Letter from John Keats to George and Thomas Keats, 22, December, 1817, *The Letters of John Keats:1814-1821*, vol. 1, Hyder Edward Rollins (ed.), Cambridge, 1958.
4 James Joyce, *Ulysses*, part 1, Oxford World Classics, 1993.
5 *Cahiers de George Braque*, 1917-1947, Douglas Cooper (trans.), Paris, 1956.
6 Braque in conversation with John Richardson, 1957; quoted in Golding et al., Braque: The Late Works, New Haven and London, 1997.
7 From Douglas Cooper, 'Georges Braque: The Evolution of a Vision', in *Georges Braque*, exh. cat., Tate, London, 1956.

'Ideas and Investigations: The Early Work' (pages 17-27)

1 Paul Klee, *Notebooks: The Thinking Eye*, vol. 1, London and New York, 1961, pp. 72, 533.
2 Georges Braque, quoted in John Richardson, *Braque* (Penguin Modern Painters), Harmondsworth, 1959.
3 Klee, 1961, p. 99.
4 Charles Baudelaire 'Correspondances', *Fleurs du Mal*, Paris, 1857.
5 Klee, 1961, p. 92.
6 John McCracken, interview with Thomas Kellein, August 1995, in *John McCracken*, exh. cat., Kunsthalle Basel, 1995.

'The Hanging Paintings' (pages 29-37)

1 Quoted in Richardson, 1959.
2 Leo Steinberg, *Other Criteria: Confrontations in Twentieth-century Art*, New York, 1972.
3 Quoted in Richardson, 1959.
4 William Blake, *The Marriage of Heaven and Hell* (c. 1783), and letter to Rev. Dr Trusler, August 23, 1799, *Poetry and Prose of William Blake*, ed. Geoffrey Keynes, London, 1939.
5 Quoted in Richardson, 1959.
6 Steinberg, 1972.
7 Richardson, 1959.
8 Francois Fédier, 'Braque and Heidegger: Recollections for the Author', in Alex Danchev, *Georges Braque: A Life*, London, 2007.
9 Danchev, 2007.
10 Gaston Bachelard, *The Poetics of Space*, New York, 2014, see chapter 1, note 4.

'Abstractions, Things, Evocations' (pages 51-67)

1 Maurice Merleau-Ponty, 'Art and the World of Perception', in *The World of Perception*, Oliver Davis (trans.), New York, 2004.
2 Merleau-Ponty, 2004.
3 Merleau-Ponty, 2004.
4 Marcel Proust, *In Search of Lost Time*, Volume 2: *In the Shadow of Young Girls in Flower*, James Grieve (trans.), London, 2003, p. 414.
5 Proust 2003.
6 *Mick Moon*, exh. cat., Waddington Graphics, London, 1986.
7 Wallace Stevens, *The Necessary Angel: Essays on Reality and the Imagination*, 'Three Academic Pieces', London, 1960.
8 Ad Reinhardt, 'Art as Dogma', in Art as Art: The Selected Writings of Ad Reinhardt, Barbara Rose (ed.), New York, 1975.
9 Agnes Martin [1987], quoted in Haskell, Chave and Krauss, Agnes Martin/Barbara Krauss, exh. cat., Whitney Museum of American Art, New York, 1992.
10 Ad Reinhardt, in Rose, 1975.
11 Ad Reinhardt, in Rose, 1975.
12 Proust, 2003.
13 Mick Moon, personal notes.
14 Mick Moon, quoted in 'Introduction' by John McEwen, *New Paintings*, exh. cat., Waddington Graphics, London, 1992.
15 Mick Moon, notes to the present author, 2018.
16 McEwen, 1992.
17 McEwen, 1992.
18 Quoted in Cooper, 1956.
19 Mick Moon, personal notes.
20 Proust, 2003.
21 Mick Moon, personal notes.
22 Steinberg, 1972
23 Steinberg, 1972
24 Samuel Beckett, 'Proust', in Samuel Beckett and Georges Duthuit, Proust: Three Dialogues, Samuel Beckett and Georges Duthuit, London, 1970.
25 Proust, 2003.

'The Late Works' (pages 103-17)

1 J.-P. Sartre, *Imagination: A Psychological Critique*, Michigan, 1962.
2 Martin Heidegger, 'Building, Dwelling, Thinking' in *Poetry, Language Thought*, Albert Hofstadter (trans. and ed.), New York, 1975.
3 Mick Moon, personal notes.
4 Mick Moon, personal notes.
5 Samuel Beckett, 'Proust', in Beckett and Duthuit, 1970.
6 Ludwig Wittgenstein, 'Proposition 7', in *Tractatus Logico-Philosophicus*, London, 1955.
7 Quoted in Teresa Montaner, 'The Profound and Poetic Reality', in *Joan Miró: The Ladder of Escape*, exh. cat., Tate, London, 2011.
8 Montaner, 2011.
9 Montaner, 2011.
10 Montaner, 2011.
11 Proust, 2003.
12 Rainer Maria Rilke, 'What birds plunge through is not the intimate space', in *Selected Poetry*, London, 1982.
13 Gaston Bachelard, 'Intimate Immensity' in *The Poetics of Space*, New York, 2014.
14 McCracken, 1995.
15 Mick Moon, personal notes.
16 Mick Moon, personal notes.
17 Maurice Merleau-Ponty, 'Eye and Mind', II, in Johnson, 1993.
18 Maurice Merleau-Ponty, 'Eye and Mind', II, in Johnson, 1993.

Exhibition History

Solo exhibitions

1969 Waddington Galleries, London
1970 Waddington Galleries, London
1972 Waddington Galleries, London
1976 Tate Gallery, London
1978 Waddington Galleries, London
1980 Ikon Gallery, Birmingham
1982 Macquarie Galleries, Sydney
1983 Christine Abrahams Gallery, Melbourne
 Waddington Galleries, London
1985 Chapter Gallery, Cardiff
1986 Waddington Graphics, London
 Dolan Maxwell Gallery, Philadelphia
1988 Kass Meridien Gallery, Chicago
1992 Waddington Graphics, London
1994 Linda Goodman Gallery, Johannesburg
1996 Serge Sorokko Gallery, San Francisco
 Alan Cristea Gallery, London

Selected group exhibitions

1963 'Young Contemporaries', FBA Galleries, London
1972 'Caulfield, Hodgkin, Moon', Stadler Gallery, Paris
1973 'La Peinture Anglaise D'aujourd'hui', Musée d'Art Moderne, Paris
1974 'British Painting 1974', Hayward Gallery, London
1977 'British Painting 1952 to 1977', Royal Academy of Arts, London
1979 'Recent purchases for the Arts Council', Serpentine Gallery, London
1980 'British Art 1940 to 1980', Hayward Gallery, London
 'Hayward Annual', Hayward Gallery, London
 'John Moores 12', Walker Art Gallery, Liverpool
1981 'Acquisitions 1980 to 1981', Power Gallery of Contemporary Art, Sydney
1982 'The Maker's Eye', Crafts Council Gallery, London
 'Fabric and Form', Art Gallery of Queensland, Brisbane, and touring
 'Fourth Sydney Biennale', Sydney

1983 'Perspecta', NSW Museum, Sydney
'Three Decades', Royal Academy of Arts, London
'The London Suite', Anne Berthoud Gallery, London
1984 'Monoprints', Ikon Gallery, Birmingham, and Third Eye Centre, Glasgow
1985 'Cézanne to Chia: A Spectrum of Twentieth-century Masters', Goodman Gallery, Johannesburg
1987 'American and European Monoprints', Pace Prints, New York
'European Vision', Vancouver Art Gallery, Vancouver
'New Impressions', Fay Gold Gallery, Atlanta
1988 'Exhibition Road: Painters at The Royal College of Art', RCA Galleries, London
'Four Painters', Dolan Maxwell Gallery, Philadelphia
'Athena Art Awards', Barbican Gallery, London
'The Presence of Painting', Mappin Art Gallery, Sheffield
1993 'Vancouver Collects', Vancouver Art Gallery, Vancouver
1996 'British Abstract Art Part Three', Flowers East, London
1997 'Twenty-five Years', Advanced Graphics, London
1999 Royal Academy Summer Exhibition (exhibits annually)
2001 'Contemporary Prints', Alan Cristea Gallery, London
2013 'Under The Greenwood, Picturing British Trees', St Barbe Museum and Art Gallery, in conjunction with Southampton City Art Gallery

Prizes and awards

1980 Major Arts Council Award
First Prize, John Moores Exhibition 12, Walker Art Gallery, Liverpool
1984 Gulbenkian Print Award

Works in Public Collections

Aberdeen Museum of Modern Art
Birmingham City Art Gallery
Australian National Gallery, Canberra
Scottish National Gallery, Edinburgh
Johannesburg Municipal Gallery
Walker Art Gallery, Liverpool
Arts Council of Great Britain, London
Deutsche Bank, London
Saatchi Collection, London
Tate, London
Unilever, London
University College London
Victoria and Albert Museum, London
British Consulate, New Delhi
Museum of Western Australia, Perth
Power Institute of Contemporary Art, Sydney
Art Gallery of New South Wales, Sydney

Select Bibliography

Articles by Mick Moon

'The Water Tank and the Insulating Jacket', *Artscribe*, no. 14, 1978
'Preface', in Sylvie Turner, *About Prints*, London, 1993
'Echoes and Memories' (an appreciation of late Braque), *RA Magazine*, no. 53, Winter 1996
'A History in Outline' (an appreciation of Patrick Caulfield), *RA Magazine*, no. 61, Winter 1998

Solo exhibition catalogues

Judy Marle, *Michael Moon*, Tate, London, 1976
John McEwen, *Mick Moon*, Waddington Graphics, London, 1992

General bibliography

Guy Brett, 'Michael Moon's First Exhibition', *The Times*, 5 February 1969
Norbert Lynton, 'Airs and Spaces', *Guardian*, 7 February 1969
Bryan Robertson, 'Space in Time', *The Spectator*, 7 February 1969
Anna Marchesini, 'Le Mostre a Londra', *Le Arti*, March 1969

R. C. Kennedy, 'London Letter', *Art International*, 20 April 1969
Françoise Pluchard, 'Constantes et Diversites', *Combat*, 29 March 1972
Janine Warnod, 'Les Arts: Mercredi, Rives Gauches', *Le Figaro*, Paris, 29 March 1972
Geneviève Breerette, 'Les Arts', *Le Monde*, Paris, 29 March 1972
Anthony Everitt, 'London Commentary', *Studio International*, April 1972
William Feaver, 'London Letter', *Art International*, 20 April 1972
The Tate Gallery, List of Acquisitions, London, 1970-72
Jaques Lassagne, *La peinture Anglaise Aujourd'hui*, exh. cat., Musée d'Art Moderne, Paris, 1973
John McEwen, 'Placement', *The Spectator*, 26 June 1976
Ian Mayes, 'Michael Moon', *Birmingham Post*, 26 June 1976
William Packer, 'Four Exhibitions', *Financial Times*, 29 June 1976
Caroline Tisdall, 'Tate Gallery: Mick Moon', *Guardian*, 1 July 1976
William Feaver, 'High and Dry', *Observer*, 4 July 1976
Catherine Lampert, 'Michael Moon', *Studio International*, September/October 1976
The Tate Gallery, List of Acquisitions, London, 1976-78
Saranjeet Walia, *Contemporary British Artists with Photographs*, London, 1979
Matthew Collings, 'Hayward Annual', *Art Monthly*, no. 41, 1980
Matthew Collings, 'Overcooked', *Artscribe*, no. 25, 1980
Tim Hilton, *Hayward Annual*, exh. cat., Hayward Gallery, London, 1980
William Feaver, 'In Search of Sleeping Beauty', *Observer*, 31 August 1980
Marina Vaizey, 'A Sense of Excitement', *The Sunday Times*, 31 August 1980
Michael McNay, Hayward Annual, *Guardian*, 2 September 1980
William Packer, 'The Fourth Annual', *Financial Times*, 2 September 1980
John McEwen, 'Pastiche', *The Spectator*, 13 September 1980
'Winning lines', Colour Magazine, *Observer*, 13 November 1980
Phillip Key, 'The Box Room is Decorated', *Liverpool Daily Post*, 26 November 1980
'Six Thousand Pound Prize for Artist's "Box Room"', *Liverpool Echo*, 28 November 1980
William Feaver, 'The Liverpool Lottery', *Observer*, 30 November 1980
Michael Shepherd, 'British Style', *Sunday Telegraph*, 30 November 1980
Robert Waterhouse, 'Moonshine over Merseyside', *Guardian*, 2 December 1980
Jane Clifford, 'John Moores Exhibition', *Daily Telegraph*, 8 December 1980
Sydney Biennale, exh. cat., 1982
Elwynn Lynn, 'Letter from Australia, the Fourth Sydney Biennale', *Art International*, September/October 1982
Hugh Casson et al., *53 83 Three Decades of Artists from Inner London Art Schools*, London, 1983
David Spode, 'Moon Reflects Australia in One-man Exhibition', *The Australian*, 11 January 1983
Terence Maloon, 'Michael's Paintings Pose Some Puzzles', *Sydney Morning Herald*, 15 January 1983
Robert Rooney, 'The Paid Holiday Down Under Attracts the Poms, *The Australian*, 3 April 1983
Rod Carmichael, 'Art Scene', *Melbourne Sun*, 6 April 1983
Memory Holloway, 'Art', *Melbourne Age*, 6 April 1983
Ronald Millar, 'A Fine Display of Prints', *Melbourne Herald*, 8 April 1983
Sarah Kent, 'Visual Arts', *Time Out*, 8 December 1983
John McEwen, 'The Golden Age of Junk Art', *The Sunday Times*, 18 December 1983
Waddington Graphics Catalogue, London, 1986
Athena Art Awards Catalogue, Barbican Art Gallery, London, 1986
Victoria Donohue, 'A Dynamic Approach to Monotypes', *The Philadelphia Enquirer*, 5 March 1986
Guy Burn, 'Mick Moon', *Arts Review*, 9 May 1986
Marco Livingstone, *Exhibition Road: Painters at the RCA*, London, 1988
Mike Tooby, *The Presence of Painting*, exh. cat., Mappin Art Gallery, Sheffield, 1988
Karen Wright, 'Gallery', *Modern Painters*, Spring 1992
Will Harvey, 'Art Exhibitions', *City Limits*, no. 550, 23 April 1992
Tim Hilton, 'Visual Art', *Guardian*, 25 April 1992
John McEwen, 'Moon Breaks Through', *Sunday Telegraph*, 26 April 1992
Charles Hall, 'Report: Prints', *Arts Review*, May 1992
John McEwen, 'The A-Z of Moon's Art', *RA Magazine*, no. 50, Spring 1996
John McEwen, 'Neglect is the Mother of Inventiveness', *Sunday Telegraph*, 28 April 1996
Deutsche Bank, 'Contemporary Art at Deutsche Bank London', Frankfurt, 1996
John McEwen, 'Mick Moon', *Modern Painters*, Spring 1996
Tim Hilton, 'The Summer School of 1998', *Independent on Sunday*, 7 June 1998
Royal Academy Summer Illustrated, exh. cat., Royal Academy of Arts, London, 1998 – present
Dennis Toff, *The Painter RAs*, London, 2008

Index

Page numbers in *italic* refer to the illustrations

Photographic acknowledgements

Unless otherwise stated, all works of art are copyright Mick Moon RA. Every attempt has been made to trace photographic acknowledgements. We apologise for any inadvertent infringement and invite appropriate rights holders to contact us.

We are grateful to Prudence Cuming Associates Limited and Todd-White Art Photography for their photography throughout this book, and to Celine Langan at Sothebys, Julia Chinnery at Christies, Leonora Rae at Deutsche Bank and Rosebery's Auction House for their assistance in sourcing images.

Photo credits
Arts Council Collection, Southbank Centre, London: figs 6, 25, 134. Photo: Jonathon Bayer: fig. 28. Photography: John Bodkin: figs 95, 96, 98, 99, 121, 122, 128, 131. © 2019 Christie's Images Limited: fig. 97. © 2012 Christie's Images Limited: fig. 109. © 2011 Christie's Images Limited: figs 81, 82, 83. Photo © Christie's Images / Bridgeman Images: fig. 20. © Image; Crown Copyright: UK Government Art Collection: fig. 102. Photography FXP Photography and John Riddy: figs 69, 70, 85, 89, 90, 101, 111, 118. Photo: Lucy Kenyon: figs 93, 94. Photo: Colin Mills: figs 50, 52, 86, 87, 103, 104, 105, 106, 112, 113, 114, 115, 116, 117, 119, 123, 124, 125, 126, 127, 129, 130. Digital Image © The Museum of Modern Art / Licensed by Art Resource, NY: fig. 91. Courtesy National Museums Liverpool, Walker Art Gallery: fig. 27. © 1961 by Percy Lund, Humphries & Co. Ltd, London and Bradford: fig. 8. Photo: John Riddy: fig. 88. Image courtesy of Rosebery's, London: fig. 3. © Sotheby's / Art Digital Studio: fig. 84. © Tate, London 2019: figs 9, 18.

Additional copyright
© ADAGP, Paris and DACS, London 2019: fig. 20. © The estate of Patrick Caulfield. All Rights Reserved, DACS 2019: fig. 97. © Successió Miró / ADAGP, Paris and DACS London 2019: fig. 91.

Illustrations

Royal Academy Publications
Florence Dassonville, Production Co-ordinator
Alison Hissey, Project Editor
Carola Krueger, Production Manager
Peter Sawbridge, Editorial Director
Nick Tite, Publisher

Design: Lizzie Ballantyne
Typeset in Financier Text

Colour origination: DawkinsColour Ltd

Printed by Graphicom in Italy, on Furioso 150 gsm

British Library Cataloguing-in-Publication Data
A catalogue record for this book is available from the British Library

ISBN 978-1-910350-92-8 (hardback)
ISBN 978-1-912520-48-0 (limited edition)

Distributed outside the United States and Canada by
ACC Art Books Ltd, Sandy Lane, Old Martlesham, Woodbridge, Suffolk
IP12 4SD

Distributed in the United States and Canada by ARTBOOK | D.A.P.,
75 Broad Street, Suite 630, New York, NY 10004

Artist's acknowledgements
I would very much like to acknowledge wholeheartedly the following for
their contributions to the publication of this book. First, Nick Tite at the
RA and his staff members, Florence Dassonville, Alison Hissey and Carola
Krueger, for their meticulous and empathetic treatment of this project,
as well as Lizzie Ballantyne for her beautiful book design. Their sensitive
professionalism has been eye opening. Mel Gooding for his very enquiring
intellect and for bringing a wealth of critical knowledge to a very in-depth
text. Alan Cristea for his faithful support and not least his foresight in
recording over the years many of the images in the book. Bob Saitch
of Advanced Graphics and Alan Cox of Sky Editions. The printmaking
material illustrated owes much to their skills on the press with ink and
paper. Finally my wife, Philippa Stjernsward – without her loving support,
patience, keen critical faculties and inspiring communication skills this
book might not exist.

Editorial Note
Unless otherwise specified, all works illustrated are by Mick Moon RA.
Dimensions of works of art are given in centimetres, height before width.

Limited Edition
A limited edition of 50 copies of this book, signed by the artist, contains
the following work:

Back and Forth, 2019
Screenprint, 23 × 23 cm
Printed on Velin Arches Blanc under the supervision of the artist at
Advanced Graphics, London. Edition of 50 (with 10 artist's proofs).